Me and my Idol

For Anthony
 and my mother and Nick

Peter Werner
Me and my Idol

Text: Kriss Rudolph

BRUNO GMÜNDER

Willkommen
Bienvenue
Welcome

When I was 13, the fair came to our small town. The boy who checked the tickets at the roller coaster let me ride for free because he thought I was a girl. But my friends tattled. I took off and lost one of my wooden clogs, but otherwise I escaped unscathed.

From then on I imagined that being a woman meant a free ride, until I discovered that the world is not quite so simple. Since then, I was never again that girl inside me. And so I have an even greater admiration for all the performers and drag queens who put on their lipstick and venture out in their high heels.

Where do they get their inspiration from? From their mothers? Their best friends? Or the great divas of the world? The sensual, erotic Marilyns, the intellectual Emma Goldmans, the Dions, Jacksons or Partons? Or is it the other way round, maybe the divas get their inspiration from the drag queens? Perhaps the drag queens are the real divas in the end? Do they embody the "real" feminine ideal?

Since drag queens fascinate me just as much as divas, the originals as well as the copies, I photographed men who believably represent both—an inspiration to live out every facet of our being.

Peter Werner
Berlin, San Francisco, 2012

Ich war 13, da kam der Jahrmarkt in unsere kleine Stadt. Der Junge, der die Eintrittskarten an der Achterbahn kontrollierte, ließ mich kostenlos mitfahren – weil er mich für ein Mädchen hielt. Aber meine Freunde verpetzten mich. Auf der Flucht verlor ich zwar einen meiner Holzclogs, ich kam aber dennoch unbeschadet davon.

Fortan lebte ich in der Vorstellung, dass Frausein bedeutet kostenlos mitzufahren, bis ich entdecken musste, dass nicht immer alles so einfach ist. Das Mädchen in mir habe ich seither nie wieder gelebt. Umso mehr bewundere ich alle Performer und Dragqueens, die Lippenstift auflegen und in ihren Highheels nicht nur die Jahrmärkte unsicher machen.

Nur woher nehmen sie die Inspiration? Von ihren Müttern? Den besten Freundinnen? Oder den großen Diven dieser Welt? Den sinnlichen, übererotischen Marylins, den intellektuellen Emma Goldmans, den Dions, Jacksons, Partons? Oder ist es etwa anders herum, dass sich die Diven ihre Inspiration von den Drag Queens holen? Sind die Dragqueens am Ende die wahren Diven? Verkörpern vielleicht sie die „wahre" Weiblichkeit?

Da mich Dragqueens genauso faszinieren wie die Diven, die Originale ebenso wie die Kopien, habe ich Männer fotografiert, die beides glaubhaft darstellen – zur Inspiration, alle Facetten von uns auszuleben.

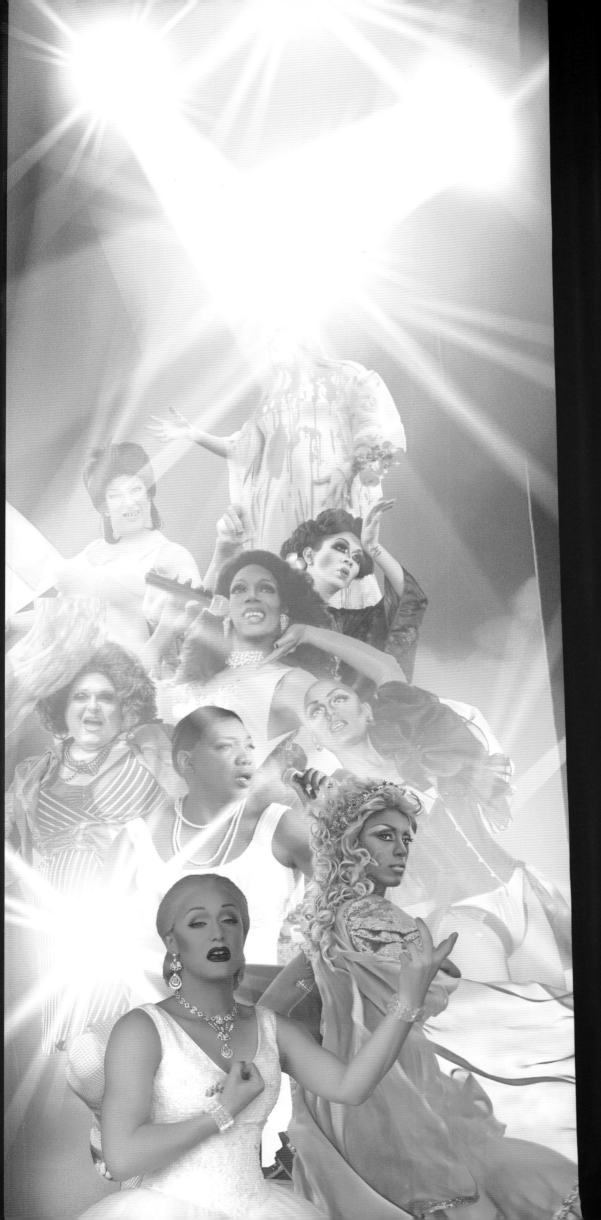

Contents

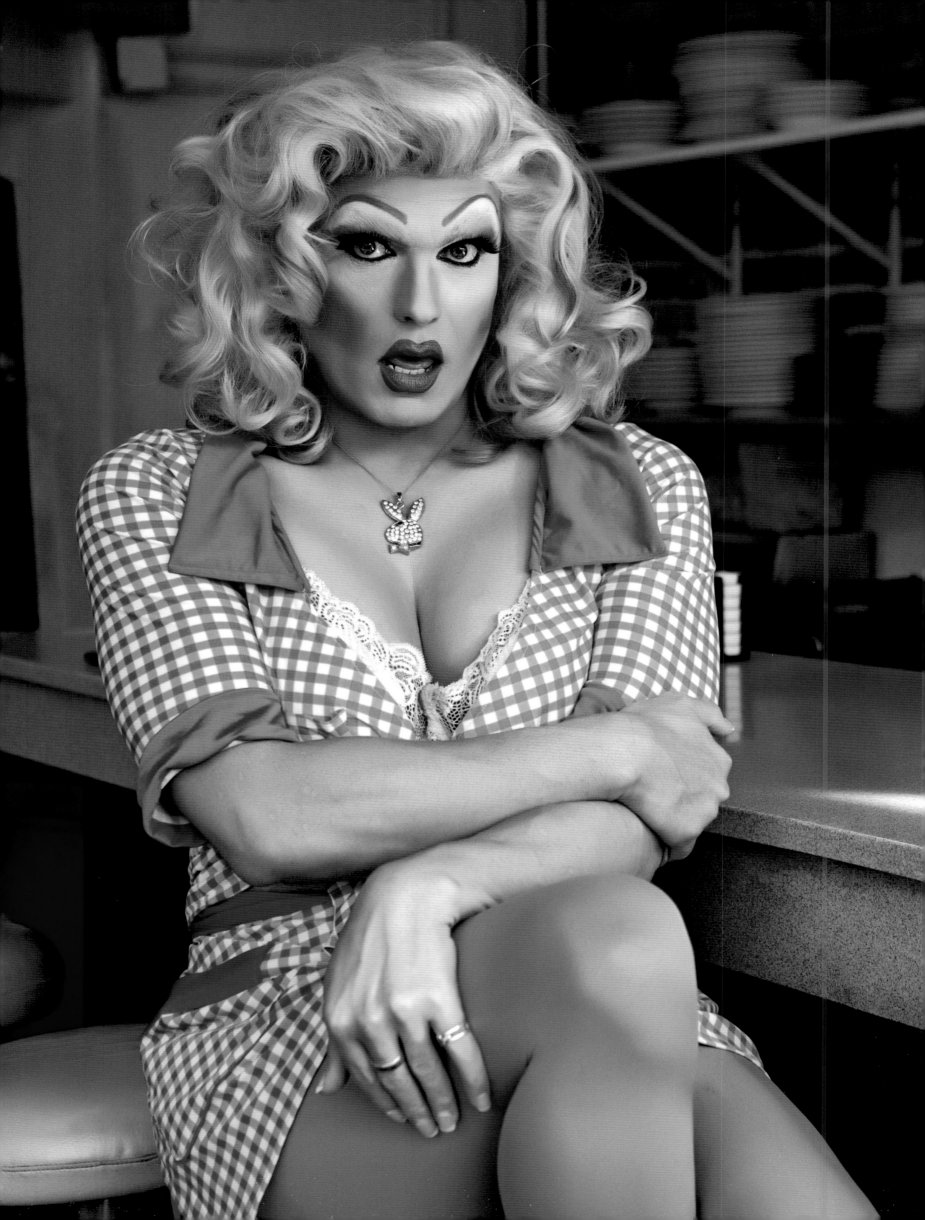

Pollo del Mar inspired by
Anna Nicole Smith

Pollo Del Mar
Celebrity reporter, cover girl, singer—the award-winning Pollo Del Mar has been a permanent fixture in San Francisco for years. She presents a drag show every Sunday in the Castro

Promireporterin, Cover-Girl und Sängerin – in San Francisco gehört die preisgekrönte Pollo Del Mar seit Jahren zum festen Inventar. Im Castro präsentiert sie jeden Sonntag eine Drag Show

She was one of us: Lying in bed, watching TV and shopping were among Anna Nicole's favorite pastimes. And her fascination with one's own body is something that many gay people share. She pimped out her originally harmless tits up to a size D. About her breasts she once said: "Everything I have is because of them." That surely also included her marriage to Howard Marshall, the ancient oil billionaire, whose eye she caught as a topless dancer. Graciously, her husband died just 14 months after the wedding, leaving her some big money.

This supporter of gay rights has been a lifelong fan of Marilyn Monroe. In 1994 there was an epidemic of car accidents in Europe after H&M put up huge billboards everywhere with the former playmate and her chest pitching lingerie. Anna Nicole died at the age of 39 from an overdose of prescription drugs. Her colorful, enigmatic life was memorialized both in film and opera.

Sie war eine von uns: Im Bett liegen, fernsehen und shoppen gehörten zu den erklärten Lieblingsbeschäftigungen von Anna Nicole. Auch die Faszination mit dem eigenen Körper ist etwas, das viele Schwule teilen. So pimpte sie ihre ursprünglich harmlosen Titten auf Körbchengröße D. „Alles was ich habe, verdanke ich meinen Brüsten" hat sie mal gesagt. Dazu zählt sicher auch die Ehe mit Howard Marshall, dem greisen Ölmilliardär, dem sie als Oben-ohne-Tänzerin die Augen verdrehte. Netterweise starb der Gatte schon 14 Monate nach der Hochzeit und hinterließ ihr ein beachtliches Vermögen.

Die Unterstützerin von Homo-Rechten war zeitlebens ein großer Fan von Marylin Monroe. 1994 kam es in ganz Europa zu Autounfällen, nachdem H&M überall großflächige Plakate geklebt hatte, auf denen das ehemalige Playmate und ihre Brüste für Dessous warben. Anna Nicole starb im Alter von 39 an einer Überdosis Medikamenten. Ihrem schillernden Leben wurden mit einem Film und einer Oper gleich zwei Denkmäler gesetzt.

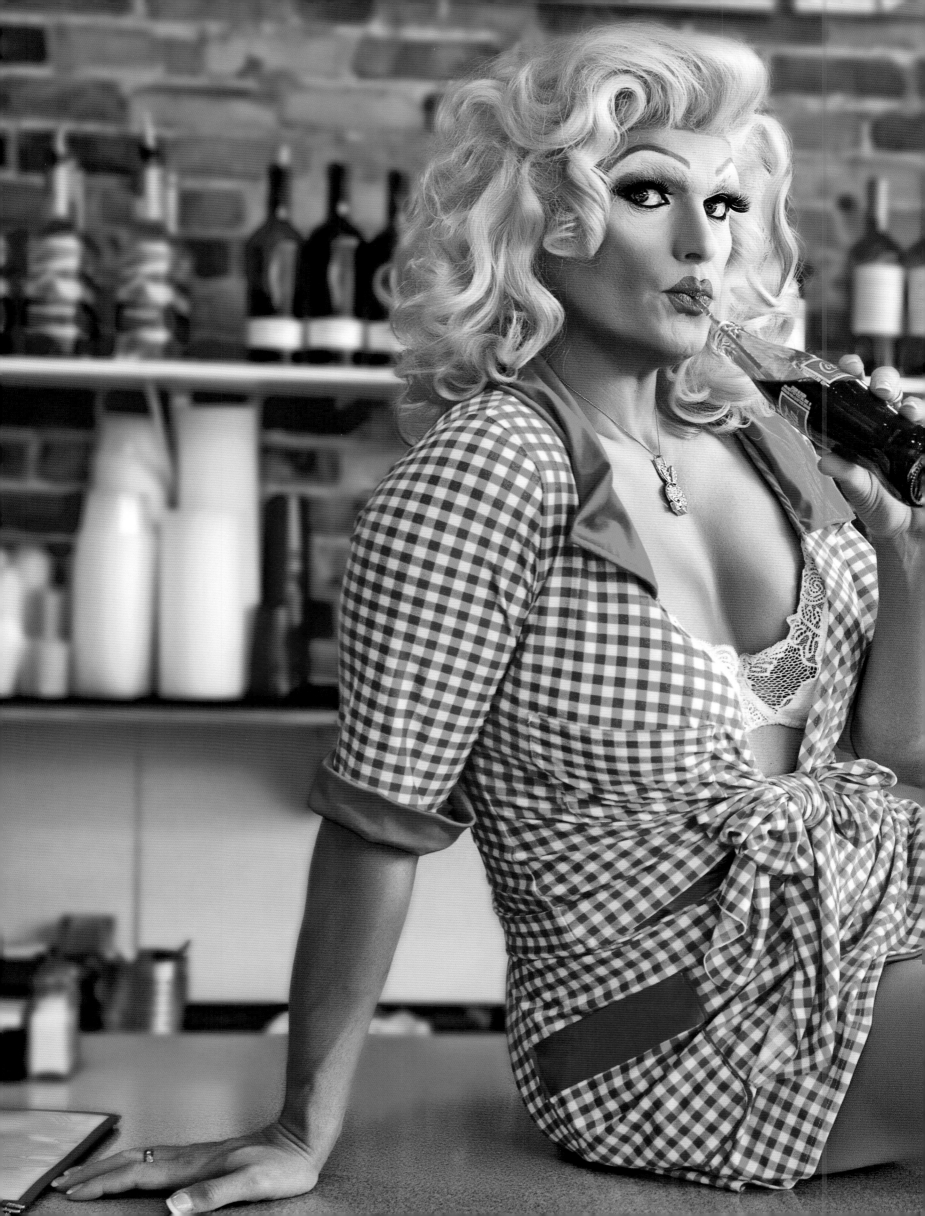

As a complex individual myself, full of dualities, I was drawn to Anna Nicole, whose physical beauty masked a vulnerable, sensitive, often troubled reality—a woman as fragile and dark, it seemed, as she was stunning.

— Pollo del Mar

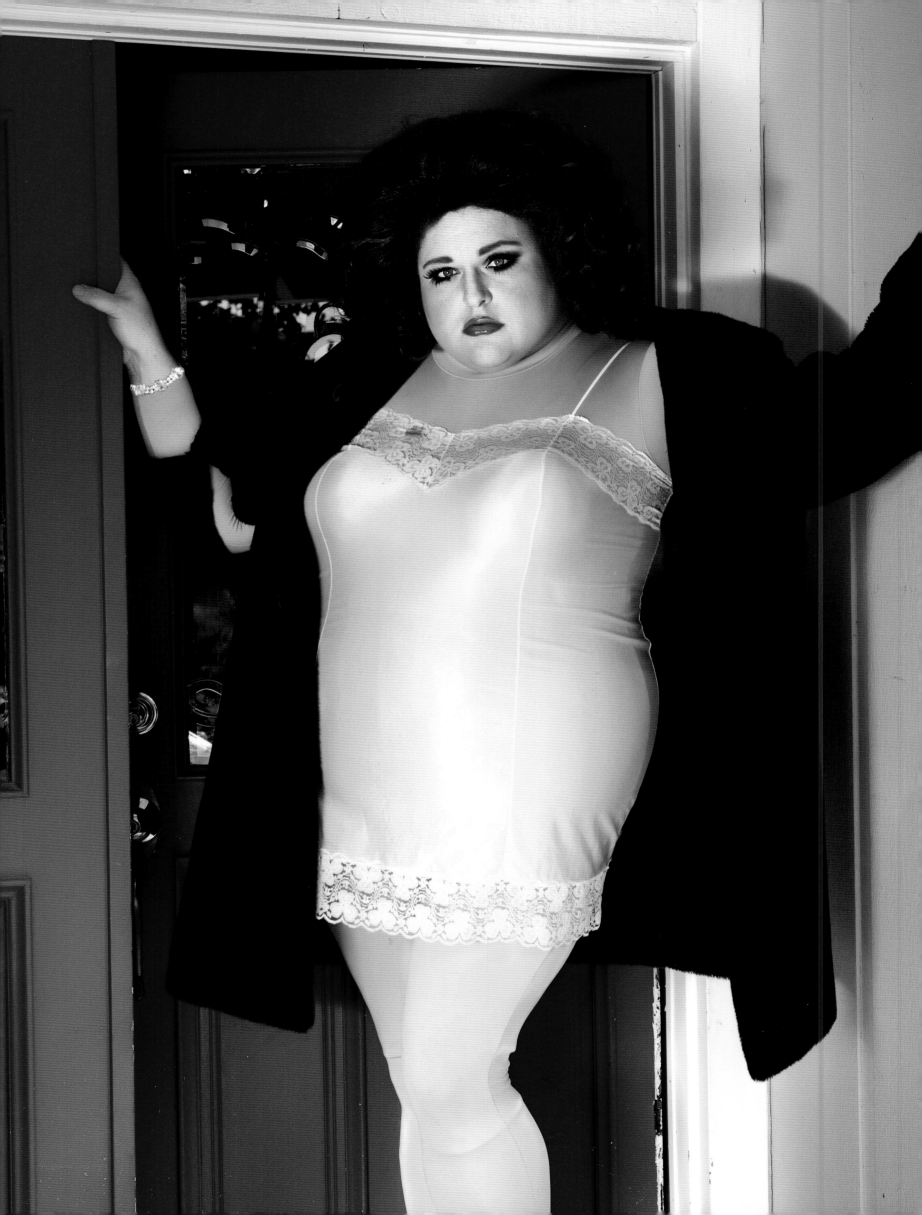

Lady Bear inspired by
Elizabeth Taylor

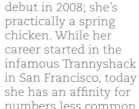

An entire lifetime with the same man in bed? As a gay man, this may not be the most appealing proposition. But no other star of her caliber sought-out a church-approved change of partner as often as Liz, 8 times with 7 men! And how she could put it back: her drinking prowess was as notorious as her beguiling gaze. One time she topped a magazine survey: Who has the most memorably eyelashes in the country? Lassie, by the way, was second.

In *Cleopatra*, she was the first actress to earn over a million dollars; in *Cat on a Hot Tin Roof* she was married to the hot Paul Newman. In the stage version, he was an in-the-closet gay; unfortunately, there was little mention of this in the movie. Although homosexuality was taboo at the time in Hollywood, Taylor became a vehement advocate for gays later in life. Her AIDS foundation has collected an impressive amount of money. She even sold her engagement ring from Richard Burton for the cause.

Ladybear
Ladybear had her debut in 2008; she's practically a spring chicken. While her career started in the infamous Trannyshack in San Francisco, today she has an affinity for numbers less common in the drag scene, such as Mötley Crüe.

Mit ihrem Debüt im Jahr 2008 ist Ladybear noch fast ein Küken. Während sie ihre Karriere im berüchtigten Trannyshack in San Francisco begann, ist sie musikalisch heute eher für drag-untypische Nummern, etwa von Mötley Crüe zu haben.

Ein Leben lang mit demselben Kerl ins Bett gehen? Als schwuler Mann findet man diese Vorstellung nicht rasend reizvoll. Aber so oft wie Liz, die insgesamt 8 Mal mit 7 Männern verheiratet war, hat kein Star ihres Kalibers die kirchlich gesegnete Abwechslung gesucht. Und was konnte diese Frau zechen: Ihre Trinkfestigkeit war ebenso berüchtigt wie ihr betörender Blick. Einmal führte sie die Umfrage eines Magazins an: Wer hat die unvergesslichsten Wimpern im ganzen Land? Auf Platz 2 landete übrigens Filmhund Lassie.

Die Schauspielerin, die mit *Cleopatra* als Erste die 1-Million-Dollar-Gagen-Grenze überschritt, war in *Die Katze auf dem heißen Blechdach* mit dem heißen Paul Newmann verheiratet. In der Dramenvorlage war der verkappt schwul, aber davon merkt man im Film leider nicht viel. So tabu wie Homosexualität damals noch in Hollywood war, so vehement hat sich die Taylor später für Schwule eingesetzt. Mit ihrer Aids-Stiftung hat sie eine Menge Geld gesammelt. Sogar den alten Verlobungsklunker von Richard Burton hat sie dafür verkauft.

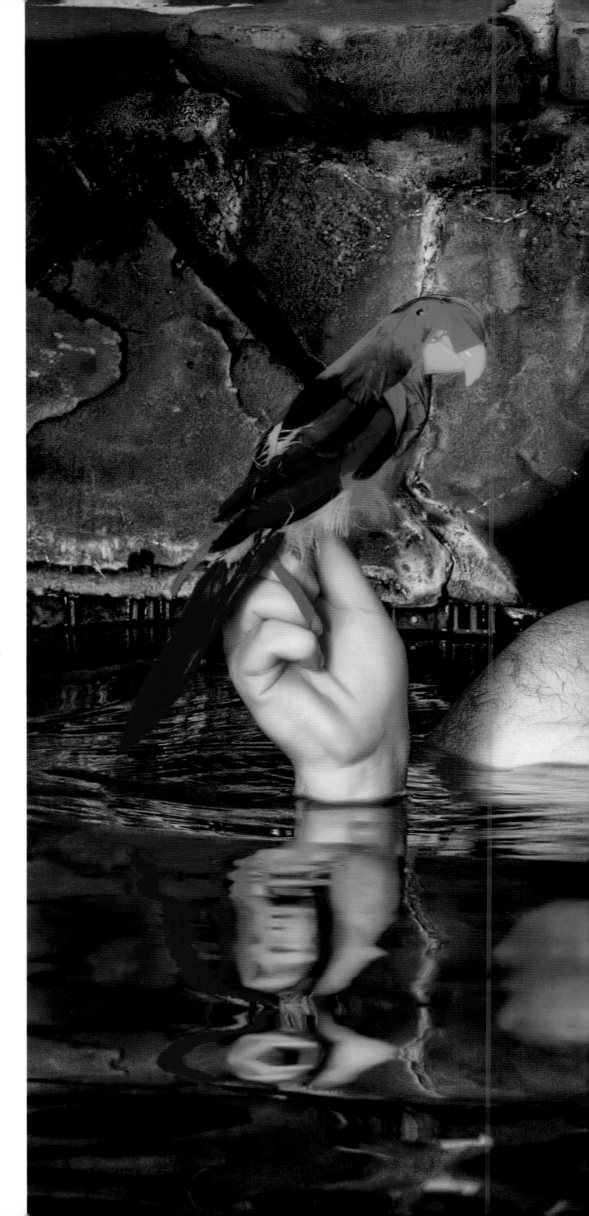

Elizabeth Taylor always said she was ruled by her passions for life and love. And so is Lady Bear— I see her as a kindred spirit ...

— **Lady Bear**

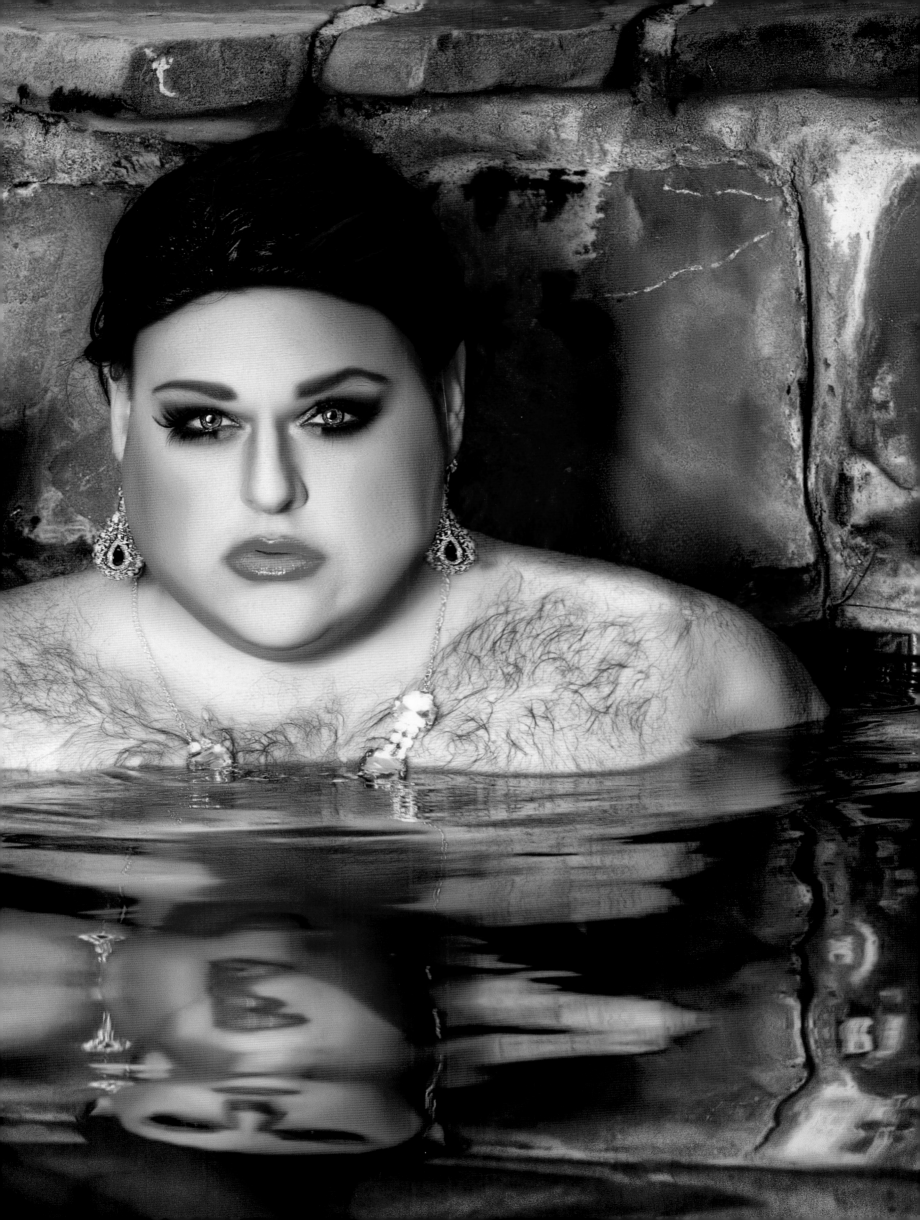

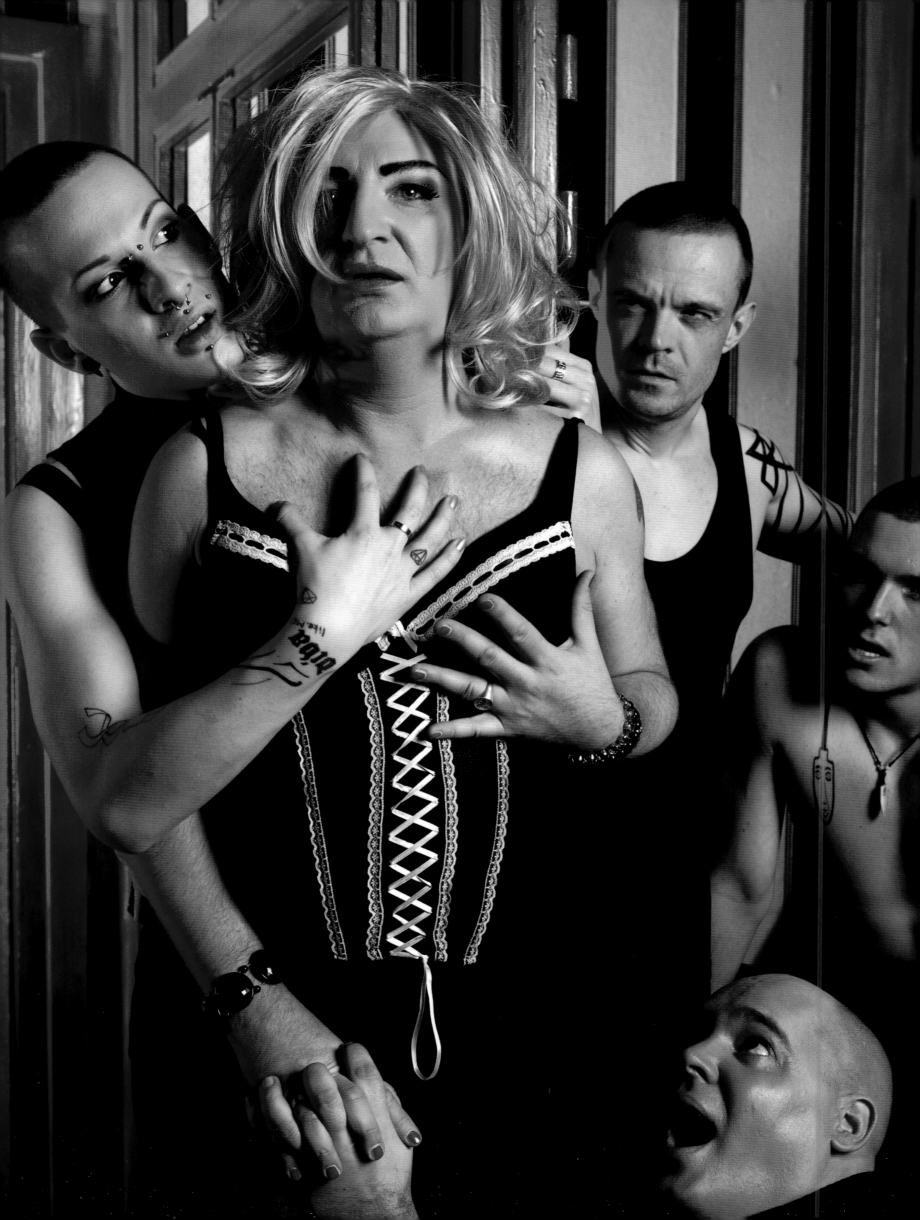

Ades Zabel inspired by
Madonna

Ades Zabel
In the business since the 1980s, Ades Zabel is a fixture of the Berlin cabaret and transvestite scene. He performs as the jobless, constantly horny, drink-happy Edith Schröder throughout Germany.

Seit den 1980er Jahren im Geschäft, ist Ades Zabel aus der Berliner Kabarett- und Travestieszene nicht mehr wegzudenken. Als notgeile Futschi-süchtige Langzeitarbeitslose Edith Schröder tritt er in ganz Deutschland auf.

Whether as a whip-wielding dominatrix, dropping the F-word 13 times on the Letterman Show or getting it on with Britney at the MTV Awards, who doesn't love this naughty girl? What might have shocked us most of all was her notorious childbearing and adopting of children. And thus the woman with a reported IQ of 140 (genius!) has always stayed true to her gay public. Probably the only gay man on the face of the planet who doesn't like her is her brother Christopher, who wrote such a catty book about her.

Without her, the self-proclaimed "gay man in the body of a woman", we wouldn't know what to wear. She keeps turning out new fashion trends, such as Henna tattoos and cowboy hats, designs tracksuits for H&M or sunglasses for Dolce & Gabbana. And modern gay papas can even read to their kids out of Madonna's series of children's books. You just can't get away from the Queen of Pop.

Ob sie als Domina die Peitsche schwang, in Lettermans Show 13 Mal das böse F-Wort sagte oder bei den MTV Awards mit Britney knutschte – dieses ungezogene Mädchen muss man einfach mögen. Womit sie uns aber am meisten schockiert hat, war das notorische Kinderkriegen und Adoptieren. So oder so hat die Frau, die einen IQ von 140 haben soll (Genie-Status!), immer zu ihrem schwulen Publikum gehalten. Der einzige Homo auf der Welt, der sie nicht mag, ist wohl ihr Bruder Christopher, der ein zickiges Buch über sie geschrieben hat.

Ohne die Frau, die sich gern als „schwuler Kerl im Körper einer Frau" bezeichnet, wüssten wir nicht, was wir anziehen sollen. Regelmäßig kommt sie mit neuen Modeideen wie Henna-Tattoos und Cowboyhüten um die Ecke, designt für H&M Trainingsanzüge oder Sonnenbrillen mit Dolce & Gabbana. Außerdem können moderne Regenbogenväter ihrem Nachwuchs sogar aus Madonnas Kinderbüchern vorlesen. An der Queen of Pop kommt man einfach nicht vorbei.

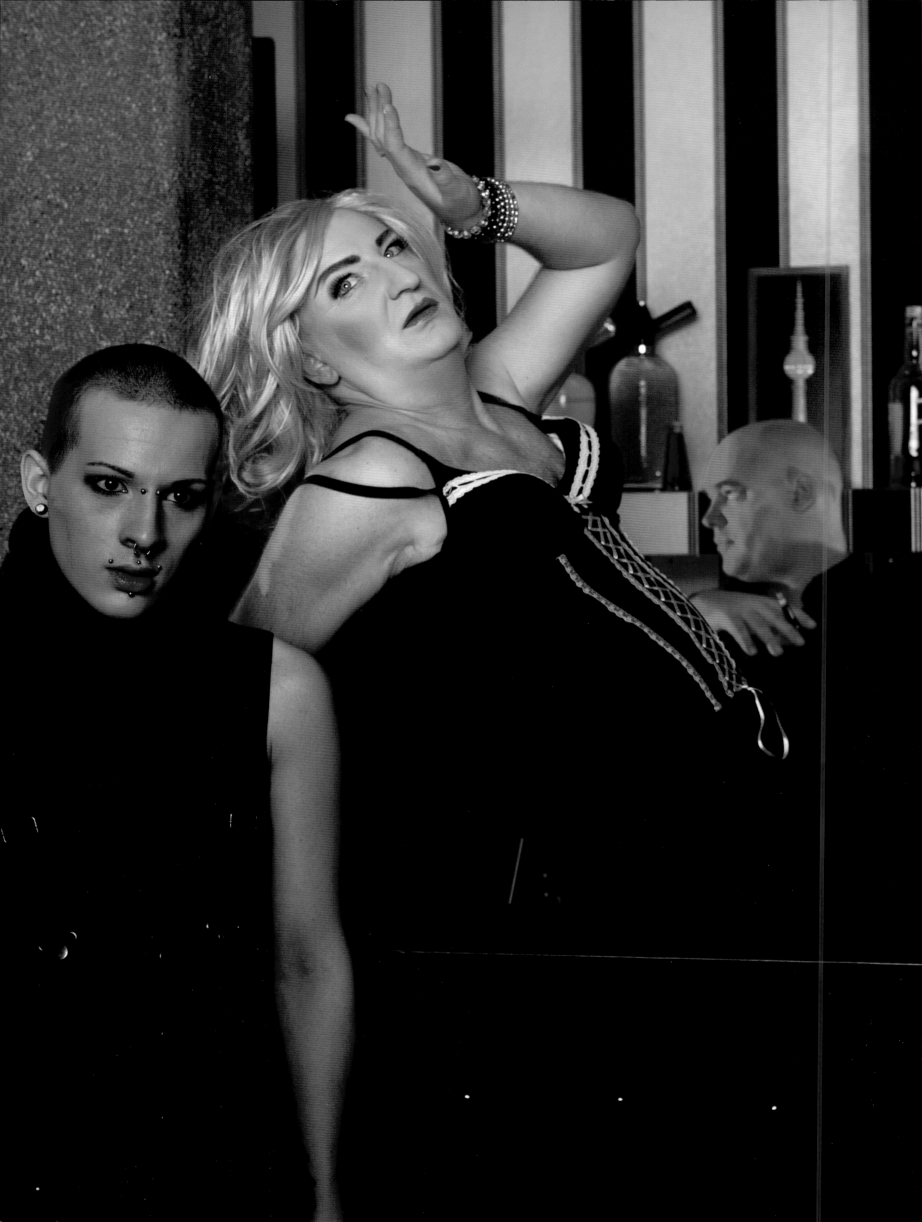

When I get
down on my
knees, it is not
to pray.

— **Madonna**

Miz Sequzoia inspired by **Pam Grier** as
Foxy Brown

Powerwoman Foxy Brown, played by Pam Grier, works in the movie of the same name as a high-end call girl, to avenge the death of her beloved, showing the men who's the boss. The film stems from the heyday of the Blaxploitation era, the beginning of black pride in the movies. Foxy was self-confident, sexy and stylish—a role model for lots of women independant of their skin color.

Like Foxy Brown, Pam Grier is a figther that never lost her femininity. After fighting for civil rights and for women's rights she later startet to act up against homophobia. You don't have to like everybody, she once stated, "but you can at least respect other people." Her role in *The L-Word*, a TV-series that also touched explosive issues like homosexuality in the military, she understood as a political statement.

Die schwarze Powerfrau Foxy Brown, gespielt von Pam Grier, arbeitet im gleichnamigen Film als Luxus-Callgirl, um den Tod ihres Geliebten zu rächen. Furchtlos vermöbelt sie die Männer und zeigt ihnen, wo der Maurer das Loch gelassen hat. Der Film stammt aus der Hoch-Zeit der Blaxploitation-Ära – der Zelluloid gewordene Stolz der Schwarzen in Amerika, der sich hier erstmals zeigte. Foxy war stark, sexy und stylish. Ein Vorbild für viele Frauen, egal welcher Hautfarbe.

Wie Foxy ist auch Pam Grier eine Kämpferin, die nie ihre Weiblichkeit verlor. Nach der Bürgerrechts- und der Frauenbewegung ist später das Engagement gegen Homophobie hinzugekommen. Man müsse nicht jeden mögen, hat sie mal gesagt. „Aber man kann sein Gegenüber zumindest respektieren." Ihre Rolle in der Serie *The L-Word*, wo auch brisante Themen wie Homosexualität im Militär angepackt wurden, verstand sie durchaus politisch.

Miz Sequioa

Miz Sequioa was just a kid when she discovered her mother's pumps, and it was love at first sight! Today, she works as a graphic designer, but always returns to the scene of the crime—the stage.

Miz Sequioa war noch ein kleines Kind, als sie die Pumps ihrer Mutter entdeckte – es war Liebe auf den ersten Blick! Heute arbeitet sie als Grafikdesigner, kehrt aber immer wieder an den Tatort Bühne zurück.

Sandra O. Noshi-Di'n't inspired by

Empress Myeongseong

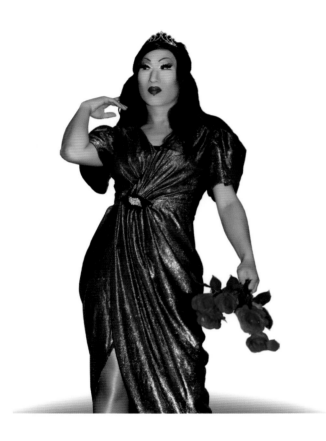

Empress Myeongseong was 14 when she was married to the future King Gojong in 1866. He, however, loved a court lady and kept his distance sexually from Myeongseong. Later, however, she was his trusted counselor. She was an outstanding politician and a modern woman. Whenever other powers put pressure on her country, the skillful diplomat found help from outside. Above all, Japan posed a constant threat. Finally, their aggressive neighbors had had enough and on 20 August 1895, they sent a group of assassins to kill her.

In South Korea, interest in this fascinating woman, who lived to just 43, has been revived. Her life story was adapted into an acclaimed musical and a television series. Recently, a movie about the empress insinuated an affair with a bodyguard.

Kaiserin Myeongseong war 14, als sie 1866 mit dem zukünftigen König Gojong vermählt wurde. Der jedoch liebte eine Hofdame und hielt Myeongseong sexuell auf Abstand. Dafür stand sie ihm später bei Audienzen als Ratgeberin zur Seite. Nicht umsonst wurde sie als herausragende Politikerin und moderne Frau bezeichnet. Wann immer andere Mächte Druck auf ihr Land ausübten, holte die geschickte Diplomatin Hilfe von außen. Vor allem gegen die Japaner musste sie sich immer wieder wehren. Bis die aggressiven Nachbarn die Nase voll hatten und ihr am 20. August 1895 ein Tötungskommando auf den Hals hetzten.

Im Süden des geteilten Landes beschäftigt man sich neuerdings wieder viel mit dieser spannenden Frau, die bloß 43 Jahre alt wurde. Ihr Leben wurde nicht nur zu einem umjubelten Musical und einer Fernsehserie verwurstet. Vor wenigen Jahren befasste sich auch ein Kinofilm mit der Kaiserin und unterstellte ihr eine Affäre mit einem Bodyguard.

Sandra O. Noshi-Di'n't
Hailing originally from New York, Sandra O. Noshi-Di'n't lives in San Francisco and mixes it up in all the most prominent drag shows. The former Miss Hooker appeared in the short film *Children of the Popcorn.*

Ursprünglich aus New York, lebt Sandra O. Noshi-Di'n't in San Francisco und mischt dort bei allen wichtigen Drag-Shows mit. Die ehemalige Miss Hooker war zuletzt auch in dem Kurzfilm *Children of the Popcorn* zu sehen.

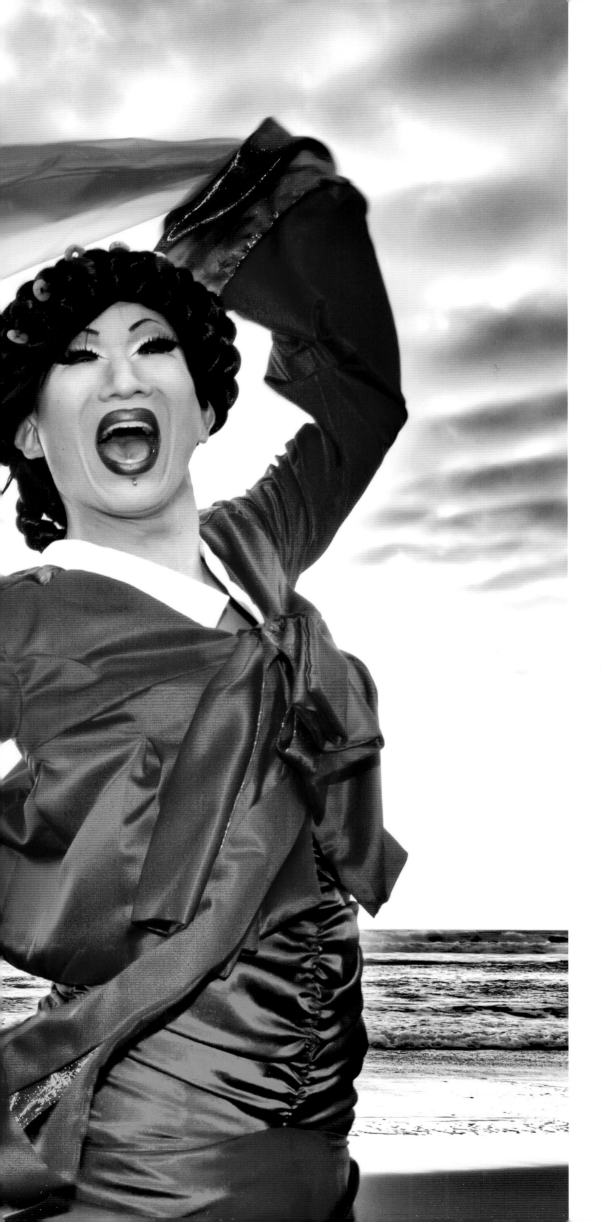

Empress Myeongseong represents undying determination, leadership, beauty, power, and most importantly, the feminine mystique.

— **Sandra O. Noshi Di'n't**

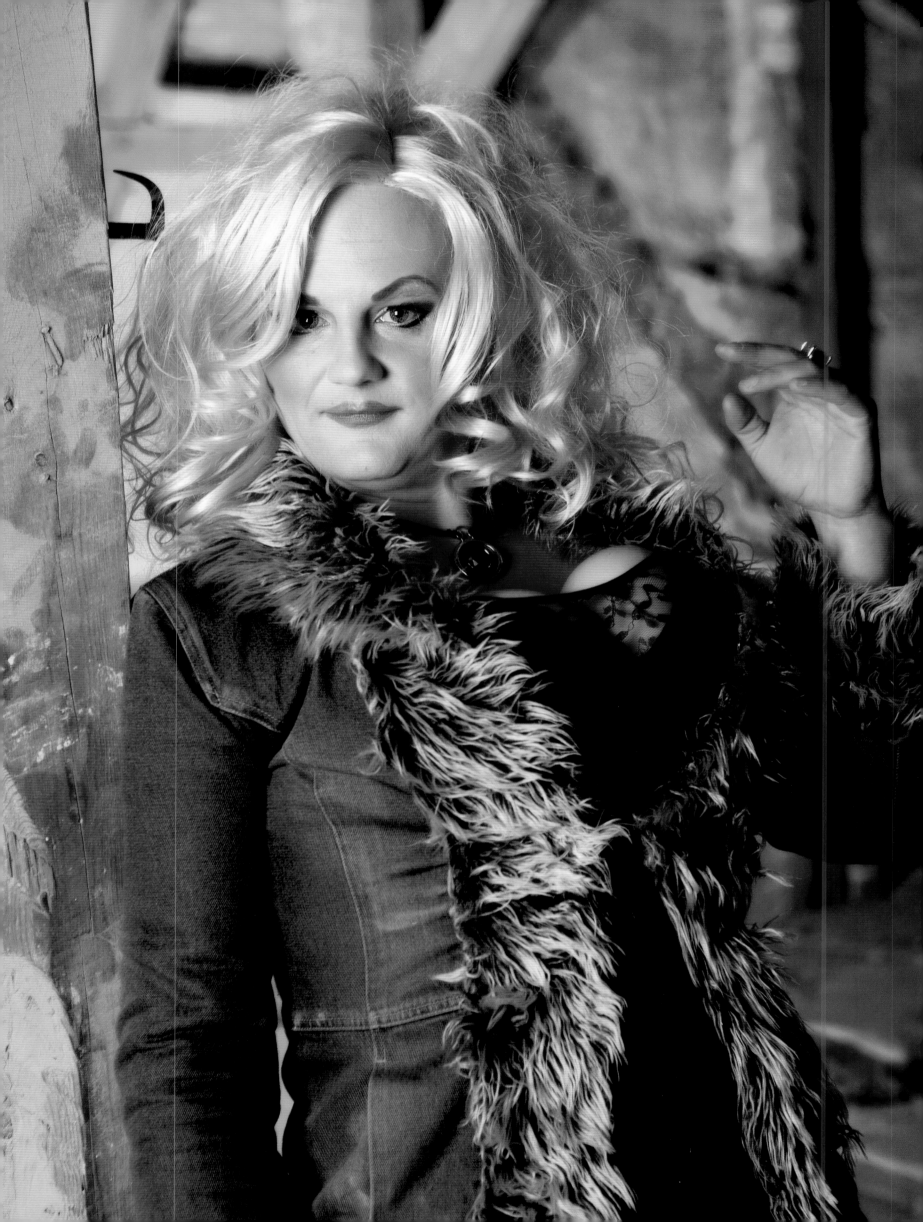

Fergie Fiction inspired by
Dolly Parton

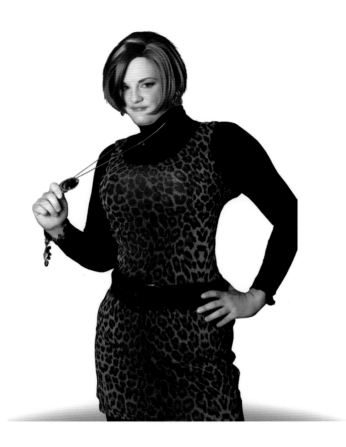

Fergie Fiction
Fergie Fiction is a newcomer in the big, colorful Berlin club scene and can be found, like most queens, in the SchwuZ club. With her voluptuous curves, she embodies the sexy, shapely feminine ideal.

Fergie Fiction ist die Newcomerin in der großen bunten Berliner Clubszene und ist wie die meisten Drags im SchwuZ anzutreffen. Mit ihren prallen Rundungen verkörpert sie den Typ sexy Vollweib.

How many women can claim that the world's first sheep clone was named after them? You need a good portion of self-irony for that kind of destiny. And that she's got. "You'd be surprised how much it costs to look this cheap. I hope people realize that there is a brain underneath the hair and a heart underneath the boobs." Years ago in L.A. she took part in a Dolly-Parton look-alike contest with a group of drag queens: She lost. Later in a television interview she was shown four Dolly Parton photos, only one of which was actually her. Dolly's reaction: "Are you kidding me? That's me every time!"

Gay men revere the singer. Each year they organize a Gay Day at the Dollywood amusement park. Dolly, who herself always felt like an outsider, contributed a song for the transgender film *Transamerica*. The conservative elements of the country scene were disappointed by pro-gay efforts from the Queen of Nashville. Not that she cared. "I'm old enough and cranky enough now that if someone tried to tell me what to do, I'd tell them where to put it."

Welche Frau kann schon von sich behaupten, dass das weltweit erste Klonschaf nach ihr benannt wurde? So ein Schicksal verlangt viel Selbstironie. Und die hat sie. „Es kostet eine Menge Geld, so billig auszusehen wie ich. Aber hinter diesen Titten schlägt ein Herz, und unter der Frisur steckt ein Hirn." Vor Jahren hat sie mal in L. A. mit lauter Drag Queens an einem Dolly-Parton-Doppelgänger-Wettbewerb teilgenommen – und verloren. Später wurde sie in einem Fernsehinterview mit vier Dolly-Parton-Fotos konfrontiert, wovon nur eins sie selber zeigte. Reaktion Dolly: „Wollt Ihr mich auf den Arm nehmen? Das bin doch jedes Mal ich!"

Schwule Männer verehren die Sängerin. Jedes Jahr organisieren sie in ihrem Vergnügungspark Dollywood einen Gay Day. Dolly, die sich selber immer als Außenseiterin fühlte, hat für den Transgender-Film *Transamerica* einen Song beigesteuert. Das erzkonservative Country-Publikum war über so viel homo-freundliches Engagement der Queen of Nashville enttäuscht. Aber die hat das nicht gejuckt. Sie sei alt und exzentrisch genug, ließ sie ausrichten. „Wenn jemand mir sagt, was ich zu tun habe, zeige ich ihm die kalte Schulter."

*It's a good thing
I was born a girl,
otherwise I'd be
a drag queen.*

— Dolly Parton

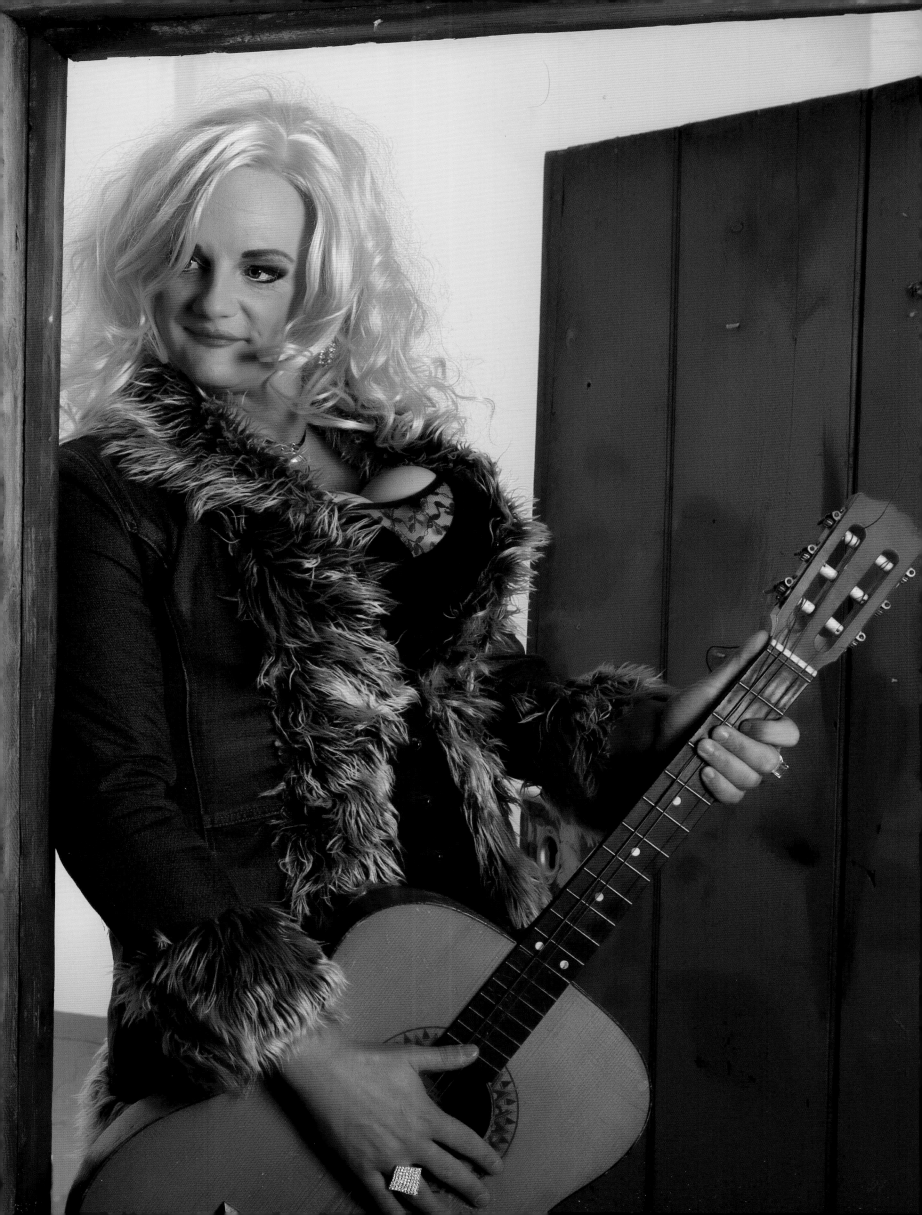

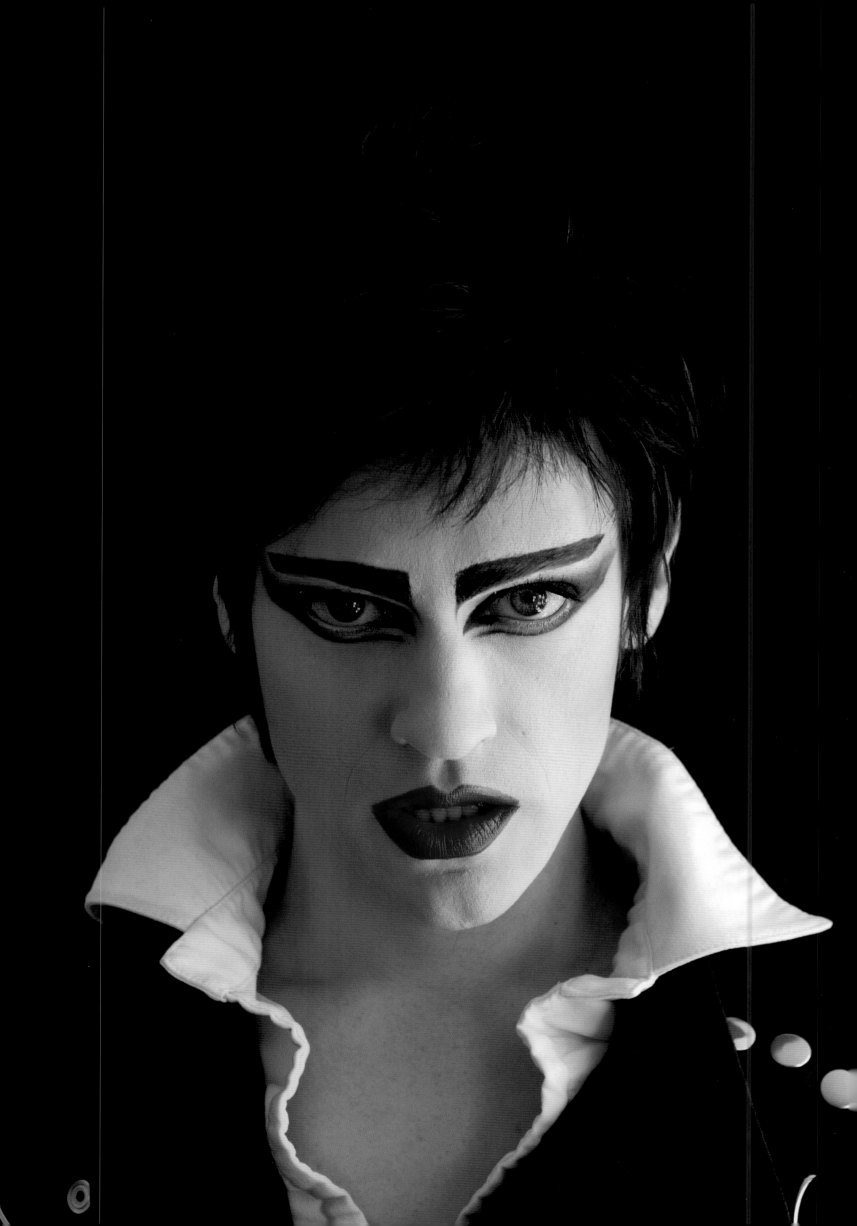

Flynn Witmeyer (formely **Virginia Suicide**) inspired by
Siouxsie Sioux

Always conspicuously done up, somewhere between a vampire and a raccoon, with a jagged punk mane and wild outfits. For her gay fans she was also a role model in style. Initially, she put together her clothes out of her mom's closet because she didn't have the money to go shopping. She grew up with the Sex Pistols and together with her band The Banshees she was the first female punk icon, feared by the studio executives for her stubbornness.

Today she sometimes appears as DJane at the London Gay Pride. As a teenager she loved to go to gay bars because they partied late and played good music. Today she makes no secret of the fact that she doesn't sleep just with men. She likes to kiss women because they're so soft. On the other hand, she's also found of the prickly pleasure of kissing a scruffy guy.

Flynn Witmeyer
Flynn Witmeyer, known to many as Virginia Suicide, lives in San Francisco. There he works as a writer, actor and filmmaker. He is also the lead singer of the rock band Sex Industry.

Flynn Witmeyer, der vielen noch als Virginia Suicide bekannt ist, lebt in San Francisco. Dort arbeitet er u.a. als Autor, Schauspieler und Filmemacher. Außerdem ist er der Leadsänger der Rockband Sex Industry.

Immer auffällig geschminkt, irgendwo zwischen Vampir und Waschbär, dazu die fransige Punkmähne, schwarz gefärbt, und schließlich die wilden Outfits. Für ihre schwulen Fans war sie nicht zuletzt auch ein Styling-Vorbild. Dabei stammten ihre Klamotten anfangs bloß aus Mamas Kleiderschrank, weil sie selber kein Geld hatte, um shoppen zu gehen. Musikalisch sozialisiert durch die Sex Pistols, war Siouxise zusammen mit ihrer Band The Banshees die erste weibliche Punk-Ikone, die bei den Plattenbossen wegen ihrer Sturheit gefürchtet war.

Heute tritt sie manchmal als DJane beim London Gay Pride auf. Als Teenagerin ging sie oft in schwule Läden, weil da noch spät gefeiert wurde und gute Musik lief. Heute macht sie längst keinen Hehl daraus, dass sie Sex nicht bloß mit Männern hatte. Frauen knutscht sie gern, weil sie so weich sind. Aber sie hat auch für das Schmirgeln und Kratzen etwas übrig, wenn man einen unrasierten Kerl küsst.

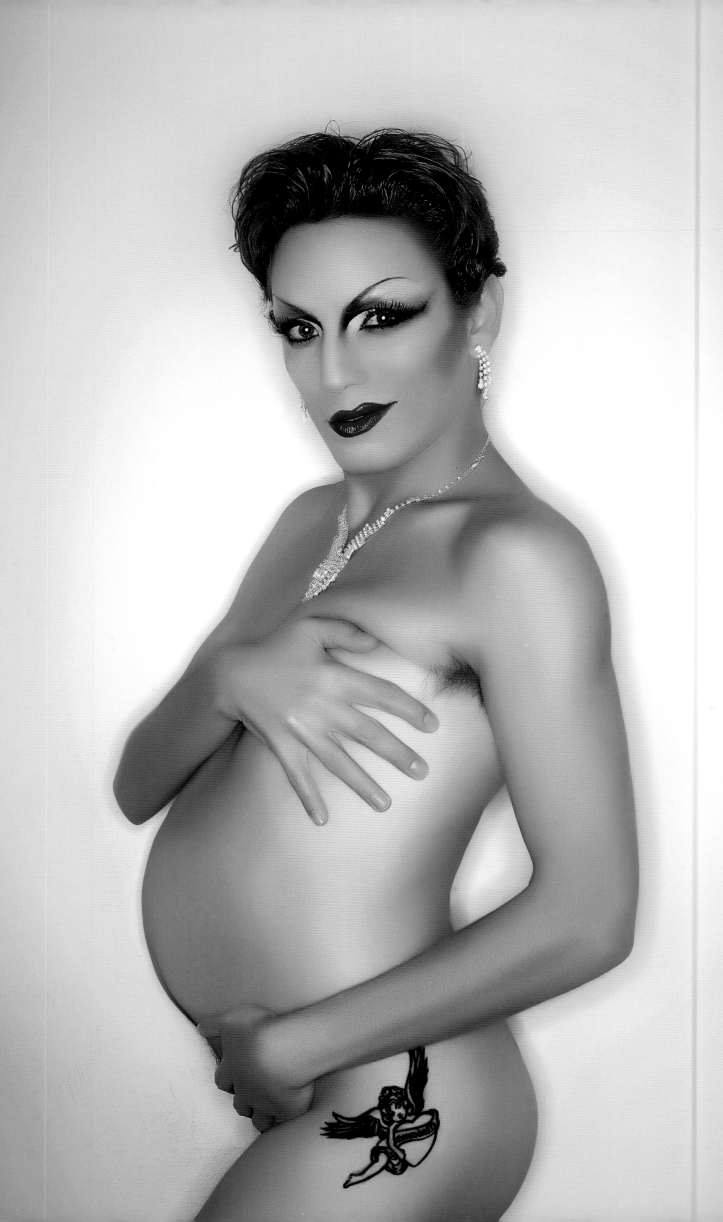

Suppositori Spelling inspired by
Demi Moore

She set her career in motion at the age of 16: She dropped out of school to work as a pin-up girl. It was not too long until she got a regular part on the series *General Hospital* as Demetria, named after a shampoo brand. She took her pay and turned it into parties and coke. Years later, at the high point of her career, she got down to the naked truth: 7 months pregnant with her daughter Scout LaRue, she posed for the cover of Vanity Fair. Bare naked.

The actress with one green and one brown eye accomplished the feat of breaking the 10 million dollar salary mark and then collected multiple Razzie Awards: They "honor" the worst movies and acting performances of the year. "I'm sure there are a lot of people who think I'm a bitch" she once said. Just because she married the hunk Ashton Kutcher and consoled herself with a younger man in her time of crisis? Please. We wouldn't have done it any differently.

Suppositori Spelling
The former Miss Trannyshack—THE title for a drag queen from San Francisco—has seen the world. In addition to regular work as a moderator, Suppositori Spelling has also appeared twice at the Glastonbury Festival in England.

Die frühere Miss Trannyshack – der Titel für eine Drag Queen aus San Francisco – ist längst weltweit im Einsatz. Neben regelmäßigen Moderations-Jobs ist Suppositori Spelling schon zweimal beim Glastonbury-Festival in England aufgetreten.

Den Grundstein ihrer Karriere legte sie mit 16: Sie schmiss die Schule, weil sie lieber als Pin-up-Girl arbeiten wollte. Kurz darauf bekam sie als Demetria, die ihren Namen einem Shampoo verdankt, eine feste Rolle in der Serie *General Hospital*. Ihre Gage hat sie verfeiert und in Koks angelegt. Jahre später, auf dem Höhepunkt ihrer Karriere, schuf sie nackte Tatsachen: Damals war sie mit Tochter Scout LaRue im 7. Monat schwanger und ließ sich für das Cover der Vanity Fair fotografieren. Ohne alles.

Die Schauspielerin, die ein grünes und ein braunes Auge hat, vollbrachte das Kunststück, in Hollywood als Erste die 10-Millionen-Dollar-Gage-Marke zu knacken und kurz darauf mehrere Razzie Awards zu kassieren: Damit werden Schauspieler für besonders schlechte Filme gedisst. „Da draußen glauben sicher viele Leute, dass ich eine Schlampe bin", hat sie mal gesagt. Bloß weil sie die geile Sau Ashton Kushner geheiratet hat und sich in der Krise mit einem noch jüngeren Kerl tröstete? Nicht doch. Wir hätten alles ganz genauso gemacht.

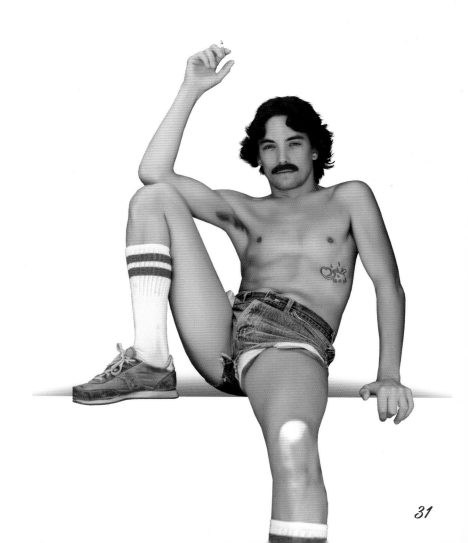

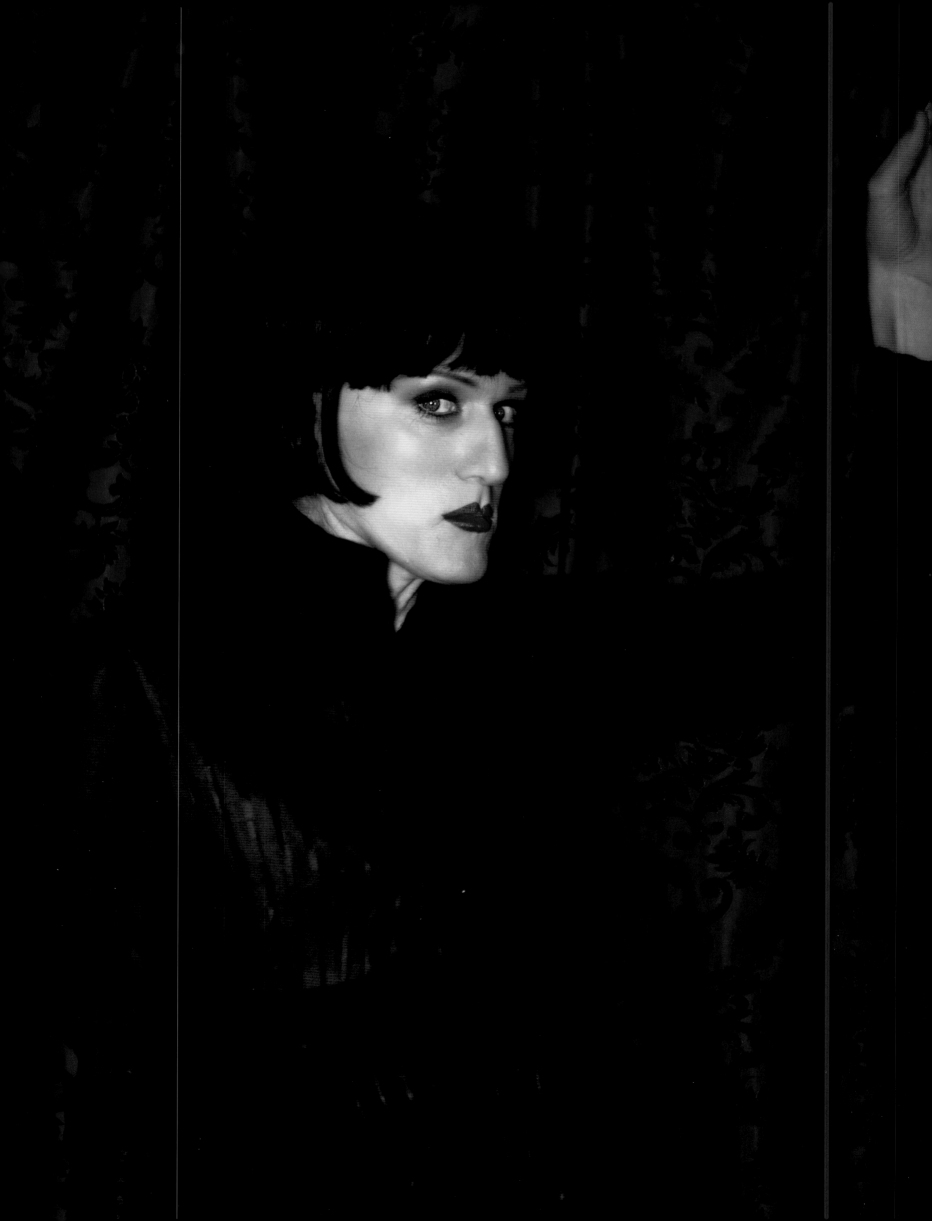

Erika von Volkyrie inspired by
Lotte Lenya

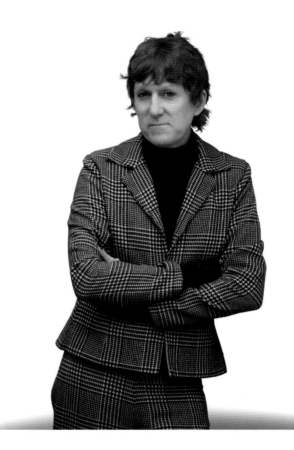

Erika von Völkyrie
Erika von Völkyrie lives in San Francisco and, according to legend, comes from former East Berlin. She plays piano, composes film music, and has her own production studio.

Erika von Völkyrie lebt in San Francisco und stammt der Legende zufolge aus dem früheren Ost-Berlin. Sie spielt Klavier, komponiert Filmmusik, und hat ein eigenes Produktionsstudio.

It was the early 1920s as Lenya came to wild Berlin. It was there that the famous portrait of her with short hair and a cigarette was taken. She also met Kurt Weill there and inspired him to write his most famous number: *Mack the Knife*. In numerous productions of the *Threepenny Opera* she played Low-Dive Jenny. Coarse, offensive and self-confident – the perfect figure for gay men to identify with.

After the Nazis seized power, Lotte and Kurt left Germany and went to the US. Weill died five years after the end of the war. Lenya then married the gay publicist George Davis, who convinced her to go back to acting. She played Low-Dive Jenny again and in 1963 had a legendary performance in *From Russia with Love*. As the renegade KGB agent Rosa Klebb, she attempts to assassinate 007 with a poisoned spike on the tip of her shoe. From then on, everyone who met Lenya checked her shoes just in case.

Es war Anfang der 1920er Jahre, als die Lenya ins wilde Berlin kam. Dort entstand das berühmte Portrait, das sie mit Bubikopf und Zigarette zeigt. Auch Kurt Weill lernte sie dort kennen und inspirierte ihn zu seiner wohl bekanntesten Nummer: *Macky Messer*. In vielen Produktionen der *Dreigroschenoper* spielte sie die Spelunken-Jenny. Derb, anrüchig und selbstbewusst – eine perfekte Identifikationsfigur für schwule Männer.

Nach der Machtergreifung der Nazis verließen Lotte und Kurt Deutschland und gingen in die USA. Fünf Jahre nach Kriegsende starb Weill. Danach heiratete Lenya den schwulen Publizisten George Davis, der sie überredete, wieder als Schauspielerin zu arbeiten. Erneut gab sie die Spelunken-Jenny und hatte 1963 einen legendären Auftritt in *Liebesgrüße aus Moskau*. Als abtrünnige KGB-Agentin Rosa Klebb versuchte sie, 007 mit einem vergifteten Stachel an ihrer Schuhspitze zu töten. Alle, die der Lenya danach begegneten, schauten zur Sicherheit erstmal auf ihre Schuhe.

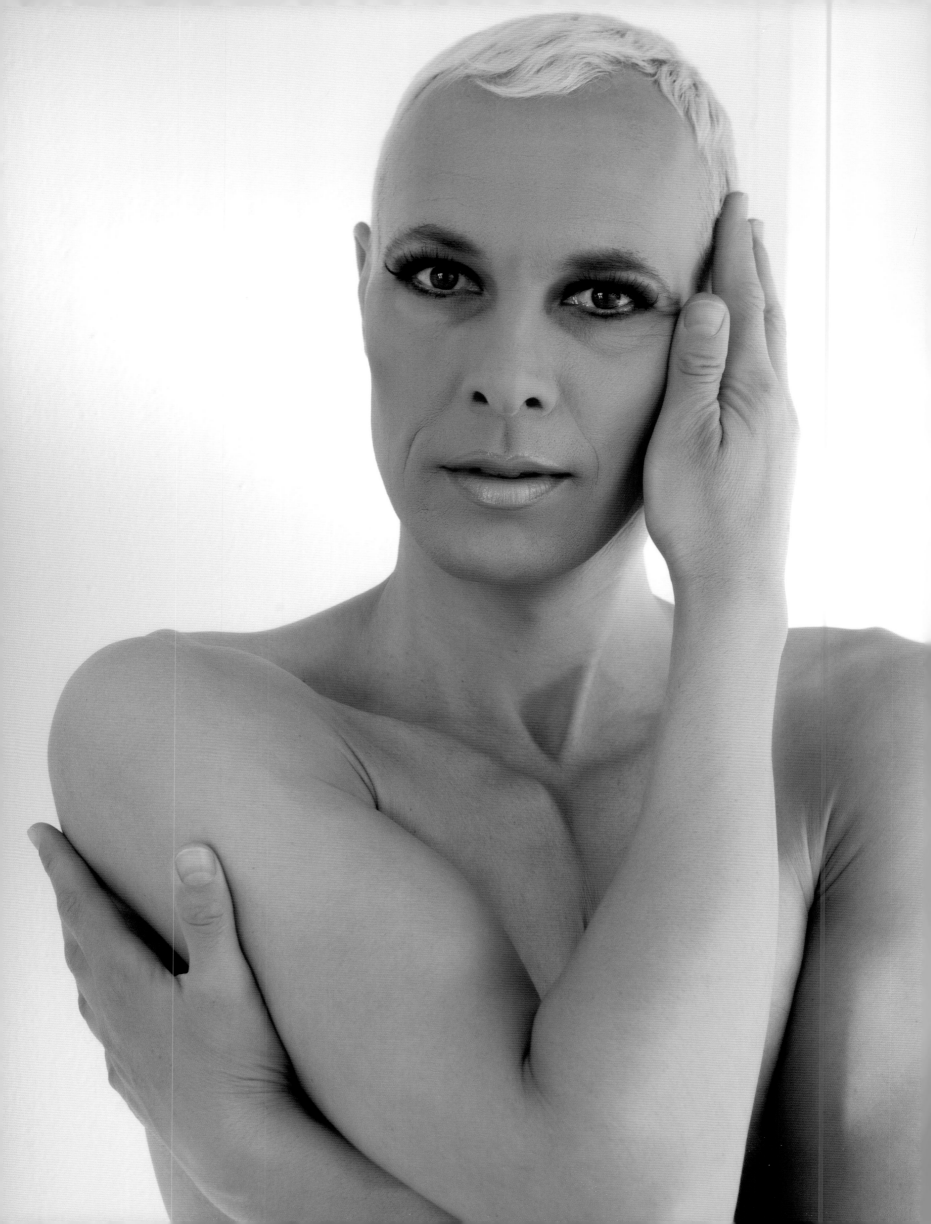

Mataina inspired by
Annie Lennox

With over 80 million albums sold, Ann Griselda Lennox is one of the most successful British artists ever and she became an important part of gay culture early on. Alongside of Eurythmics partner Dave Stewart, in the video for *Sweet Dreams* she brought a spotlight in pop culture to the BDSM lifestyle, long before Madonna took out her whip. And does the video *Why* not wonderfully illustrate the nightly ritual for so many gays and transgenders as they transform themselves into their colorful alter egos? Looking back on two failed marriages, she once said that maybe her life would have been easier as a lesbian.

For years she has been involved in the fight against AIDS. Her benefit song *Sing* became a gathering of the most important gay icons, from Madonna to Céline Dion and Shakira. As recognition for her tireless efforts, in 2010 Lennox was appointed to the Order of the British Empire by Queen Elizabeth II.

Mit über 80 Millionen verkaufter Platten weltweit ist Ann Griselda Lennox eine der erfolgreichsten britischen Künstlerinnen und war Schwulen schon früh eine besondere Projektionsfläche. An der Seite von Eurythmics-Buddy Dave Stewart hat sie im Video zu *Sweet Dreams* den BDSM-Lifestyle ins popkulturelle Scheinwerferlicht gerückt – lange bevor Kollegin Madonna die Peitsche herausholte. Und zeigt nicht ihr *Why*-Video trefflich, was vor zig Garderobenspiegeln allabendlich abläuft, wenn sich Homos und Transgender in ihr buntes Alter Ego verwandeln? Im Rückblick auf zwei gescheiterte Ehen hat sie mal gesagt, vielleicht wäre ihr Leben als Lesbe einfacher gewesen.

Seit Jahren engagiert sie sich im Kampf gegen Aids. Ihr Benefizsong *Sing* war nebenbei ein Gipfeltreffen der bedeutendsten Gay Icons, die alle mitsangen – von Madonna über Céline Dion bis Shakira. Zum Dank für ihren unermüdlichen Einsatz wurde Lennox 2010 von Königin Elisabeth II. zur Offizierin des Ordens des Britischen Empires ernannt.

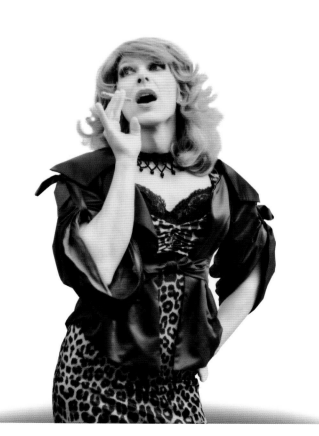

Mataina
Born in New York and raised in Berlin in the 1990s, Mataina blossomed under the Greek Sun on Mykonos. You can admire her today as the host of the Karaoke party in SOHO HOUSE in Berlin.

Auf die Welt gekommen in New York und aufgewachsen im Berlin der 1990er, ist Mataina schließlich aufgeblüht unter der Sonne Griechenlands – auf Mykonos. Aktuell ist sie als Host der Karaoke-Party im SOHO-HOUSE Berlin zu bewundern.

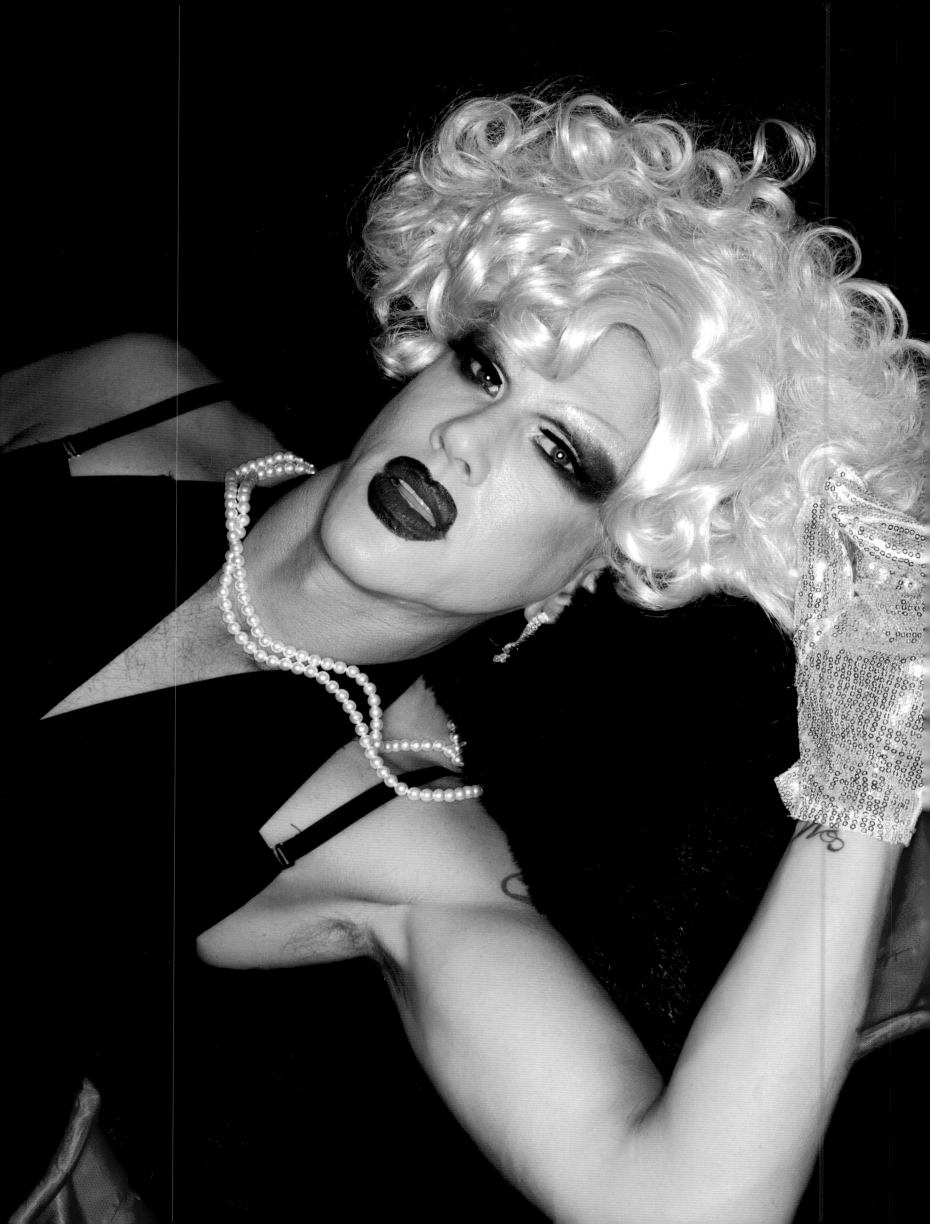

Syphillis Diller inspired by
Jean Harlow

Her first appearances were in short films with Laurel and Hardy. Her big breakthrough, however, came with the romantic comedy *Platinum Blonde*. Here she developed her reputation as a sex symbol and man-killing beast, the perfect role model for a self-confident gay man. With the film *Bombshell*, she settled firmly into the prototype for a role that others would later occupy, such as Marilyn Monroe. In 1937 she became the first actress to appear on the cover of *LIFE* magazine, also helping to make nail polish a success.

Jean was a superstitious person. Before every appearance she took a last look in her lucky mirror. It is also said that she would rub her nipples with ice before filming to look extra sexy. She always slept naked and never wore underwear. "Men like me because I don't wear a brassiere. Women like me because I don't look like a girl who would steal a husband. At least not for long."

Syphillis Diller
Syphillis Diller from San Francisco shies away from nothing. She has performed on water skis and as a larger-than-life pope. Madonna and Michael Jackson are also part of her repertoire. For a change of pace, she runs a dog walking service.

Syphillis Diller aus San Francisco schreckt vor nichts zurück. Mal performt sie auf Wasserskiern, mal als überlebensgroßer Papst. Auch Madonna und Michael Jackson gehören zu ihrem Repertoire. Zum Ausgleich betreibt sie einen Hundeausführservice.

Ihre ersten Auftritte hatte sie in Kurzfilmen an der Seite von Dick und Doof, aber der Durchbruch kam mit der Romantischen Komödie *Vor Blondinen wird gewarnt*. Hier manifestierte sich auch ihr Ruf als Sexsymbol und männermordendes Biest – damit war sie wie geschaffen als Vorbild für einen selbstbewussten Schwulen. Mit dem Film *Sexbombe* wurde sie endgültig zum Prototyp für das Schema, in das man später u. a. Marilyn Monroe steckte. Als erste Filmschauspielerin schaffte sie es 1937 aufs Cover des *LIFE*-Magazins und verhalf nebenbei dem Nagellack zum Durchbruch.

Jean war abergläubisch. Vor jedem Auftritt warf sie einen letzten Blick in ihren Glücksspiegel. Außerdem ist überliefert, dass sie ihre Brustwarzen vorm Drehen mit Eis abrieb, um sexy zu wirken. Sie schlief immer nackt und trug nie Unterwäsche. „Männer mögen mich, weil ich keinen BH trage. Frauen mögen mich, weil ich nicht wie jemand aussehe, der ihnen den Ehemann wegnimmt. Jedenfalls nicht für lange."

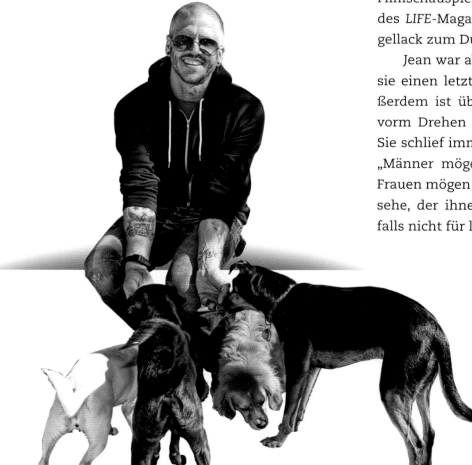

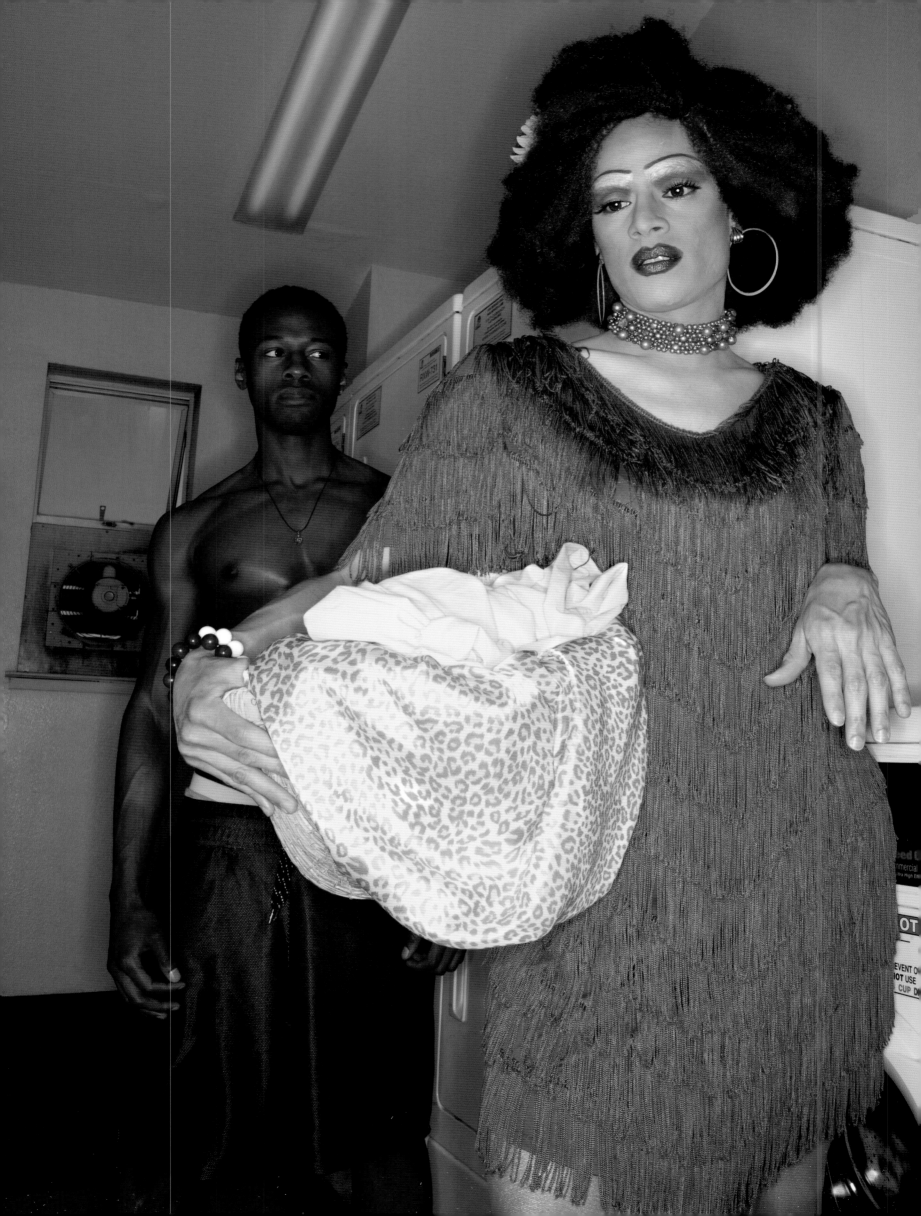

Gibson OGF inspired by
Erykah Badu

Her very name is music. The fact that she doesn't read music and composes by ear couldn't matter less. Erykah, 5 feet of coolness. She doesn't sell albums by bare skin or staged depravity, like so many of her colleagues. She is an esoteric diva, who has long been interested in telekinesis and telepathy. Sometimes her message to the people is messianic, sometimes it's political. She can also be close to her fans, like during the birth of her youngest child, which she live tweeted from the delivery room, at least when the contractions let her.

The high priestess of soul is a style icon for many. Her look can be Indian or Japanese, military or 70s bell bottoms. When she wears stilettos and frills along with a top heat, she plays with gender stereotypes – a perfect match with her ancient Egyptian ankh amulet, which symbolizes the union of male and female principles.

Gibson OGF

Actor, singer, dancer, and much more—Gibson OGF cannot be pigeonholed. In 2011 he was elected the best up and coming artist in the San Francisco region.

Schauspieler, Sänger, Tänzer und vieles mehr – Gibson OGF lässt sich nicht auf eine Sache festlegen. 2011 wurde er in der Region San Francisco zum besten aufstrebenden Künstler gewählt.

Schon der Name ist Musik. Dass sie keine Noten lesen kann und nach Gehör komponiert, ist vollkommen wurscht. Erykah – das sind 1,52 Meter Coolness. Ihre Platten verkauft sie nicht mit nackter Haut oder über inszenierte Verruchtheit, wie viele ihrer weißen Kolleginnen. Sie ist die eher esoterische unter den Diven, die sich lange mit Telekinese und Telepathie befasst hat. Mal bring sie messianische Botschaften unter die Leute, mal politische. Sie kann aber auch volksnah – so wie bei der Geburt ihres letzten Kindes, über die sie twitternd aus dem Kreissaal berichtete, wenn die Wehen sie ließen.

Die Hohepriesterin des Soul ist für viele auch eine Style-Ikone. Ob indianisch oder japanisch, Military-Look oder in 70er Schlaghosen. Wenn sie Stilettos und Rüschen zum Zylinder trägt, spielt sie mit Geschlechterklischees – passend zu ihrem altägyptischen Ankh-Amulett, das die Vereinigung des männlichen und weiblichen Prinzips symbolisiert.

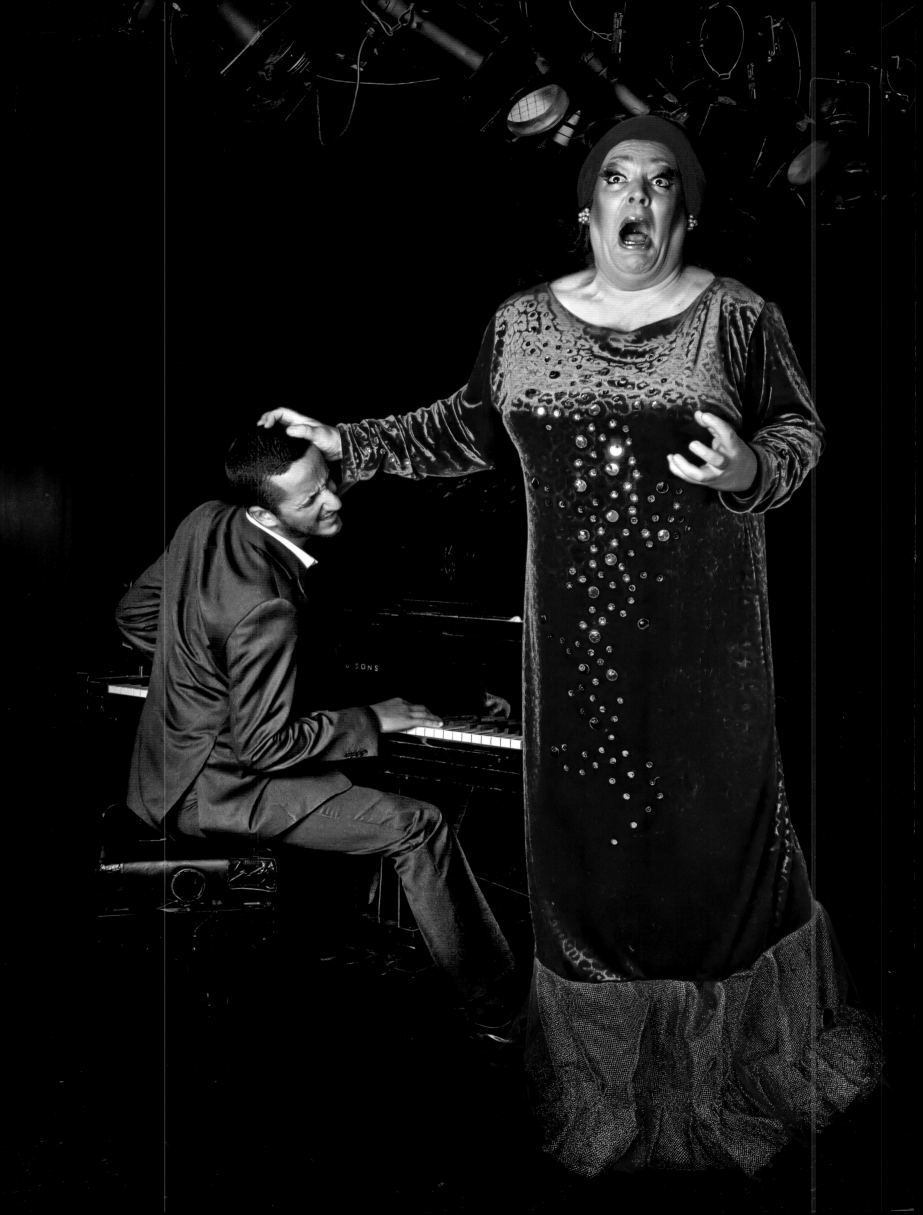

Stefan Kuschner inspired by
Jessye Norman

Stefan Kuschner
Raised in Belgium, Stefan Kuschner can be found above all in the orbit of Edith Schröder. As an actor, film musician and unit manager, he works together with directors such as Bruce LaBruce and Jörn Hartmann.

In Belgien aufgewachsen, ist Stefan Kuschner heute vor allem im Dunstkreis von Edith Schröder anzutreffen. Als Schauspieler, Filmmusiker und Aufnahmeleiter befriedigte er seine Muse bei Regisseuren wie BruceLaBruce und Jörn Hartmann.

She is considered one of the world's leading opera singers, but it's also a sublime pleasure to hear her sing jazz or spirituals. The fact that the Soprano often cancels her appearances at the last second makes every Norman show an event. On top of that, sometimes she doesn't even bother to invent a good excuse for why she can't or won't perform. Of course, she's aware of her reputation as a diva, but she sees herself as a perfectly normal woman and explains in interviews that she often stands around barefoot in the kitchen to brew herself a tea. And really, what diva would do such a thing?

Performances from Jessye Norman are more like an audience. Her fans come to worship her. Politically, she supports Barack Obama, for whom she sang in the presidential election campaign. She has no children herself, but she likes to talk about her numerous nephews and all the brats in her circle of friends. She probably wouldn't have any room for them anyway, after all, she has multiple (!) walk-in closets, the exact number she'd rather not disclose.

Sie gilt als eine der weltweit bedeutendsten Opernsängerinnen, der man aber auch gerne lauscht, wenn sie Jazz oder Spirituals singt. Dass die Sopranistin häufig ihre Auftritte in letzter Sekunde absagt, macht jeden Norman-Abend zum Ereignis. Zumal sie sich nicht immer die Mühe macht, einen triftigen Grund zu erfinden, warum sie gerade nicht kann oder will. Ihr Ruf als Diva ist ihr bewusst, aber natürlich: Sie selbst sieht sich als ganz normale Frau und erzählt in Interviews, dass sie oft barfuß in der Küche steht und sich einen Tee braut. Klar doch, das ist extrem undivenhaftes Verhalten.

Auftritte von Jessye Norman gleichen eher einer Audienz. Ihre Fans kommen, um sie abzubeten. Politisch steht sie auf Barack Obama, für den sie schon im Präsidentschaftswahlkampf sang. Fortgepflanzt hat sie sich nicht, aber sie verweist gerne auf ihre zahlreichen Neffen und all die Blagen in ihrem Freundeskreis. Platz für Kinderzimmer hätte sie zu Hause wahrscheinlich sowie nicht – schließlich verfügt Frau Norman über mehrere (!) begehbare Kleiderschränke, über deren genaue Zahl sie lieber schweigt.

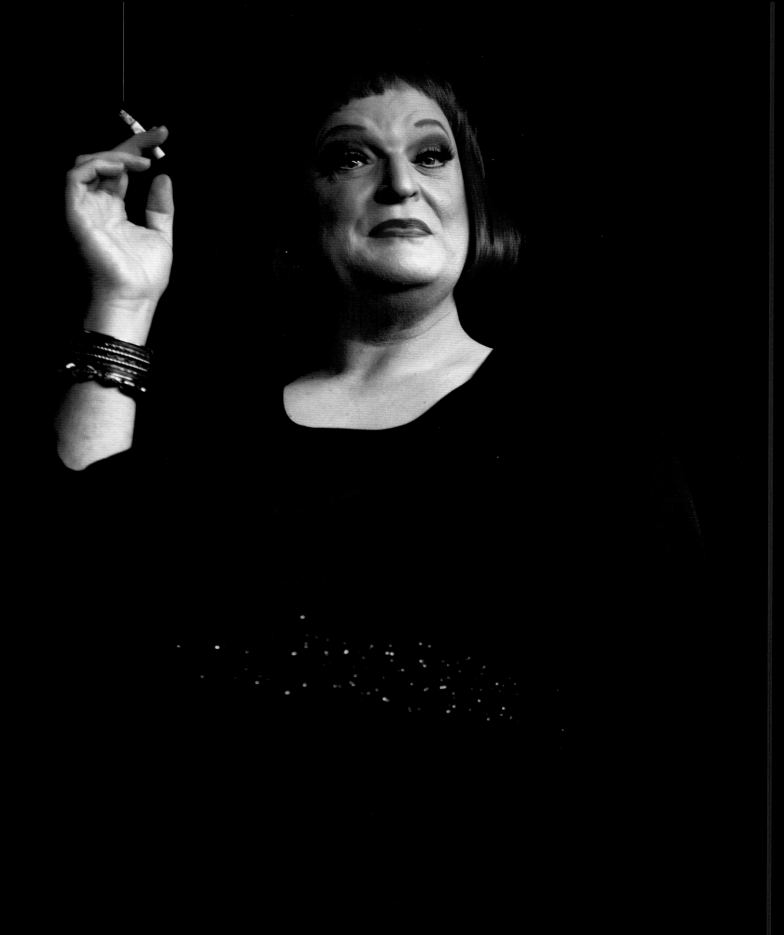

Lucy Manhattan inspired by
Bette Davis

Lucy Manhattan
At 19, Lucy Manhattan performed for the first time in gay bars in San José. In addition to appearing on the stage and on TV, she has moderated the Manhattan Mondays show for the last 12 years.

Mit 19 trat Lucy Manhattan das erste Mal in den Schwulenbars von San José auf. Neben Engagements auf der Bühne und im Fernsehen moderierte sie 12 Jahre lang die Show Manhattan Mondays.

What a career! In 1941 she was the first woman president of the Oscar Academy, a year later she was the country's top female earner. She even sued her film studio for only offering her mediocre roles. She came to believe: "In this business, until you're known as a monster you're not a star." The only person she liked to mix it up with more than her film bosses was her archrival Joan Crawford. "I wouldn't piss on her if she was on fire." She supported gay rights ("Gay Liberation? I ain't against it, it's just that there's nothing in it for me") and made the mistake of marrying four times. One of her husbands died; she divorced the rest. "None of my husbands was ever man enough to become Mr. Bette Davis." A few years before her death, the diva told *Playboy* that as a youth she posed naked for a sculptor. Supposedly the statue is still out there somewhere in Boston. Bostonians went out in droves to find the statue, which they still look for to this day.

Was für eine Karriere! 1941 war sie die erste Frau an der Spitze der Oscar-Akademie, ein Jahr später Amerikas Spitzenverdienerin. Immer wieder verklagte die Königin des bösen Blicks ihr Filmstudio wegen öder Rollenangebote. Sie war überzeugt: „Solange du nicht als Monster wahrgenommen wirst, bist du kein Star." Noch lieber als mit Filmbossen zoffte sie sich mit ihrer lebenslangen Erz-Rivalin Joan Crawford. „Da würde ich nicht mal draufpissen, wenn sie in Flammen steht."

Sie sprach sich für die Emanzipation Homosexueller aus („Nichts dagegen, aber was springt für mich dabei heraus?") und machte den Fehler, viermal zu heiraten. Ein Gatte starb, von den anderen ließ sie sich scheiden. Es war eben keiner Manns genug, Herr Bette Davis zu werden. Wenige Jahre vor ihrem Tod erzählte die Diva dem *Playboy*, sie hätte als Jugendliche nackt für einen Bildhauer posiert. Das Ergebnis stehe irgendwo draußen in Boston. Die Bostonians zogen scharenweise los und suchen die Statue – noch heute.

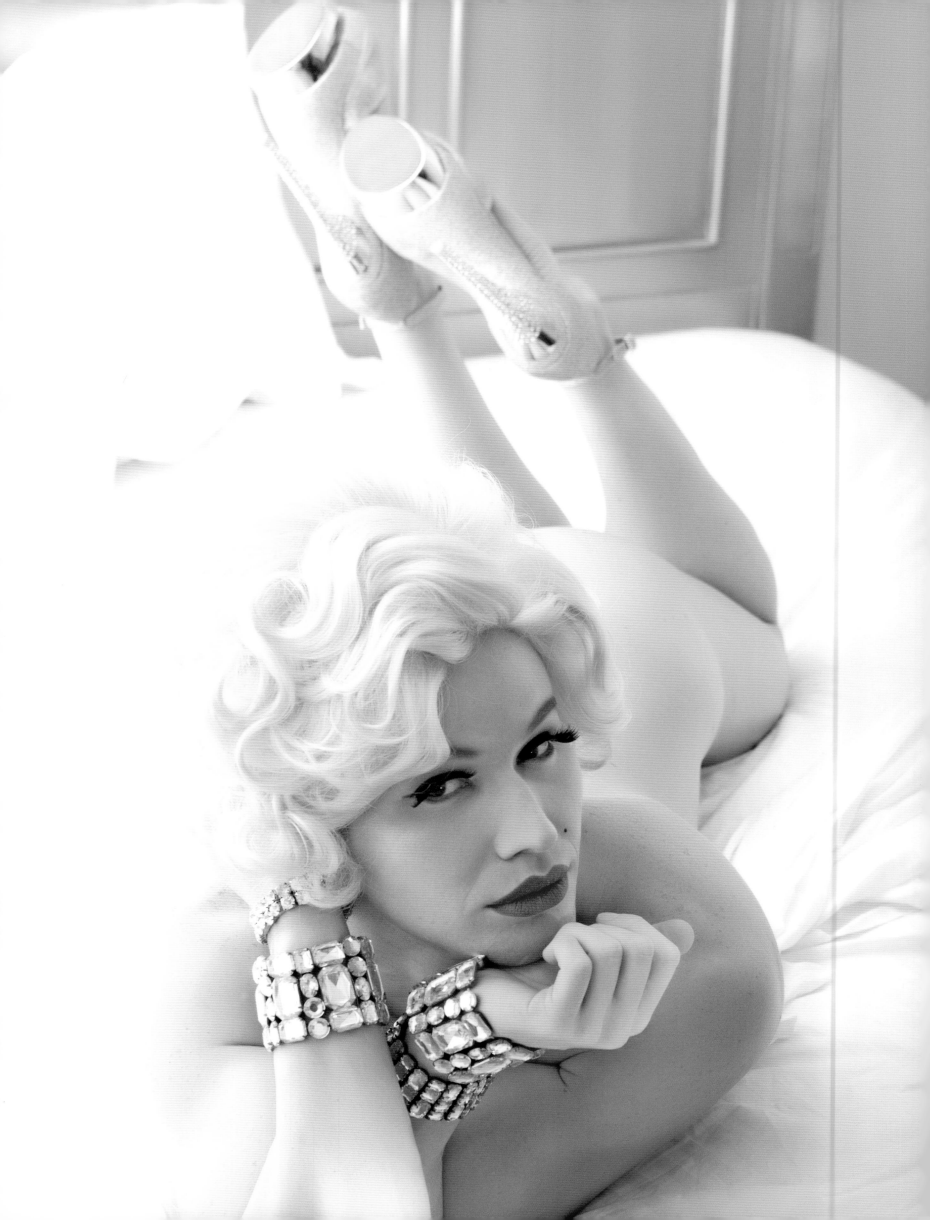

Jason Wimberly inspired by

Marilyn Monroe

Boop-boop-a-doop! This inane line from *I Wanna be Loved by You* represents the drama of Monroe. For she was never the airheaded sex object she liked to be seen as. Even when she graced the very first *Playboy* cover in 1953 and was later named by the magazine as the "Number One Sex Star" of the 20th century. She was so sexy in the swimsuit she wore on the set of *Love Nest*, that the director closed the set because the male audience members were getting too excited.

She was never a top earner in her field. She preferred her right side and she tried nine different shades of blonde before she made platinum blonde her trademark. She earned 5 dollars for her first model job. And although she was the most famous actress of the 50s, Taylor and Stanwyck made significantly higher salaries. She never won an Oscar. But she certainly would have won the prize for best faked orgasm. No one else would have stood a chance. To use her own words: MM.

Boop-boop-a-doop! In dieser dümmlichen Zeile aus *I wanna be loved by you* steckt das ganze Drama der Monroe. Denn das hohle Sexobjekt, als das sie gerne gesehen wurde, war sie nie. Auch wenn sie 1953 das allererste *Playboy*-Cover zierte und später vom selben Blatt als „Number One Sex Star" des 20. Jahrhunders bezeichnet wurde. In dem Badeanzug, den sie bei den Dreharbeiten zu *Love Nest* trug, sah sie so sexy aus, dass der Regisseur den Set für Zuschauer sperrte, weil Marilyn alle Männer wuschig machte.

Zu den Großverdienern gehörte die Frau nie, die ihre rechte Seite als Schokoladenseite betrachtete und die neun verschiedene Blondtöne ausprobierte, bevor Platinblond zu ihrem Markenzeichen wurde: Für ihren ersten Modeljob verdiente die Monroe fünf Dollar. Und obwohl sie in den 50ern die wohl bekannteste Schauspielerin war, haben die Taylor und die Stanwyck deutlich höhere Gagen kassiert. Auch einen Oscar hat sie nie gewonnen. Aber hätte es einen Preis dafür gegeben, beim Sex einen Orgasmus vorzutäuschen, sie hätte alle Konkurrenten aus dem Rennen geworfen. O-Ton: MM.

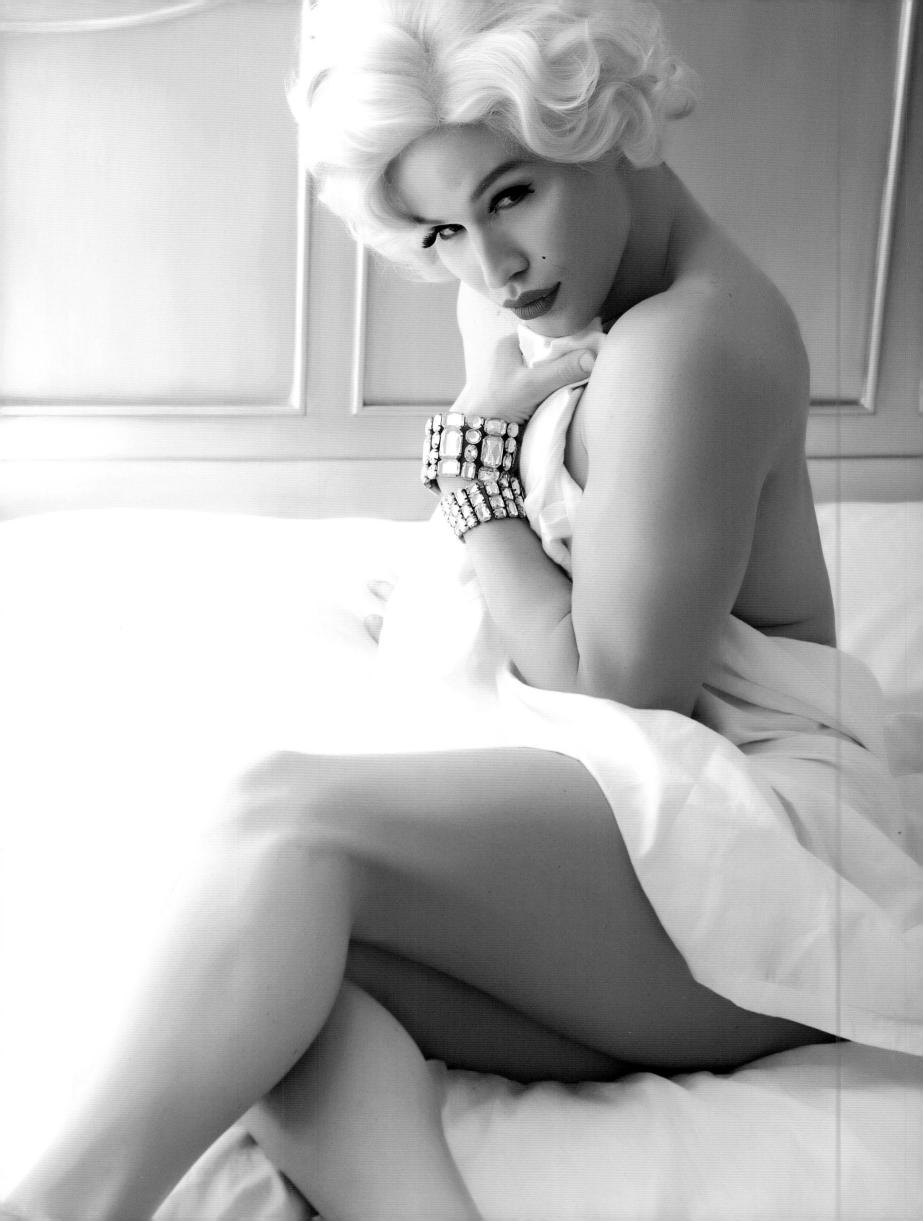

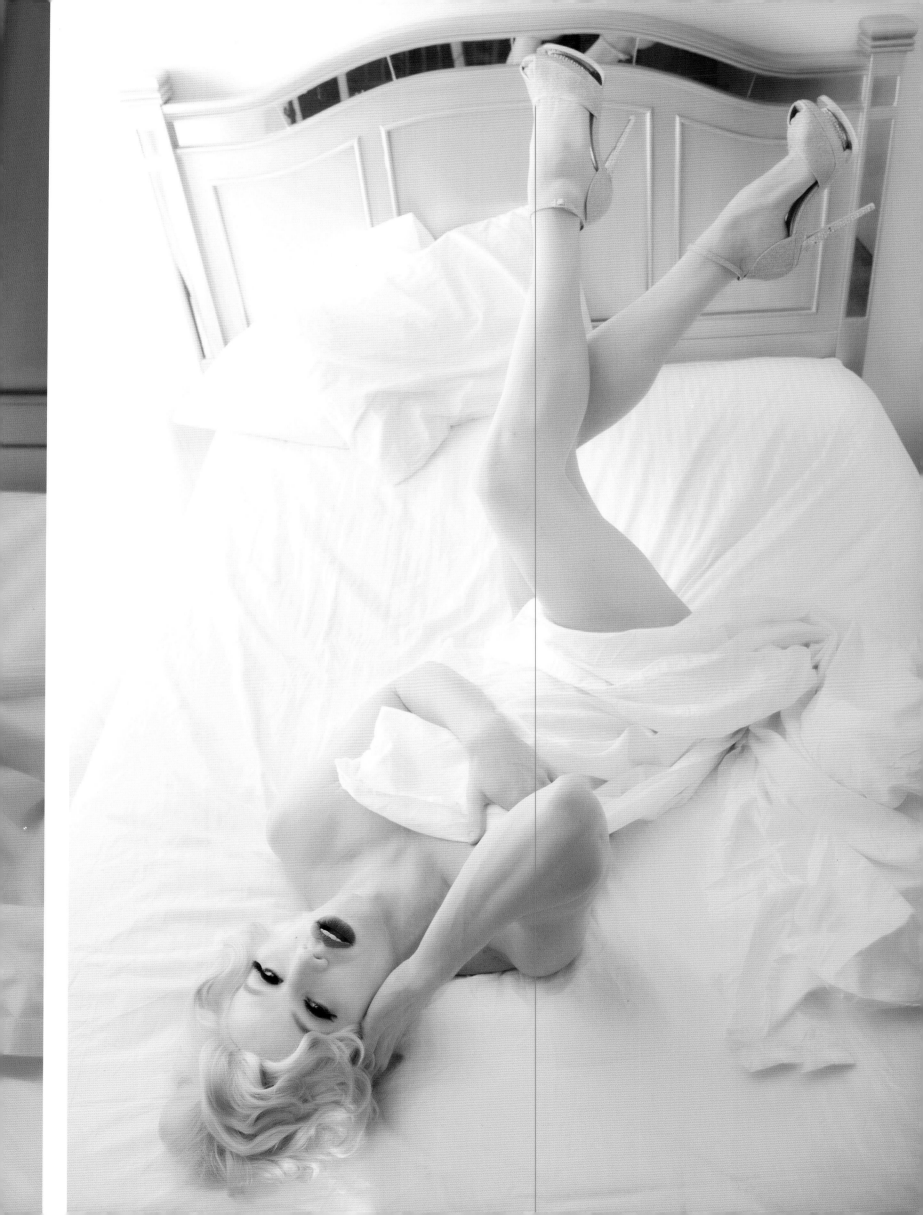

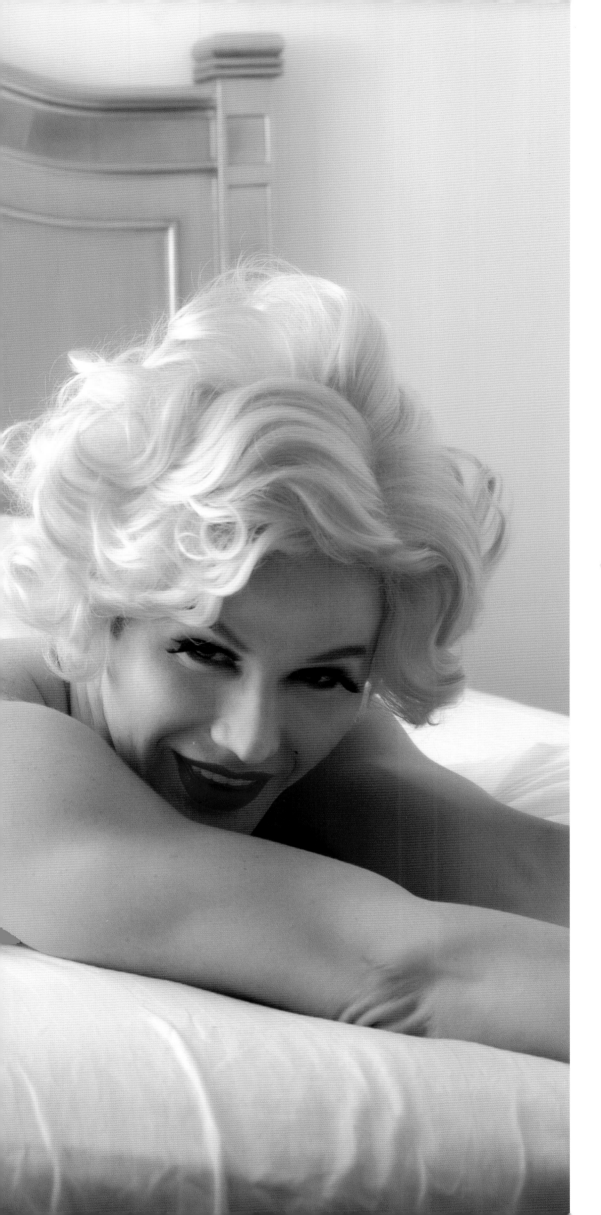

Marilyn managed to turn on an entire generation and continues to inspire people till today. If only we could all be so lucky.

— **Jason Wimberly**

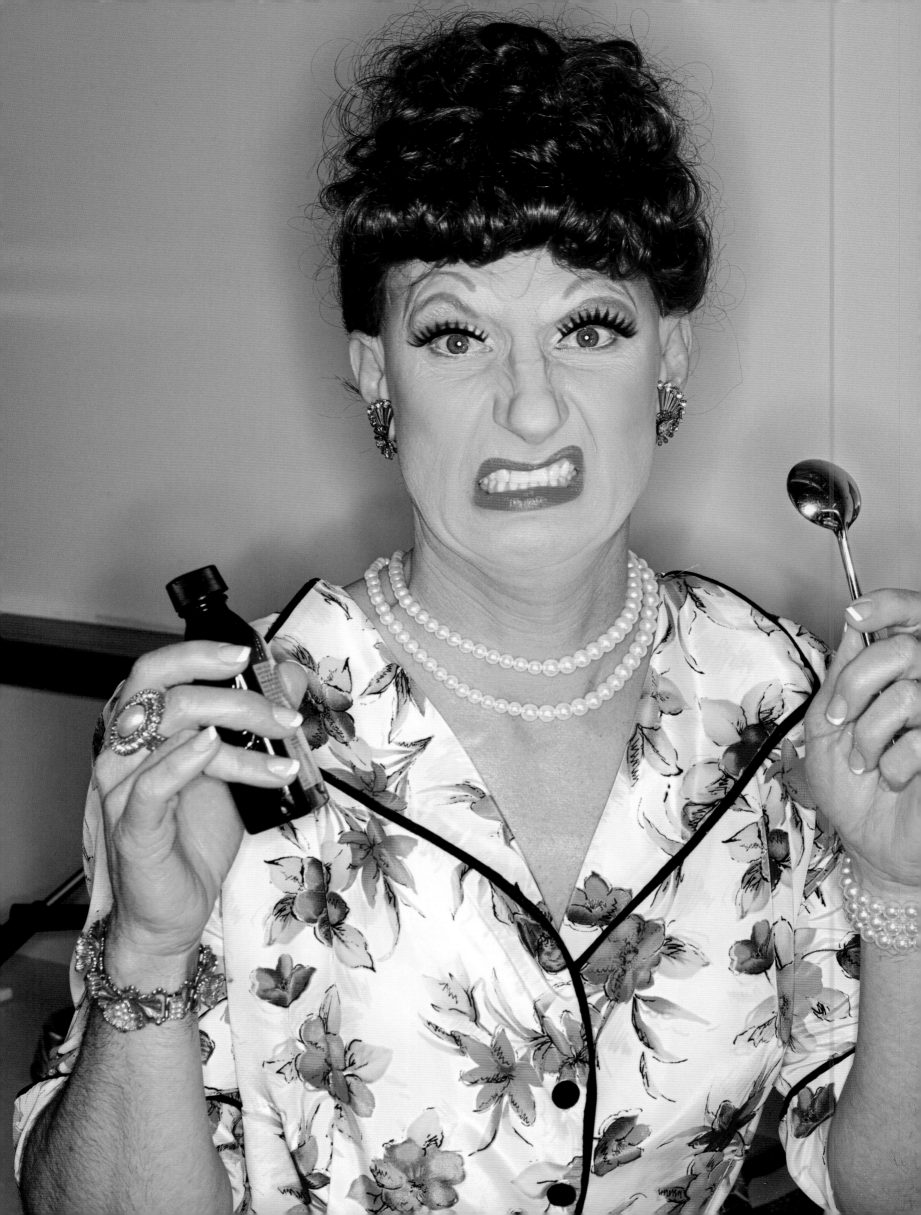

Daft-Nee Gesuntheit! inspired by
Lucille Ball

She lost her job at the ice cream parlor because she kept forgetting a rather important ingredient in the banana split. The banana. Later in drama school she was outshone by her model classmate Bette Davis. No one believed she could possibly make it. Hardly! As creator and star of *I Love Lucy*, which is still a hit in gay bars to this day, she was a sitcom pioneer. She was one of the first stars to film in front of a live studio audience. She came to be known as the "Queen of Comedy". She was the first woman in Hollywood to head a film studio – without her Star Trek would never have existed. At the age of 42 Lucille filmed the birth of her son on live TV, breaking a taboo, which was watched by 44 million viewers.

The woman with bright dyed-red hair, who became an advocate for gay rights early on, simply loved life. "I would rather regret the things that I've done than regret the things that I haven't done."

Daft-Nee Gesuntheit!
Daft-NeeGesuntheit! can be found every Saturday performing in Marlena's Bar in San Francisco. After the show you can discuss poetry with her; that was her college major after all.

Immer wieder samstags trifft man Daft-Nee Gesuntheit! zur Show-time in Marlena's Bar in San Francisco. Nach der Show kann man mit ihr über Lyrik diskutie-ren, denn darin hat sie einen Uni-Abschluss.

Den Job im Eisladen verlor sie, weil sie ständig eine nicht unwesentliche Zutat beim Bananensplit vergaß. Bananen nämlich. Später in der Schauspielschule wurde sie von ihrer Mus-termitschülerin Bette Davis überstrahlt. Von Lucille hieß es: Die schafft es nie. Von wegen!

Als Erfinderin und Star der Fernsehserie *I love Lucy*, die noch heute gerne in amerikanischen Schwulenbars gezeigt wird, gilt sie als Sitcom-Pionierin. Sie war einer der ersten Stars, der vor Live-Publikum filmte. Man nannte sie die „Queen of Comedy". Als erste Frau in Hollywood leitete sie ein Filmstudio – ohne ihren Einsatz hätte es die TV-Serie Star Trek wohl nie gegeben. Im Alter von 42 Jahren ließ Lucille die Geburt ihres Sohnes live im Fernsehen zeigen – ein Tabubruch, den sich 44 Milli-onen US-Zuschauer ansahen.

Die Frau mit den feuerrot gefärbten Haaren, die sich schon früh für die Anerkennung schwuler Rechte aussprach, liebte das Leben. „Ich bedauere lieber die Dinge, die ich getan habe, als die, die ich nicht getan habe."

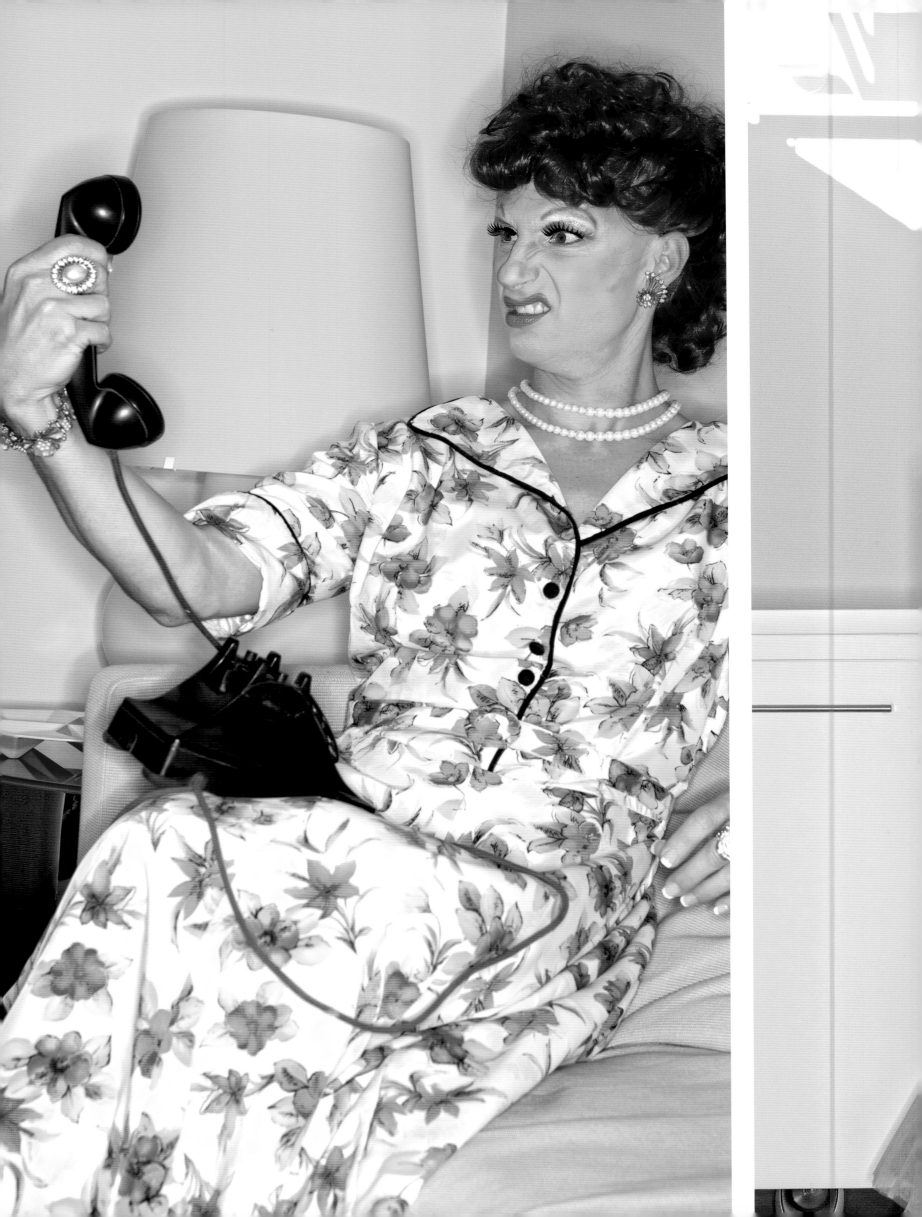

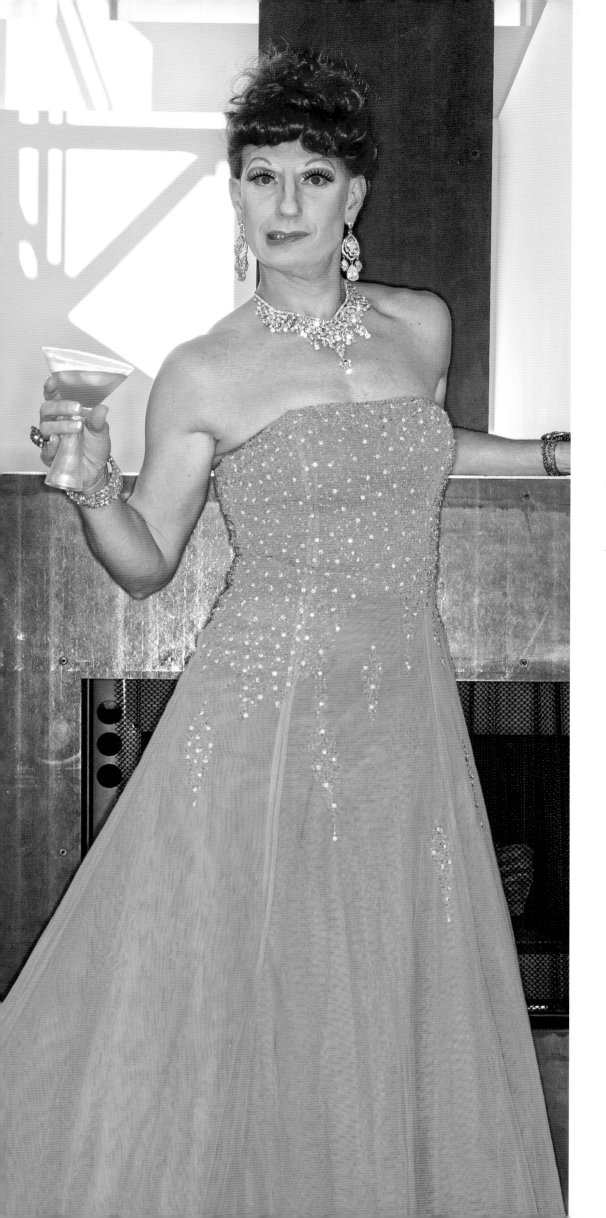

Lucy allowed me to escape into her zany, mischievous, glamorous, henna-dyed world as a child and taught me that women can be simultaneously beautiful, smart, funny, and ridiculous.

— Daft-Nee Gesuntheit!

53

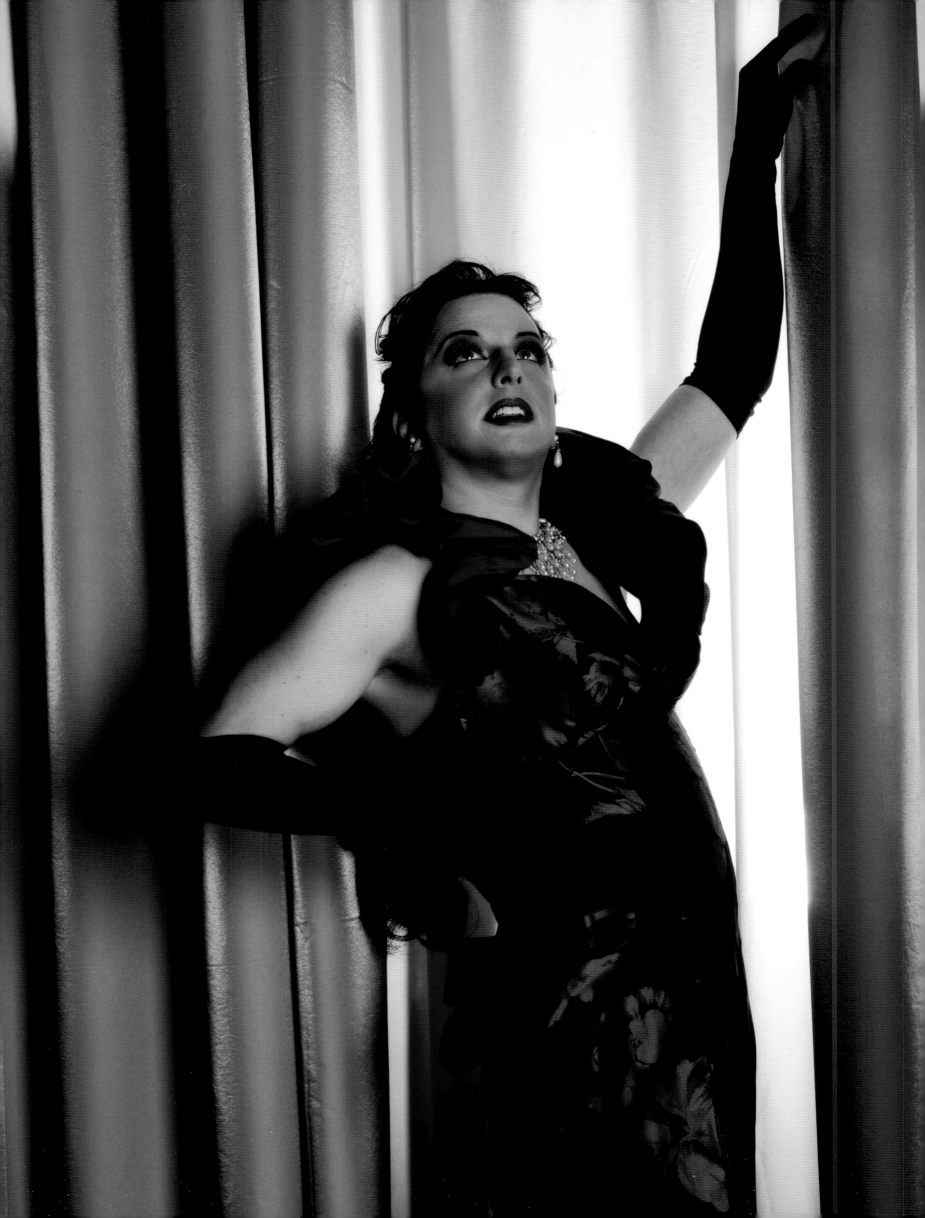

LeMay inspired by
Hedy Lamarr

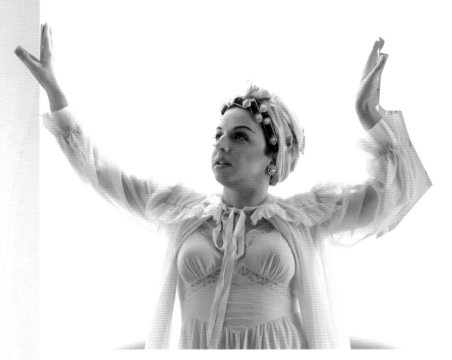

Steven LeMay
Steven LeMay doesn't just work as a designer and model. He has been on stage at numerous theaters in and around San Francisco. He also took part in the drag episode of the Heidi Klum show Project Runway.

Steven LeMay arbeitet nicht nur als Designer und Model. Als Schauspieler stand er bei verschiedenen Theatern in und um San Francisco auf der Bühne. Außerdem hat er bei der Drag-Ausgabe der Heidi-Klum-Show Project Runway mitgemacht.

The film *Ecstasy* was produced in Austria in 1933. With great dedication, a young actress simulated an orgasm, with just her face. And because it was followed by the first naked scene in film history, a huge scandal ensued. Hedwig Kiesler was the name of the 20-year old, who would later go to Hollywood and make a career as Hedy Lamarr. She gave this tip to all those who wanted to emulate her: "Any girl can be glamorous: All you have to do is stand still and look stupid."

Max Reinhardt called her "the most beautiful woman in Europe", while Ed Sullivan thought she was the beauty of the century. Hedy was surely the most beautiful nerd ever: The avowed opponent of the Nazis developed a technique for radio control of torpedoes in the middle of World War II, which she patented. Her invention provided the basis for wireless communication, as used today in Bluetooth technology, for instance. Naturally, Hedy's patent expired long ago.

1933 war es, als in Österreich der Film *Ekstase* produziert wurde. Mit viel Hingabe simulierte eine junge Schauspielerin einen Orgasmus – und zwar allein mit ihrem Gesicht. Weil dazu noch die erste Nacktszene der Kinogeschichte kam, gab es einen Riesen-Skandal. Hedwig Kiesler hieß die damals 20-jährige, die anschließend nach Hollywood ging und als Hedy Lamarr Karriere machte. Allen, die ihr nacheifern wollten, gab sie folgenden Tipp: „Jedes Mädchen kann glamourös sein: Man muss nur stillstehen und dumm gucken können."

Max Reinhardt nannte sie „die schönste Frau Europas", während US-Entertainer Ed Sullivan sogar eine Jahrhundert-Schönheit in ihr sah. Mit Sicherheit war Hedy der hübscheste Nerd: Die erklärte Gegnerin der Nazis entwickelte mitten im Zweiten Weltkrieg eine Funkfernsteuerung für Torpedos, die sie sich patentieren ließ. Ihre Erfindung hat den Weg zur drahtlosen Kommunikation geebnet und wird heute z. B. bei Bluetooth-Verbindungen angewendet. Leider ist Hedys Patent längst ausgelaufen.

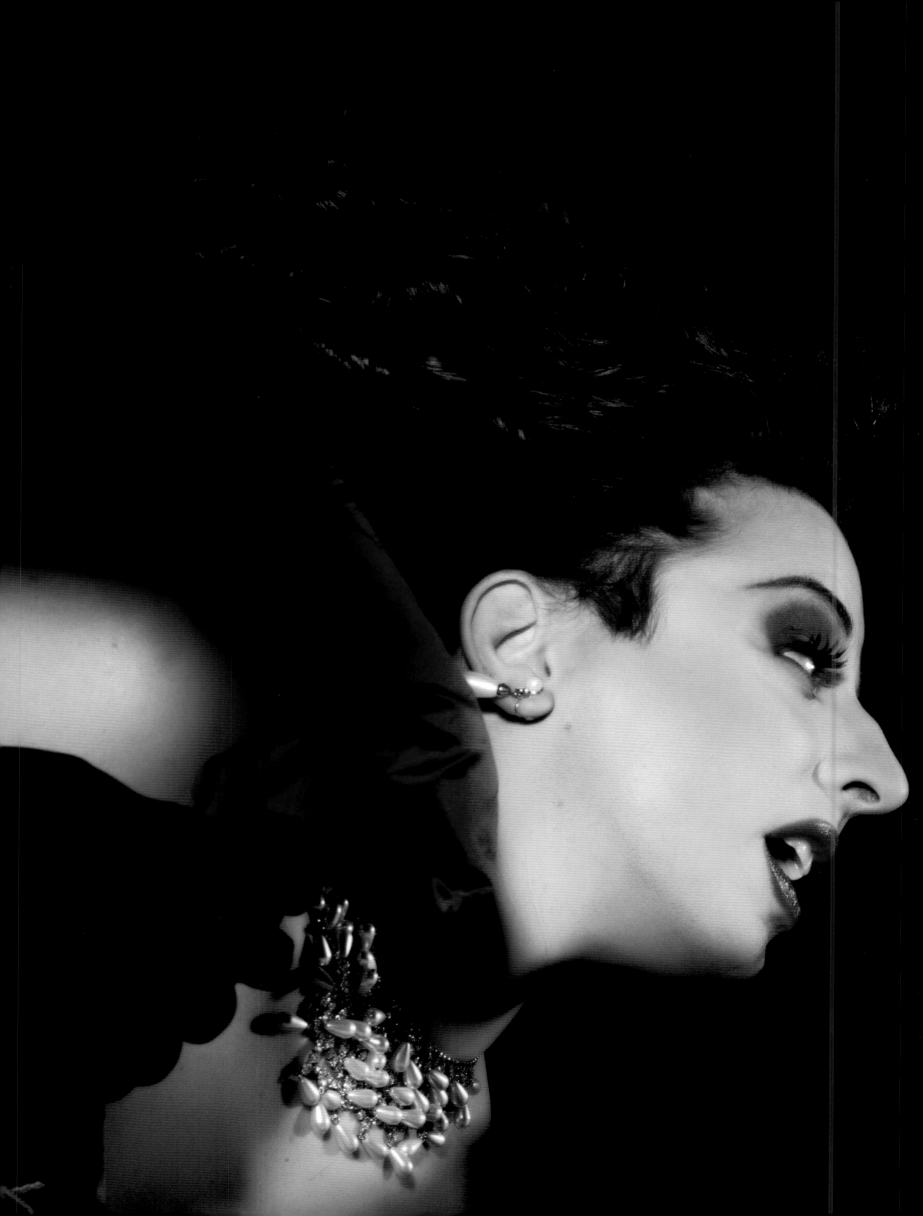

I adore Hedy Lamarr for the combination of her beauty, which deceptively belied her high intellect. Like me ...

— **Steven LeMay**

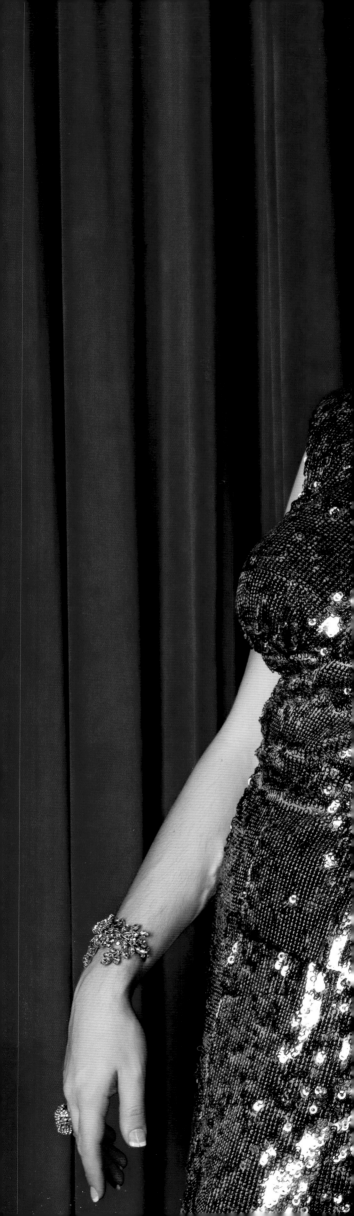

Katya Smirnoff-Skyy inspired by
Joan Crawford

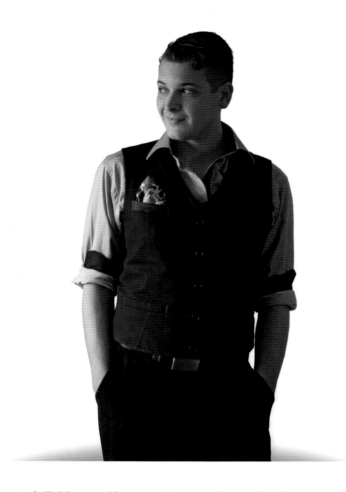

Katya Smirnoff-Skyy
Countess Katya Smirnoff-Skyy was once considered the greatest mezzo-soprano of Eastern Europe; she now appears in the theaters and bars of America. According to her creator, the actor J. Conrad Frank, she can be admired in her day job doing nails at Macy's.

Einst galt die Gräfin Katya Smirnoff-Skyy als größte Mezzosopranistin Osteuropas und tingelt noch heute durch die Theater und Bars Amerikas. Ihrem Schöpfer, dem Schauspieler J. Conrad Frank, zufolge lackiert sie tagsüber im Kaufhaus Macy's den Kundinnen die Nägel.

A full-blown diva needs a trademark idiosyncrasy and Joan had hers, an obsession with cleanliness. She washed her hands every ten minutes. She hated the idea of sitting in her own bathwater, so she preferred showers. She would scrub the bathroom in her hotel before using it. But she could be lighthearted as well. On the set she is said to have taught Steven Spielberg how to let out a hearty burp. Her long-time feud with Bette Davis was also a source of constant pleasure. In one scene her co-star had to drag her across the floor; Crawford put heavy weights in her pockets beforehand.

About her romantic life she said: "I need sex for a clear complexion, but I'd rather do it for love." The diva, who took to drinking almost a liter of vodka a day as she got older, originally wanted to be a dancer and initially showed no interest in films. Later she admitted, "I'd like to think every director I've worked with has fallen in love with me."

Zu einer ausgewachsenen Diva gehört eine ebensolche Meise: Joan hatte einen Putzfimmel. Alle zehn Minuten wusch sie ihre Hände. Weil sie es hasste, im eigenen Badewasser zu sitzen, duschte sie lieber. In jedem Hotel schrubbte sie erstmal das Bad, bevor sie es benutzte. Aber man konnte auch mit ihr herumalbern. So soll sie Steven Spielberg bei Dreharbeiten beigebracht haben, wie man herzhaft rülpst. Auch die Dauerfehde mit Bette Davis bereitete ihr viel Vergnügen. Als die Kollegin sie mal bei gemeinsamen Dreharbeiten über den Boden schleifen musste, steckte sich die Crawford vorher schwere Gewichte in die Taschen.

Sex, sagte sie mal, brauche sie, um reine Haut zu bekommen. Bevorzugt würde sie es allerdings aus Liebe tun. Die Diva, die im Alter fast einen Liter Wodka täglich trank, wollte ursprünglich Tänzerin werden und interessierte sich anfangs nicht für den Film. Später gab sie zu, dass sie sich gerne einredete, bei jedem Dreh hätte sich der Regisseur in sie verliebt.

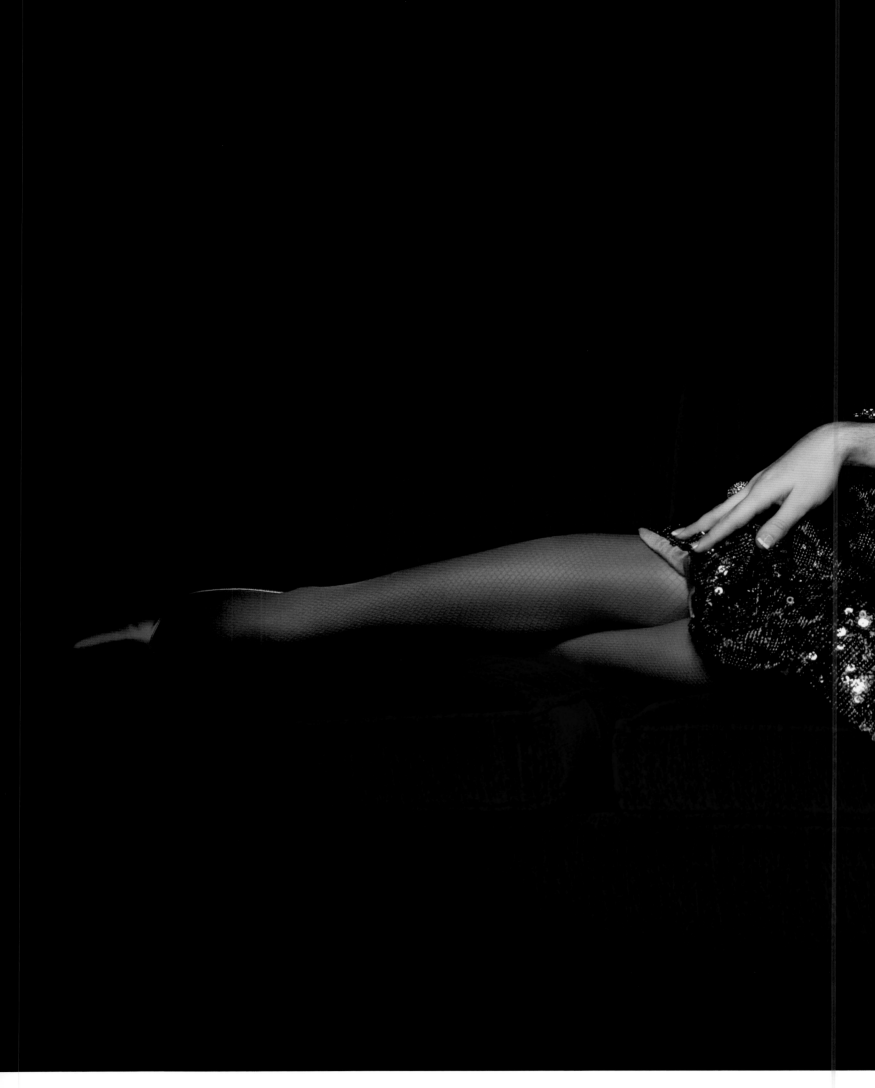

She was sex, her style, grace, glamour and talent rolled into one celluloid goddess. — Katya Smirnoff Skyy

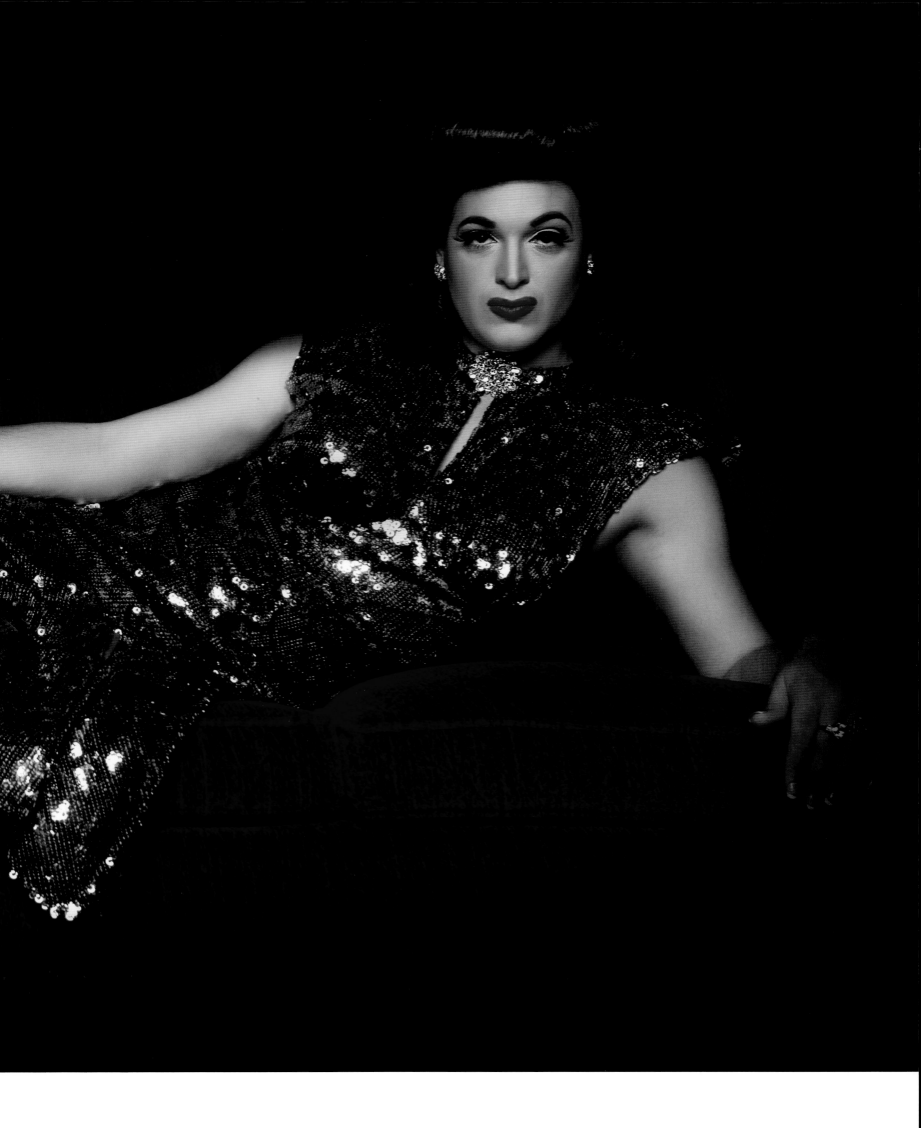

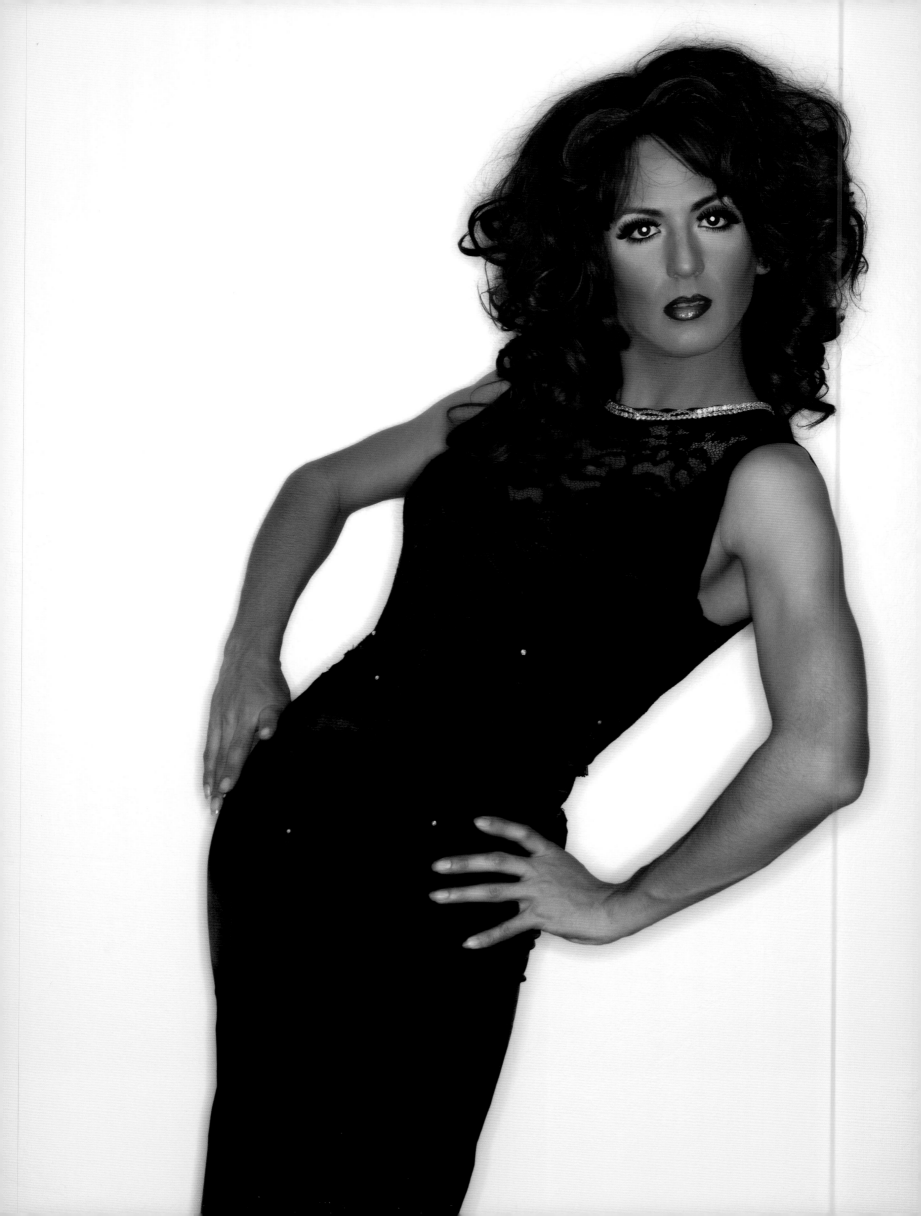

Mona lot MooRe inspired by
Celine Dion

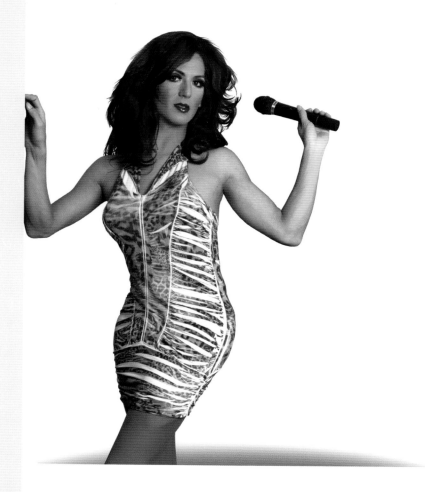

Miss MonA lot MooRe
Miss MonA lot MooRe hails from New Jersey and can be found at drag shows as Beyonce or Cher. She has also slipped into roles such as Britney and Lady Gaga.

Miss MonA lot MooRe stammt aus New Jersey und ist bei Drag-Shows vorzugsweise als Beyonce oder Cher anzutreffen. Auch in die Rollen von Britney und Lady Gaga ist sie schon geschlüpft.

As a gay man, how can you not love this woman? She owns 3,000 pairs of shoes. With a range of over five octaves, she won Europe's Grand Prix Contest (with *Ne partez pas sans moi* for Switzerland in 1988), one of the world's most popular song contests. She has recorded a duet with Barbra Streisand and is related to Madonna, even if only distantly. With *My Heart Will Go On* she consoled us over the death of Leonardo DiCaprio, after that ridiculously expensive ship hit the iceberg. But above all, we identify with her for this reason: she too can only have children with the help of test tubes. This makes her one of us. And if it should turn out one day that her son Rene Charles is gay, so what! She already told him, she wouldn't love him one bit less. The most important thing is that he's happy.

Diese Frau muss man als schwuler Mann einfach lieb haben: Sie besitzt 3.000 Paar Schuhe. Die Frau mit dem Stimmumfang von über fünf Oktaven hat den Grand Prix gewonnen, als er noch nicht Eurovision Song Contest hieß (*Ne partez pas sans moi* für die Schweiz, 1988). Mit Barbra Streisand hat sie ein Duett aufgenommen, und mit Madonna ist sie verwandt, wenn auch um etliche Ecken. Mit *My heart will go on* hat sie uns über den Tod von Leonardo DiCaprio hinweggetröstet, nachdem dieses sauteure Schiff den blöden Eisberg gerammt hatte. Aber vor allem aus diesem Grund können wir uns mit ihr identifizieren: Auch sie bekommt ihre Kinder mit Hilfe von Reagenzgläsern. Damit ist sie eine von uns. Und sollte sich eines Tages herausstellen, dass Sohnemann Rene Charles schwul ist – so what! Sie würde ihn deswegen nicht weniger lieben, hat sie ihn bereits wissen lassen. Hauptsache, er ist glücklich.

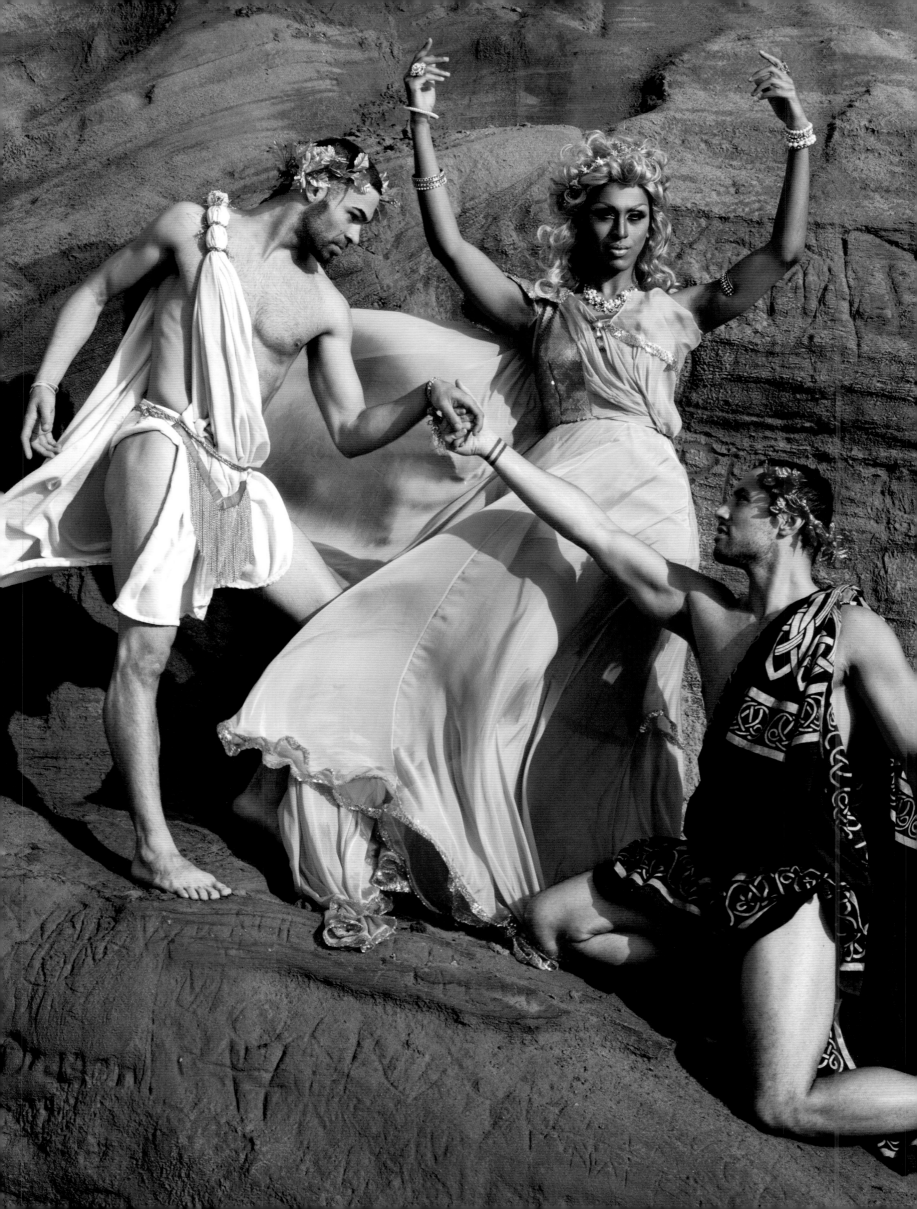

Honey Mahogany inspired by
Helen of Troy

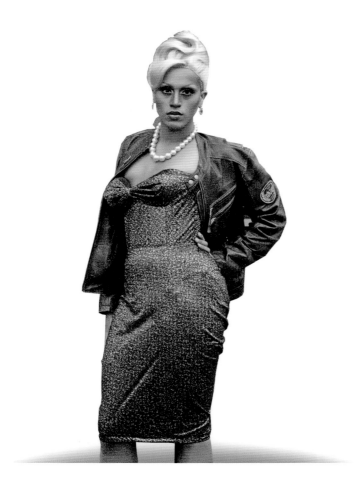

Honey Mahogany
In addition to the awards "Best Drag Queen" and "Miss Blow Up", Honey Mahogany has been a cover girl and on stage in numerous theater productions. In her debut single from two years ago she covered Adele.

Neben der Auszeichnung als „Best Drag Queen" und „Miss Blow Up" war Honey Mahogany schon Covergirl und stand in mehreren Theaterproduktionen auf der Bühne. Auf ihrer Debüt-Single vor zwei Jahren hat sie Adele gecovert.

What a feeling that must be! As if it were your birthday, Gay Pride and the final of the Eurovision Song Contest all in one day: When you are so damn hot that men fight just to be able to touch you. Too bad, that the open relationship hadn't yet been invented in ancient Greece.

Helen, daughter of Zeus, was married to the King of Sparta. This, however, didn't matter to Aphrodite, Goddess of Love: She made sure that the heir to the Trojan throne, Paris, fell deeply in love with Helen and then abducted her. The insulted Greeks then declared war on Troy. The Greeks won the war after long years of siege with the help of a wooden horse filled with Greek warriors who were smuggled into the city. What an invention, the Trojan horse: You put it in your bedroom and at night, a group of buff, half-naked men in sandals (no socks!) climb out.

Das muss der Gipfel sein fürs Ego. Ein Gefühl, als fielen Geburtstag, CSD und das Finale des Eurovision Song Contest auf einen Tag: Wenn man so verdammt heiß ist, dass die Männer um einen balgen, weil jeder mal anfassen will. Doof nur, dass im alten Griechenland die offene Beziehungen noch nicht erfunden war.

Helena – Tochter des Götterhäuptlings Zeus – war nämlich mit Spartas König verheiratet. Das aber kümmerte Aphrodite, hauptberuflich Göttin der Liebe, herzlich wenig: Sie sorgte dafür, dass der trojanische Thronfolger Paris sich heftig in Helena verknallte und sie dann auch noch entführte. Darauf erklärten die beleidigten Griechen Troja den Krieg. Den gewannen sie nach langjähriger Belagerung mit Hilfe eines hölzernen Pferdes, gefüllt mit griechischen Kriegern, das man in die Stadt schmuggelte. Toll, so ein Trojanisches Pferd: Man stellt es sich in Schlafzimmer, und des Nachts kommen lauter durchtrainierte halbnackte Kerle in Sandalen (ohne Strümpfe!) herausgeklettert.

Gillette Thebestamancanet inspired by

Janet Jackson

Gillette Thebestaman-canget
Gilette Thebesta-mancanget has been dancing since the age of two. At 12 she started earning money with her passion. In addition to stage appearances across the United States, she also works as a choreographer.

Schon seit ihrem zweiten Lebensjahr tanzt Gilette Thebestamancanget. Seit sie 12 ist, verdient sie damit ihr Geld. Neben Bühnenengagements quer durch die USA arbeitet sie auch als Choreografin.

Wow, the way she could dance! From her first video on, which were always perfectly choreographed, she set the standard at MTV. The Superbowl Nipplegate came much later and is now just a faint memory. But let's be honest, who among us wouldn't lose control of their tits when performing side-by-side with Justin Timberlake?

For those of us who grew up with Janet's music, her lyrics always related to our lives. She broke away from her family with her debut album, and not just in terms of content, and in her next album she railed against hypocrisy and prejudice. One of her biggest hits was *Together Again*, a tribute to friends who had died of Aids. She donated a portion of the proceeds from the song, which sold over 6 million copies, to the American Foundation for AIDS Research. The singer, also an advocate for gay rights, was never bothered by rumors that she is a lesbian or bi. And just in case, she let us know who her first choice would be: Alicia Keys.

Uii, wie die früher tanzen konnte! Vom ersten Video an immer perfekt durchchoreographiert, setzte sie bei MTV Maßstäbe. Die Nipplegate-Episode vom Superbowl kam erst später und ist längst verziehen. Schließlich würde wohl jeder von uns die Kontrolle über seine Titten verlieren, wenn er an der Seite von Justin Timberlake auftreten darf.

Wer mit der Musik von Janet sozialisiert wurde, konnte ihre Texte immer auch auf sich beziehen. Während sie sich mit ihrem Debüt-Album nicht nur inhaltlich vom Elternhaus löste, wetterte sie auf der nächsten Platte gegen Heuchelei und Vorurteile. Einer ihrer größten Hits wurde *Together Again* – ein Tribut an Freunde, die an Aids gestorben waren. Einen Teil der Einnahmen dieses Songs, der sich über 6 Millionen Mal verkauft hat, spendete sie an die Amerikanische Aids-Stiftung. Die Sängerin, die sich auch für Homo-Rechte einsetzte, hat sich an Gerüchten, sie sei lesbisch oder bi, nie gestört. Für alle Fälle hat sie auch schon verraten, wer ihre erste Wahl wäre: Alicia Keys.

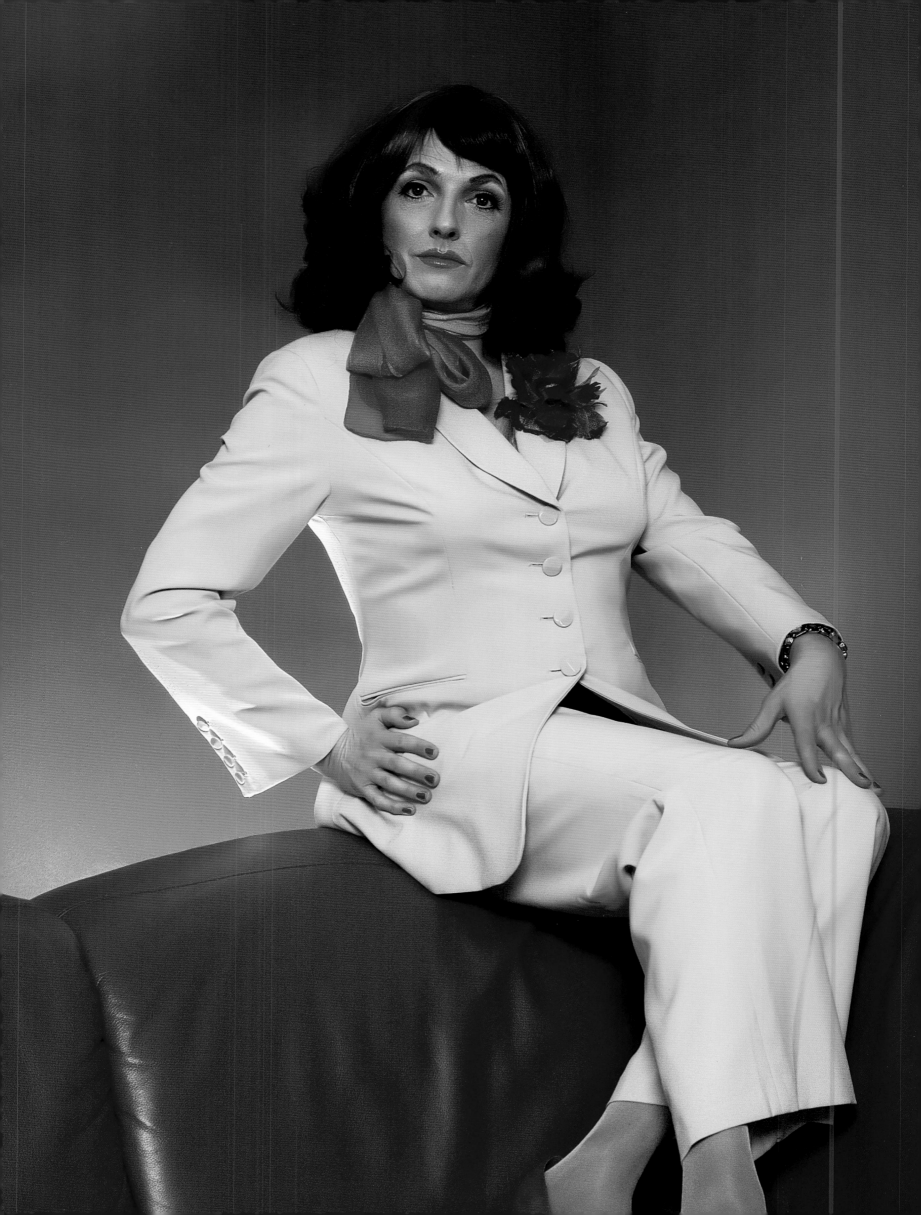

Bob Schneider inspired by
Joan Collins

Bob Schneider
The fact that he ditched Germanic studies is certainly no tragedy. After all, the German broadcasting corporation Rundfunk Berlin-Brandenburg (rbb) declared Bob Schneider's figure Jutta Hartmann a superstar, and *Variety* described his performance in the Miss Marple parody *18:15 Uhr ab Ostkreuz* as "fabulous".

Dass er sein Germanistik-Studium geschmissen hat, ist nicht tragisch. Immerhin hat der rrb Bob Schneiders Figur Jutta Hartmann zum Superstar erklärt, und die *Variety* fand seinen Auftritt in der Miss-Marple-Parodie *18:15 Uhr ab Ostkreuz* „fabulous".

Her signature role was the über-bitch Alexis in *Dynasty*. In the early 80s, her TV son Steven was one of the first gay soap characters ever. Even if she may not have been a particularly sympathetic mother, dropping perfectly snide remarks (the ones you can never actually come up with in real life when it counts), she bullied herself into our collective memory. And of course she always got the hottest guys. The series itself is long gone, but with well-chosen performances, Joan has always stayed true to her fans, staying stylish and sexy in her later years, like in her guest appearance on *The Nanny*.

The native Englishwoman is said to have had affairs with the likes of Dennis Hopper and Ryan O'Neal; Frank Sinatra wasn't so lucky, she turned him down. Because of her hedonistic lifestyle people liked to call her „The British Open". She married five times, but according to her, she never found a man who could take care of her. She ended up seeing it like this: "I don't need a husband. What I need is a wife."

Ihre Paraderolle war die Über-Bitch Alexis im Denver-Clan. Anfang der 80er Jahre war ihr TV-Sohn Steven einer der ersten schwulen Soap-Charaktere. Auch wenn sie ihm keine übertrieben verständnisvolle Mutter war – mit fiesen Sprüchen, wie sie einem im passenden Moment selber leider nie einfallen, hat sie sich in unser aller Gedächtnis gemobbt. Außerdem vögelte sie mit den heißesten Männern. Die Serie ist längst Geschichte, aber mit gezielten Auftritten hat sich Joan immer wieder bei ihrem Publikum zurückgemeldet, auch im Alter noch stylish und sexy, wie bei ihrem Gastauftritt in *Die Nanny*.

Der gebürtigen Engländerin werden Affären u.a. mit Dennis Hopper und Ryan O'Neal nachgesagt, Frank Sinatra dagegen gab sie einen Korb. Wegen ihres lustbetonten Lebenswandels nannte man sie gern „The British Open". Fünfmal hat sie geheiratet, aber nach eigenen Angaben nie einen Kerl gefunden, der sich um sie kümmern konnte. Ihr Fazit: „Eigentlich brauche ich keinen Ehemann – sondern eine Frau!"

Sandy Shorts inspired by
Katharine Hepburn

Sandy Shorts
Sandy Shorts from San Francisco has spent half her life in drag. Her specialty is the great Hollywood divas of the 40s and 50s. Underneath the dresses she hides the marvelous body of a personal trainer.

Sandy Shorts aus San Francisco hat schon ihr halbes Leben im Fummel verbracht. Ihre Spezialität sind die großen Hollywood-Diven der 40er und 50er Jahre. Unterm Fummel verbirgt sich ein ansehnliches Muskelpaket, denn Sandy arbeitet außerdem als Privattrainer.

She is one of the greatest Hollywood legends of all time. Even if Meryl Streep has since broken her record for Oscar nominations, no one has yet matched the four trophies she has won. At the beginning of her career people didn't like that she refused to wear make-up or give interviews like other stars. And on top of that, Katharine liked to wear men's clothing. Once, when her costume designer stole her pants from her wardrobe, she went around the film studio in her underwear until she got them back.

The "First Lady of Cinema" was also athletic. She liked cold showers and did all her own stunts. She was together with Spencer Tracy for 27 years, even though they never married. While gay men often wonder, how men and women manage to get along at all, Katharine had an answer: "Perhaps they should live next door and just visit now and then."

Sie gehört zu den größten Filmlegenden, die Hollywood hervorgebracht hat. Auch wenn Meryl Streep ihren Rekord an Oscarnominierungen gebrochen hat – die Hepburn ist mit vier gewonnenen Trophäen immer noch unerreicht. Dabei war das Publikum zu Beginn ihrer Karriere irritiert, dass sie sich weigerte, Make-up zu tragen oder Interviews zu geben wie die anderen Stars. Ganz zu schweigen davon, dass Katharine gerne Männerklamotten trug. Als ihr die Kostümbildner einmal die Hosen aus der Garderobe klauten, lief sie solange in Unterwäsche durchs Filmstudio, bis sie sie zurückbekam.

Die „First Lady of Cinema" war ziemlich sportlich. Sie duschte gerne kalt und machte all ihre Filmstunts selber. Mit Spencer Tracy war sie 27 Jahre lang zusammen, obwohl der mit einer anderen verheiratet war. Wenn man sich als Schwuler oft fragt, wie Männer und Frauen überhaupt zusammen passen – Katharine hatte eine Antwort: „Vielleicht sollten sie nur nebeneinander wohnen und sich ab und zu besuchen."

Adriana Mia Diamante inspired by

Lady Gaga

Adriana Mia Diamante
She's been on practically every stage on the West Coast. After performances in music videos and work as a model, she is now working on her own fashion line. High heels à la Adriana Mia Diamante are on the way.

An der US-Westküste hat sie fast schon auf allen Bühnen gestanden. Nach Auftritten in Musikvideos und Jobs als Fotomodell arbeitet sie jetzt an einer eigenen Modelinie. Auch High Heels à la Adriana Mia Diamante soll es bald geben.

Extravagant costumes, wild hairstyling and flamboyant make-up alone do not make a gay icon (although it doesn't hurt). One thing is clear, Ms. Germanotta owes a lot to her gay audience, and she knows it. Even if the same may be true for Madonna or Kylie: No other top artist refers to her gay fans as consistently as Lady Gaga. And that's not all, whether gay, lesbian, bi or transgender, in *Born this Way* she encourages everyone to be true to who they are. It was no coincidence that the 14-year old Jamey Rodemeyer thanked her expressly for her dedication before he took his life in September 2011: He could no longer endure the hostile gay baiting from his classmates.

Lady Gaga, who had already been honored repeatedly for her commitment towards gay liberation, was so outraged by his death, that she founded an anti-bullying foundation. Everyone should be accepted as the person they want to be. Thank you!

Extravagante Kostüme, wilde Frisuren, schrille Schminke – das allein macht noch keine Schwulen-Ikone (obwohl es natürlich hilft). Fest steht: Frau Germanotta hat ihrem Homo-Publikum viel zu verdanken, und das weiß sie auch. Selbst wenn für Madonna oder Kylie dasselbe gilt: Keine andere Künstlerin in der Top-Liga bezieht sich so konsequent auf ihre Homo-Fans wie Lady Gaga. Und nicht nur das: Egal ob schwul, lesbisch, bi oder transgender – in *Born this way* macht sie allen Mut, zu sich selbst zu stehen. Nicht zufällig bedankte sich der 14-jährige Jamey Rodemeyer ausdrücklich für ihr Engagement, bevor er sich im September 2011 das Leben nahm: Er ertrug die homofeindliche Hetze seiner Mitschüler nicht länger.

Lady Gaga, die für ihr schwulenfreundliches Eintreten schon mit etlichen Preisen geehrt wurde, machte sein Tod so wütend, dass sie eine Anti-Mobbing-Stiftung ins Leben rief. Jeder soll als die Person akzeptiert und geliebt werden, die er sein möchte. Danke!

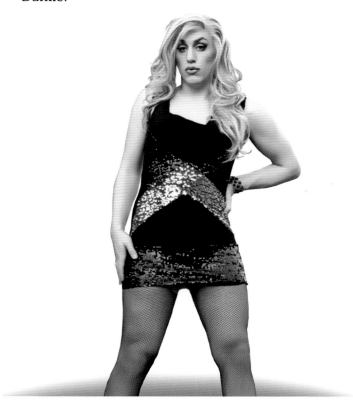

Lady GaGa's ability to truly embrace her creativity and individuality gave me the courage to embrace both the art and femininity within myself, combine that with the restrictions society has imposed on us as artists, and turn that into an ultimately indestructible and fierce being that nobody can fuck with.

— **Adrian Mia Diamante**

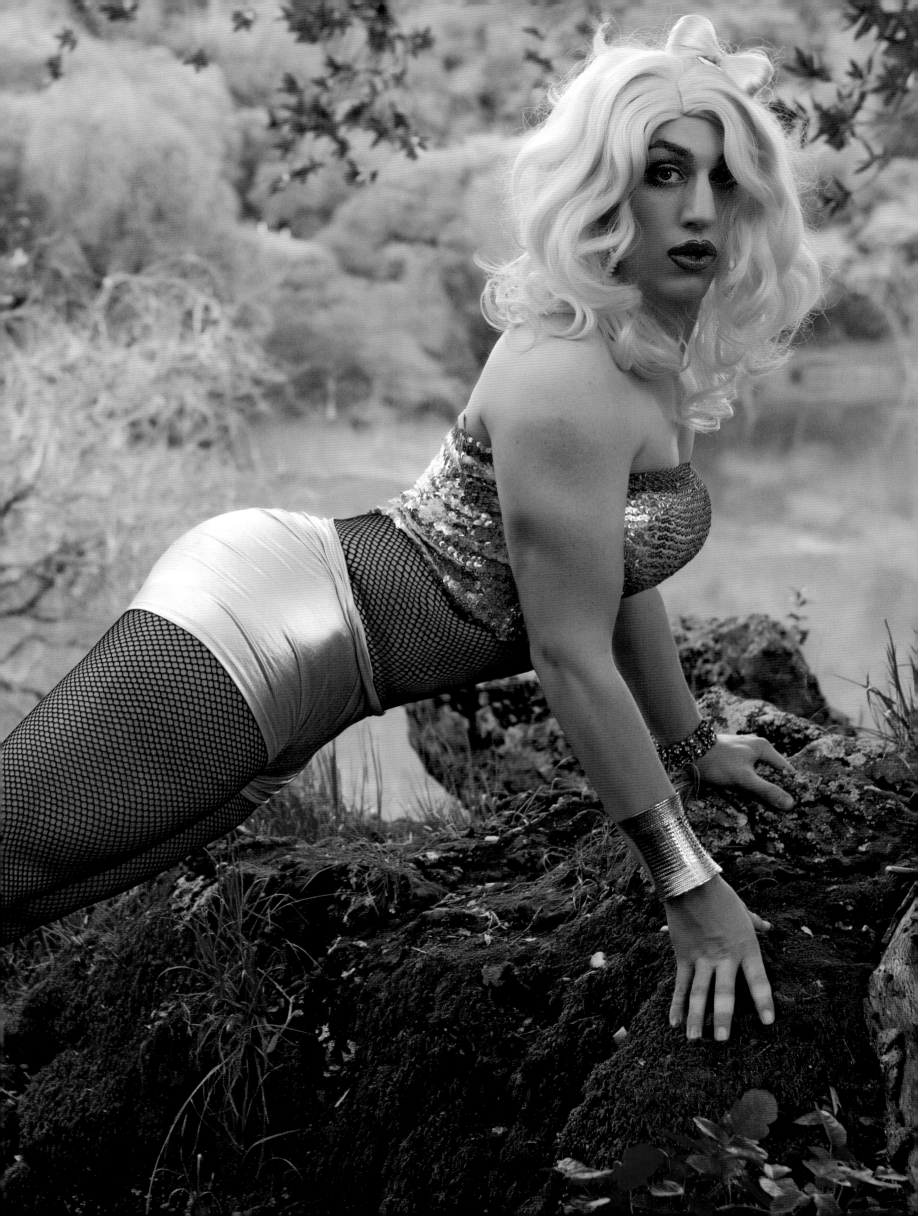

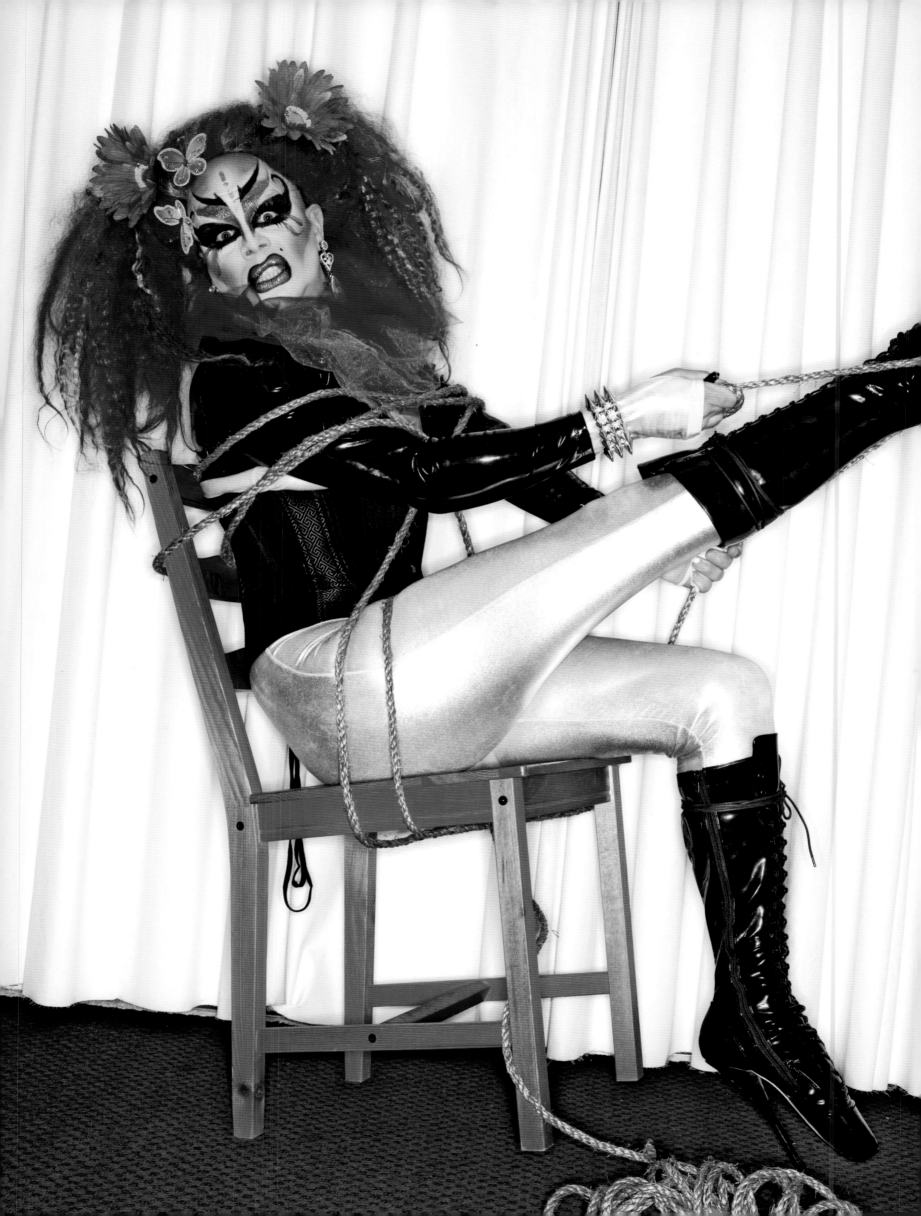

Glitz Glam inspired by

Nina Hagen

If there's one thing to be learned from Nina Hagen, it's how to not care about what others think of how you look, what makeup you wear or your clothes. The Godmother of Punk says what she thinks, even if no one can believe that she really encountered an UFO 25 years ago. In an extremely intimate appearance on an Austrian talk show in 1979 she demonstrated various positions of female masturbation.

Her choice in men often left something to be desired. She separated a week after one wedding, while her second marriage lasted only a year – who says that we gays are the ones who can't manage long term relationships. Nina has made it clear that she's on our side; she recently said in an interview that gays and heteros are equally sacred. "God loves homosexuality."

GlitzGlam
Whether in Miami, New York or Los Angeles, GlitzGlam from San Diego has performed in every drag show possible. Her trademarks include her brightly colored hair and her tremendous high heels.

Ob Miami, New York oder Los Angeles – GlitzGlam aus San Diego ist schon auf jeder Drag Show in den Vereinigten Staaten aufgetreten. Zu ihren Markenzeichen gehören die meist grellbunten Haare und die enormen Absätze ihrer High Heels.

Sich nicht scheren, was andere Leute darüber denken, wie man sich gibt, schminkt oder anzieht – wenn man etwas von Nina Hagen lernen kann, dann das. Die Godmother of Punk sagt, was sie denkt – auch wenn sich kaum jemand vollstellen kann, dass sie tatsächlich vor einem Vierteljahrhundert einem UFO begegnet ist. Da war ihr Auftritt in einer österreichischen Talkshow 1979 deutlich lebensnaher, als sie verschiedene Stellungen zur weiblichen Masturbation demonstrierte.

Bei der Wahl ihrer Männer hatte sie nicht immer ein glückliches Händchen. Einmal trennte sie sich eine Woche nach der Hochzeit, eine spätere Ehe scheiterte nach einem Jahr – da soll uns Schwulen nochmal einer nachsagen, wir würden es nicht hinkriegen, dauerhafte Beziehungen zu führen. Dass Nina diesbezüglich auf unserer Seite ist, hat sie erst kürzlich klar gemacht, als sie in einem Interview sagte, Schwule und Heten seien gleichermaßen heilig. „Gott liebt Homosexualität."

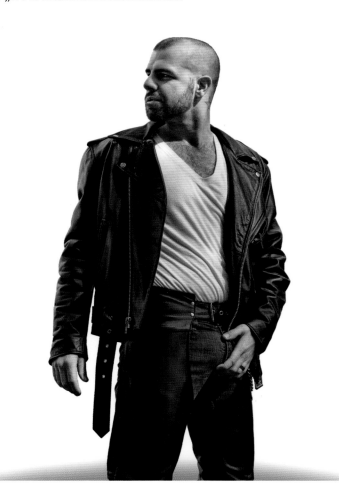

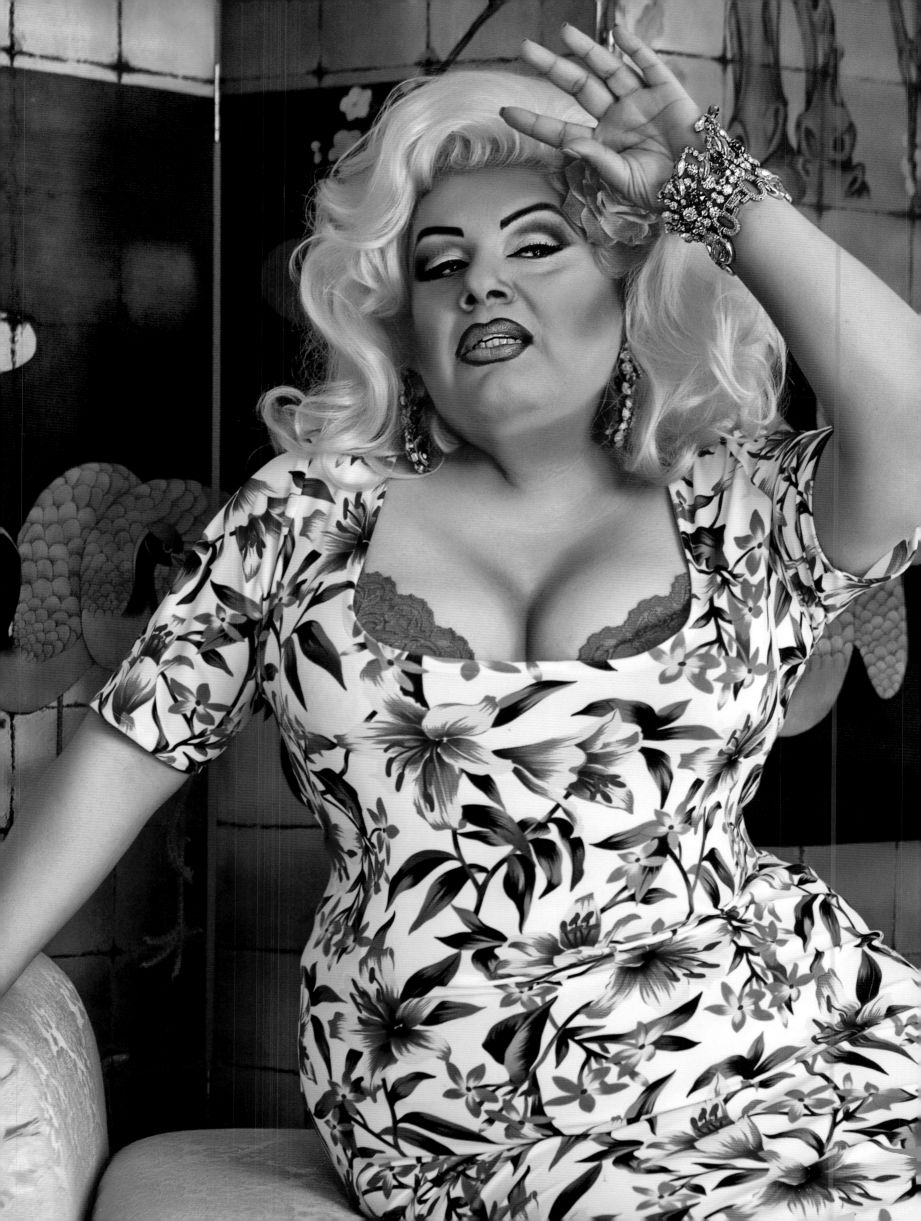

Athena Van Doren inspired by
Jayne Mansfield

Jayne, who won beauty contests at an early age, earned herself titles such as "Miss Photoflash" and "Miss Magnesium Lamp". She wanted to be a star. In order to get her first TV job, she reportedly slipped the producer the following note: "36-22-35". After Monroe, she was the prototypical Hollywood blonde of the 50s and 60s. In 1963 she was the first American actress to take it off in a mainstream movie. She liked to hold press conferences in a bathtub.

And like any good diva, she was dissed by other divas. Bette Davis said: "Dramatic art in her opinion is knowing how to fill a sweater." Hairspray director John Waters, who loves to play with gender clichés in his films, called Mansfield the "first female female-impersonator". But Jayne wasn't stupid. Not only did she love children and animals, she was trained as a classical pianist and violinist. She also spoke five languages.

Athena Van Doren
Athena Van Doren was inspired by the man-eating divas of the 1950s, such as Jayne Mansfield and Mamie Van Doren. You can admire her in drag shows around San Francisco.

Inspiriert von den männermordenden Diven der 1950er Jahre wie Jayne Mansfield und Mamie Van Doren ist Athena Van Doren entstanden. Zu bewundern ist sie in Drag Shows rund um San Francisco.

Jayne, die schon früh Schönheitswettbewerbe gewann und Titel wie „Miss Blitzlicht" und „Miss Magnesiumlampe" ergatterte, wollte unbedingt ein Star werden. Um ihren ersten TV-Job zu bekommen, soll sie dem Produzenten einen Zettel zugesteckt haben, auf dem stand: „100 – 53 – 89". Nach der Monroe war sie die Vorzeige-Blondine im Hollywood der 50er und 60er Jahre. 1963 entblätterte sie sich als erste amerikanische Schauspielerin in einem Mainstreamfilm. Pressekonferenzen hielt sie gerne mal in der Badewanne ab.

Wie es sich für eine Diva gehört, wurde sie von anderen Diven gedisst. Bette Davis lästerte zum Beispiel: „Die Mansfield glaubt, es sei schon Schauspielerei, wenn man bloß seinen Pullover ordentlich füllt." Hairspray-Regisseur John Waters, der in seinen Filmen gern mit Geschlechterklischees spielt, nannte die Mansfield den „ersten weiblichen Frauenimitator". Dumm war Jayne aber nicht. Die Frau, die Kinder und Tiere über alles liebte, hatte eine klassische Ausbildung als Pianistin und Geigerin. Außerdem beherrschte sie fünf Sprachen.

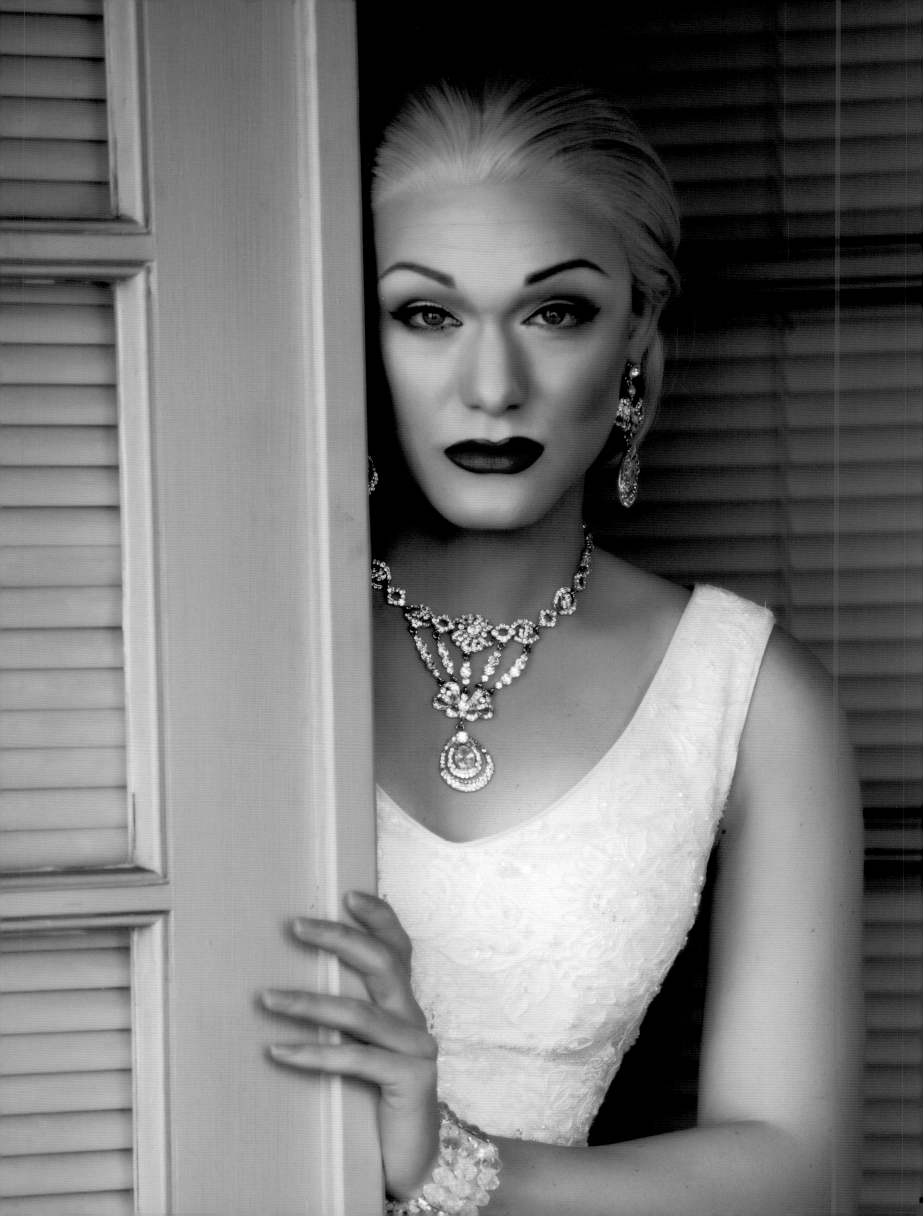

Kenneth Rex inspired by
Eva Peron

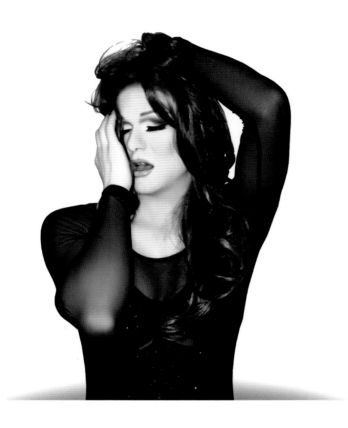

Kenneth Rex
With parents who work in show business, Kenneth Rex's path was clear from an early age. In the *Tyra Banks Show* he performed as Gwen Stefani. In Las Vegas he can be seen as Madonna, Cher or Britney Spears.

Mit Eltern, die im Showbusiness arbeiten, war der Weg von Kenneth Rex früh klar. In der *Tyra Banks Show* trat er als Gwen Stefani auf. In Las Vegas war er als Madonna, Cher oder Britney Spears zu sehen.

There are indeed so many reasons to admire Evita. She convinced her husband, President Juan Peron to introduce women's right to vote in 1947. And without her, Madonna never would have made a decent movie. And of course there was her black strapless dress, which she shocked the Pope with when she visited the Vatican.

Even if she spent millions on luxury robes and jewelry (the First Lady can't run around in a tracksuit, after all), she is still revered in Argentina. In Buenos Aires, the gay capital of South America, pubs are christened in the name of Peron and in one there is even an altar to Evita.

She passed from us more than a half century ago, so she can't take the credit for the fact that Argentina is one of the few countries on earth in which gays can marry. Nonetheless, there's more than a few gay people in Argentina who are convinced that Evita looks down from the clouds in heaven to bless every gay marriage.

Es gibt etliche Gründe, Evita zu verehren. Sie brachte ihren Mann, Präsident Juan Peron, dazu, 1947 das Frauen-Wahlrecht einzuführen. Ohne sie hätte Madonna bis heute keinen Film gedreht, für den sie nicht ausgelacht worden ist. Und dann war da natürlich ihr schwarzes trägerloses Kleid, mit dem sie beim Besuch des Vatikans den Papst schockierte.

Auch wenn sie Millionen Dollar in Luxusroben und Schmuck investierte (als Präsidentengattin kann man schließlich nicht im Trainingsanzug rumlaufen): Die Verehrung in Argentinien hört nicht auf. In Buenos Aires, wo in ganz Südamerika die meisten Schwulen leben, werden Kneipen auf den Namen Perón getauft, und in einer steht sogar ein Evita-Altar.

Da sie schon weit über ein halbes Jahrhundert tot ist, ist es nicht ihr Verdienst, dass Argentinien zu den wenigen Ländern auf der Erde zählt, in denen Homos heiraten können. Doch es gibt nicht wenige schwule Argentinier, die überzeugt sind, dass Evita irgendwo im Himmel auf einem Wolkenbalkon steht und bei jeder Schließung einer Homo-Ehe mit dieser sonderbar steifen Handbewegung grüßt.

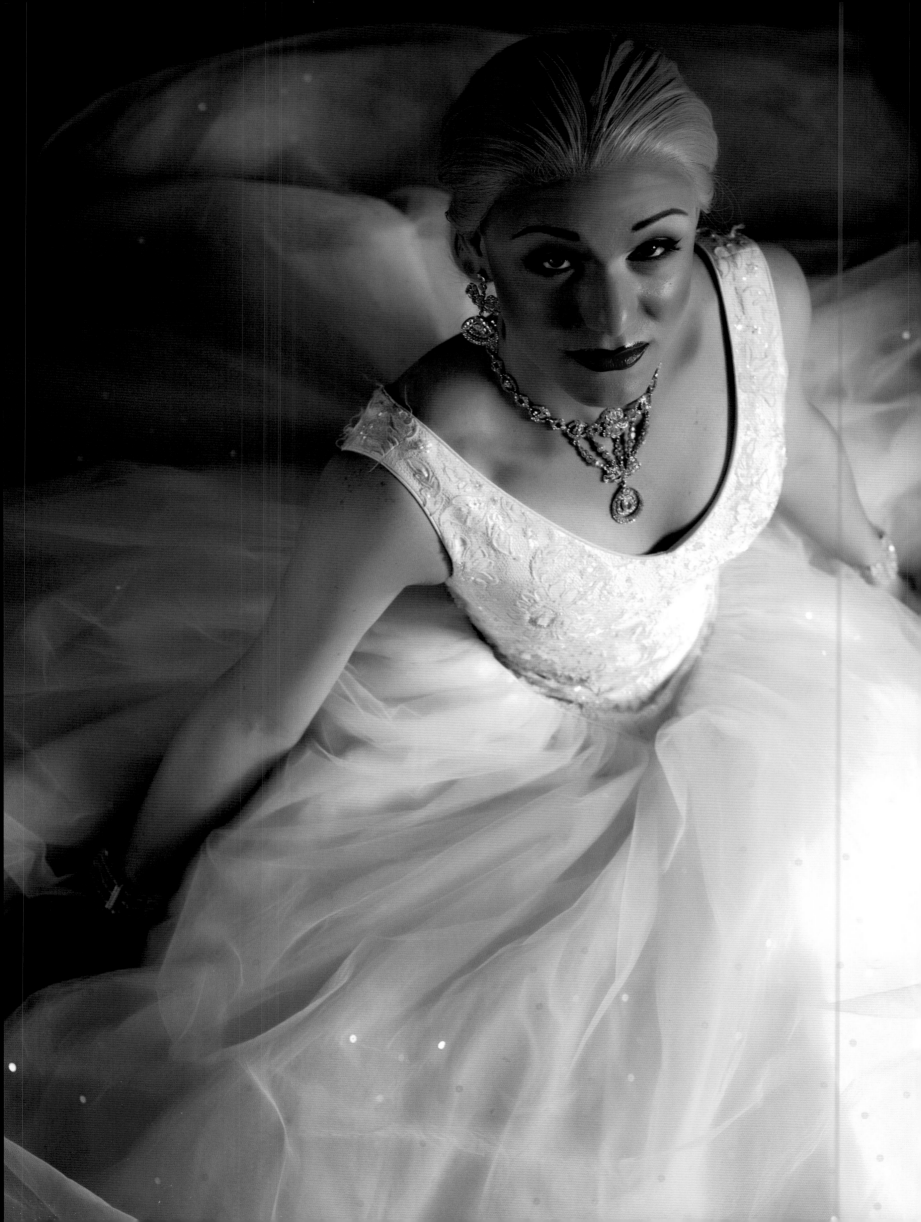

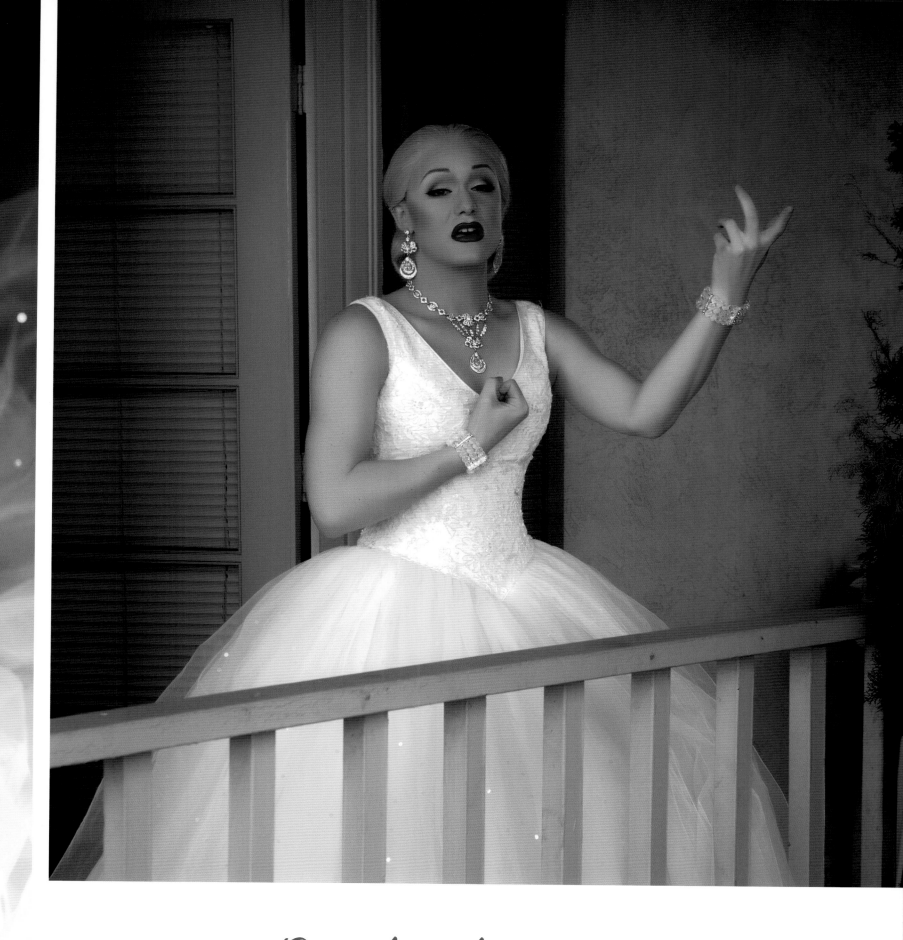

*Everything that is amazing
in a woman is found in Evita:
power, glamour, mystery,
and most of all sex.*

— **Kenneth Rex (Breathless)**

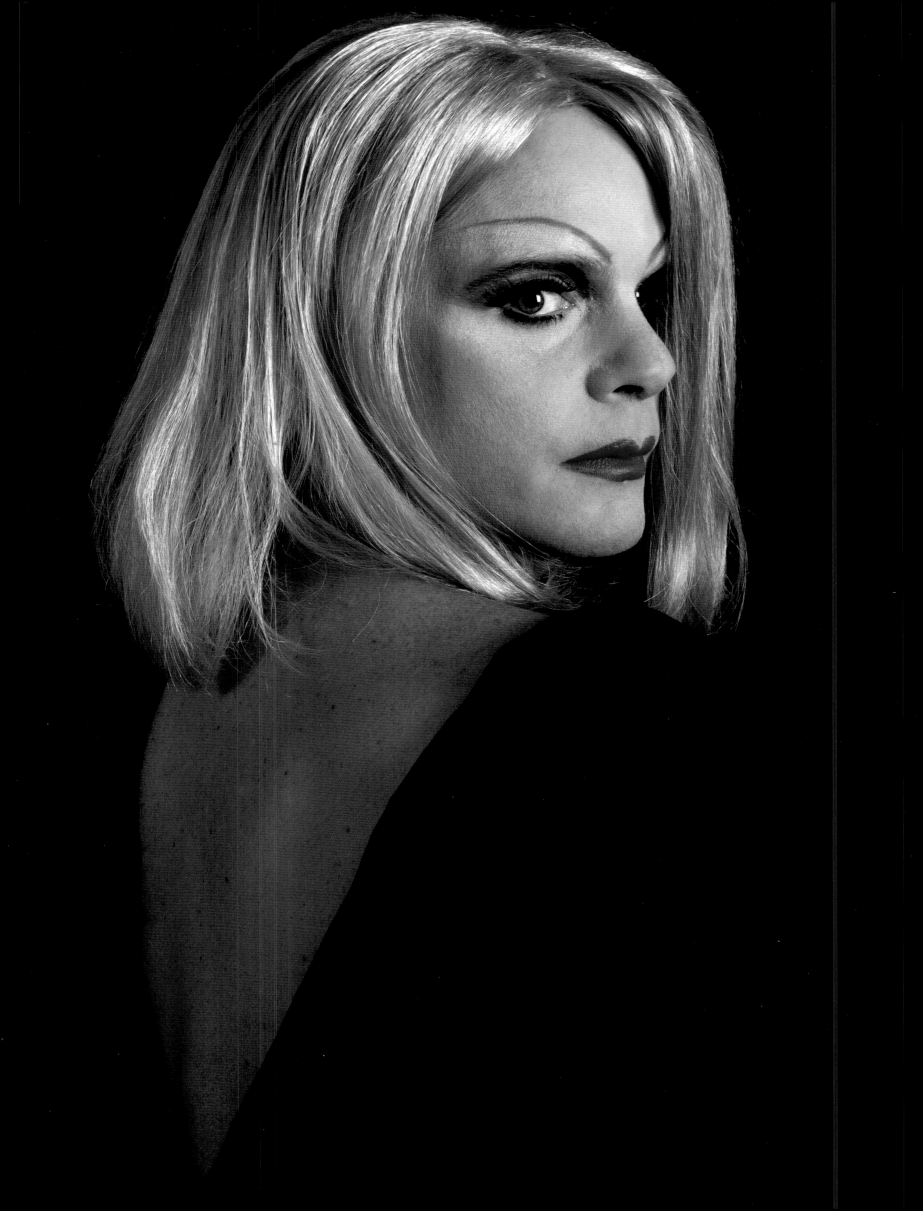

Anna Conda inspired by
Greta Garbo

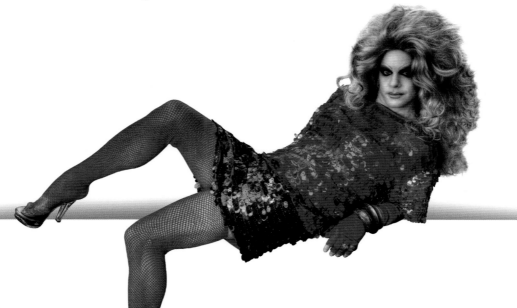

Anna Conda
Originally from Pennsylvania, Anna Conda moved to New York in the 90s, where she was reborn as a downtown star. Today she is the President of the Harvey Milk LGBT Democratic Club—the first drag queen ever elected.

Ursprünglich aus Pennsylvania, ging Anna Conda in den 90ern nach New York, um als Downtown-Star wiedergeboren zu werden. Heute ist sie die Präsidentin des Harvey Milk LGBT Democratic Club – die erste Drag Queen in diesem Amt.

The Swede, who the Guinness Book of World Records once declared as the most beautiful woman ever, had filmed just three Hollywood movies before she showed just how self-confident she was. She went on strike for more salary and better roles—successfully. After all, a single Garbo Hollywood movie brought the studio 13 percent of its annual revenue. In 1930 "The Goddess" debuted in a talking film. Her first line as a bitter, alcoholic prostitute led to the famous saying, one of two that every gay man says at least once: "Gimme a whiskey and don't be stingy, baby."

Because Garbo suffered from severe depression, she kept a strict diet. But she never gave up cigarettes and cocktails. After 1941 she never made another movie, but her popularity never wavered. She declined an invitation to tea with Queen Elizabeth II with the second saying that every gay man says sooner or later: "I have nothing to wear."

Die Schwedin, die das Guinness Buch der Rekorde mal zur schönsten Frau überhaupt erklärte, hatte gerade drei Hollywood-Filme gedreht, da war ihr Selbstbewusstsein schon recht ausgeprägt. Sie streikte für mehr Gage und bessere Rollen – mit Erfolg. Schließlich brachte ein einziger Garbo-Film dem Studio 13 Prozent aller Jahreseinnahmen ein. 1930 debütierte „die Göttliche" in einem Tonfilm. Ihre erste Wortmeldung als verbitterte, alkoholkranke Prostituierte ist einer von zwei Sätzen, den jeder schwule Mann irgendwann mal sagt: „Whiskey, aber nicht zu knapp."

Weil die Garbo unter schweren Depressionen litt, hielt sie eine strenge Diät. Nur Zigaretten und Cocktails hat sie nie aufgegeben. Nach 1941 drehte sie keine Filme mehr, doch das Interesse an ihrer Person ließ nie nach. Eine Einladung zum Tee mit Königin Elisabeth II. lehnte sie ab – mit dem zweiten Satz, den jeder Schwule früher oder später von sich gibt: „Ich habe nichts zum Anziehen."

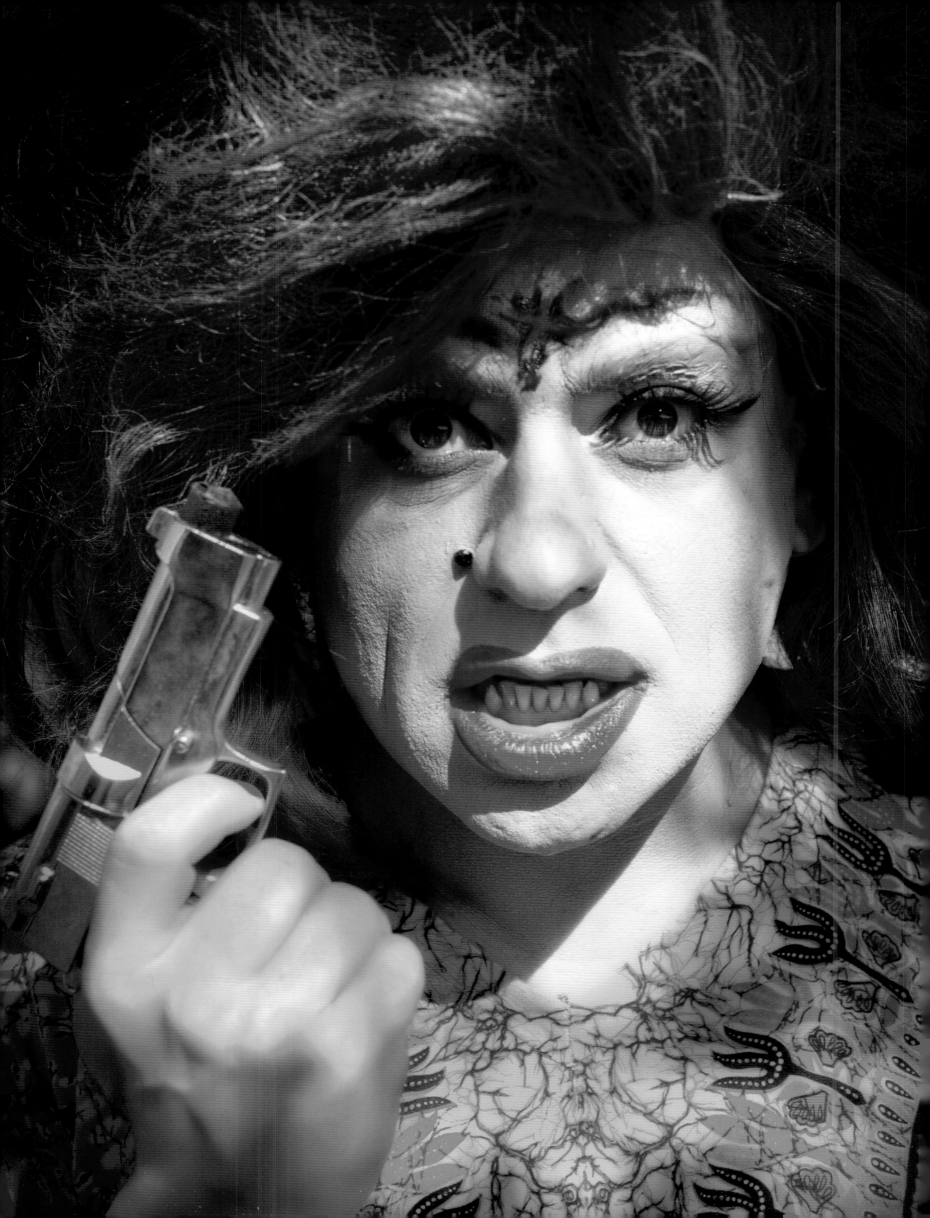

Heklina inspired by
Lynette "Squeaky" Fromme

In the 60s, Charles Manson and his satanic, racist hippy sect shocked the world with a series of brutal murders. He sent killers to the home of Roman Polanski. The director was not there. His pregnant wife and four others were literally slaughtered.

The bisexual Manson knew exactly how to seduce people. Lynette Alice "Squeaky" Fromme was one of his most trusted followers. Like all those who obeyed his commands, she etched a cross into her forehead, just like her prophet. After Manson went to prison, Fromme took over the leadership of the sect and preached his crazed religion. On 5 September 1975 she was arrested as she attempted to shoot President Ford. She had no regrets and never renounced Manson.

Of course drag queen Heklina does not see "Squeaky" as a role model, even if her life made a strong impression on Heklina. She represents a stark example of what love or reverence for the wrong man can do to us.

Heklina
Is there any event in San Francisco that Heklina has not graced with her presence, at least as a DJane? In 2009, the legendary pioneer of the drag-show *Trannyshack* was recognized for her commitment to the LGBT community. In addition to various TV appearances, she also appeared in a Scissor Sisters video.

In San Francisco gibt es kaum ein Event, das Heklina noch nicht beehrt hat, u.a. als DJane. 2009 wurde die Pionierin der legendären Dragshow *Trannyshack* für ihr LGBT-Engagement ausgezeichnet. Neben diversen TV-Auftritten hat sie auch in einem Scissor-Sisters-Video mitgespielt.

In den 60er Jahren schockierten Charles Manson und seine satanistische, rassistische Hippie-Sekte die Welt mit einer Serie bestialischer Morde. So schickte er Killer zum Haus von Roman Polanski. Der Regisseur war nicht da. Seine hochschwangere Frau und vier weitere Menschen wurden regelrecht abgeschlachtet.

Der bisexuelle Manson wusste, wie man Menschen verführte. Zu seinen treusten Anhängern gehörte Lynette Alice „Squeaky" Fromme. Wie alle, die ihm hörig waren, ritzte sie sich ein Kreuz in die Stirn, wie es ihr Prophet vormachte. Nachdem Manson ins Gefängnis kam, übernahm Fromme die Führung der Sekte und predigte seine irre Religion. Am 5. September 1975 wurde sie festgenommen, als sie versuchte, den damaligen US-Präsidenten Ford zu erschießen. Bereut hat sie nie, Manson abgeschworen ebensowenig.

Natürlich betrachtet Drag Queen Heklina „Sqeaky" nicht als Vorbild, wenngleich ihr Leben sie tief beeindruckt hat. Ein krasses Beispiel, was Liebe oder Verehrung für den falschen Mann mit uns machen kann.

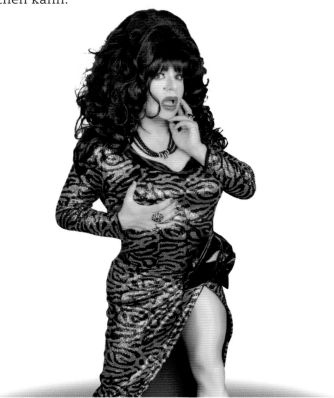

The Manson
Girls were
America's
worst nightmare.

— **Heklina**

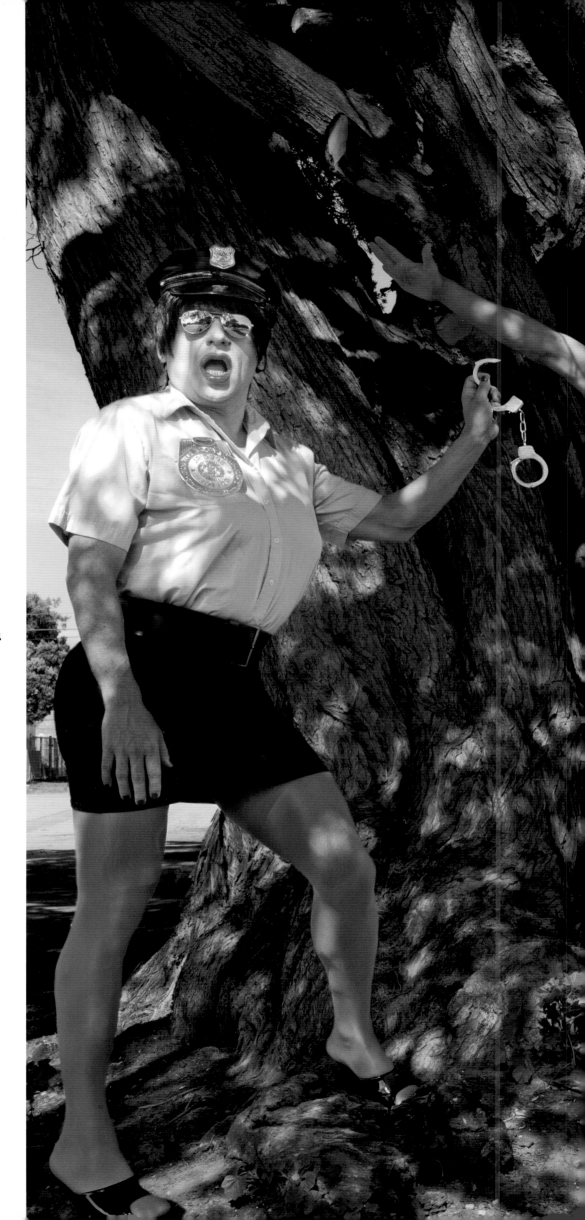

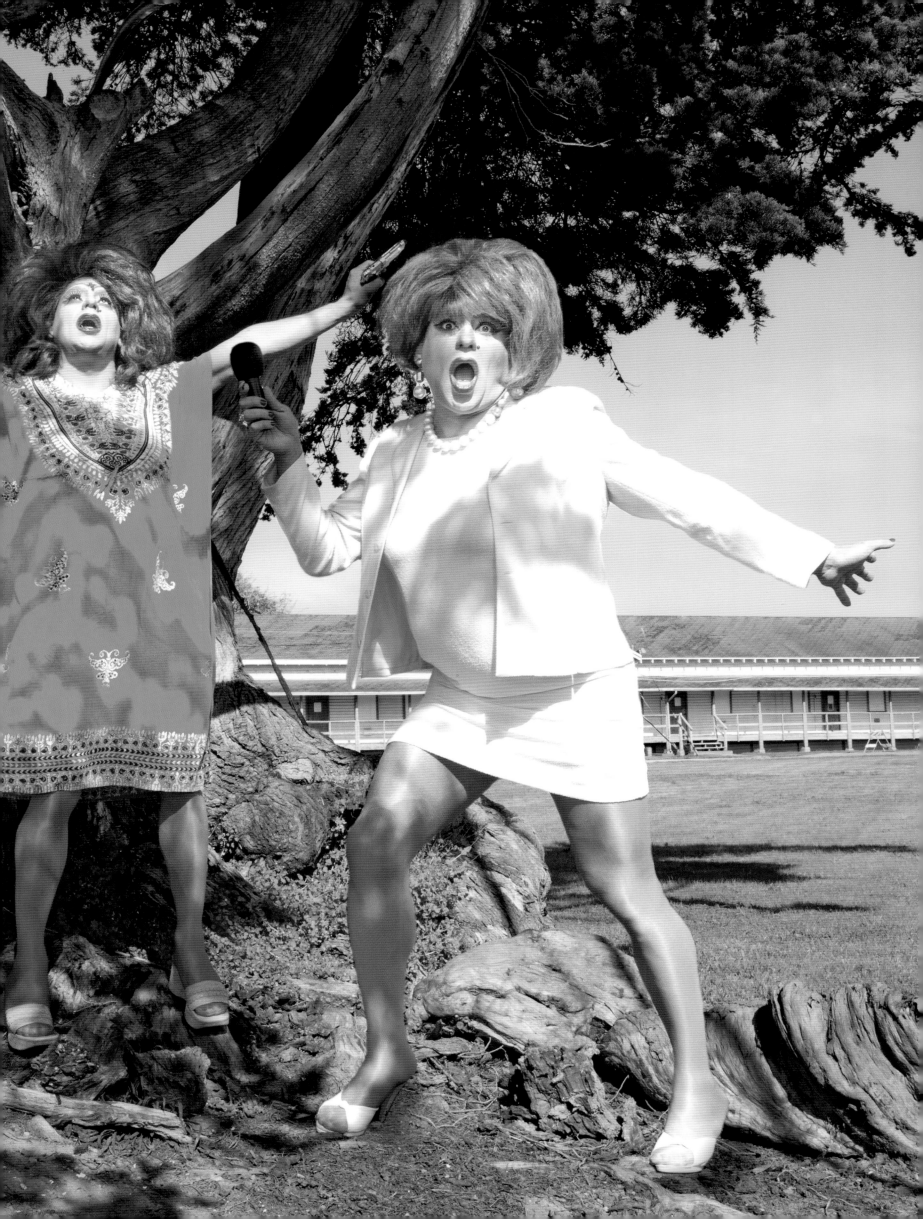

Pristine Condition inspired by
Grace Jones

Wer Songs aufnimmt, dessen Textzeile „I need a man" sich prima mitgrölen lässt, kann kein schlechter Mensch sein. Aber bei so schlichten Botschaften ist Grace nie verharrt. Wer immer dachte, dass sie in *Pull Up To The Bumper* eine Fahrt im Feierabendverkehr besingt, der erfreue sich an diesem kleinen Übersetzungsexkurs: „Schieb dich an meine Stoßstange ran, Baby, mit deiner langen schwarzen Limousine. Und mittenrein, dann noch zweimal zurückstoßen: Jetzt fühlt es sich gut an."

Kein Wunder, dass Grace die Schwulen als ihr bestes Publikum bezeichnet hat. Solche Texte machen an – ganz unabhängig, ob die Limousine schwarz ist oder weiß oder man vielleicht nur mit einem Kleinwagen unterwegs ist. Bei ihren Shows ist Grace mal als Kerl verkleidet ist, mal als Gorilla – was mitunter auf dasselbe herauskommen kann. Ihr Gesangsstil und die Art, wie sie sich auf der Bühne gibt, wirken oft unterkühlt. Aber Schwule kennen das ja von ihrer Mutter.

Pristine Condition
Pristine Condition has performed on the stage for the past three years and is the host of a weekly drag show in San Francisco.

In „tadellosem Zustand", gerne auch „unbefleckt" – das bedeutet ihr Name übersetzt. Pristine Condition steht seit drei Jahren auf der Bühne und ist die Gastgeberin einer wöchentlichen Drag Show in San Francisco.

Anyone who records a song with the perfect singalong line "I need a man" cannot be a bad person. But Grace never subscribed to such simple messages. If you think *Pull Up To The Bumper* is about a ride in rush hour traffic, listen to the lyrics a bit more closely: "Pull up to my bumper baby, in your long black limousine. Pull up to it, don't drive through it, back it up twice, now that fits nice."

No wonder, that Grace calls gays her favorite audience. The lyrics are sexy, regardless of whether the limousine is black or white, or even if you're driving a compact. At her shows Grace might dress as a man, or as a gorilla, which can sometimes come out the same in the end. Her singing style and her presence on stage often comes across as icy. But gays are used to that from their mothers.

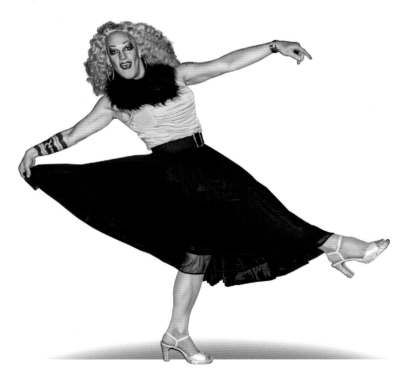

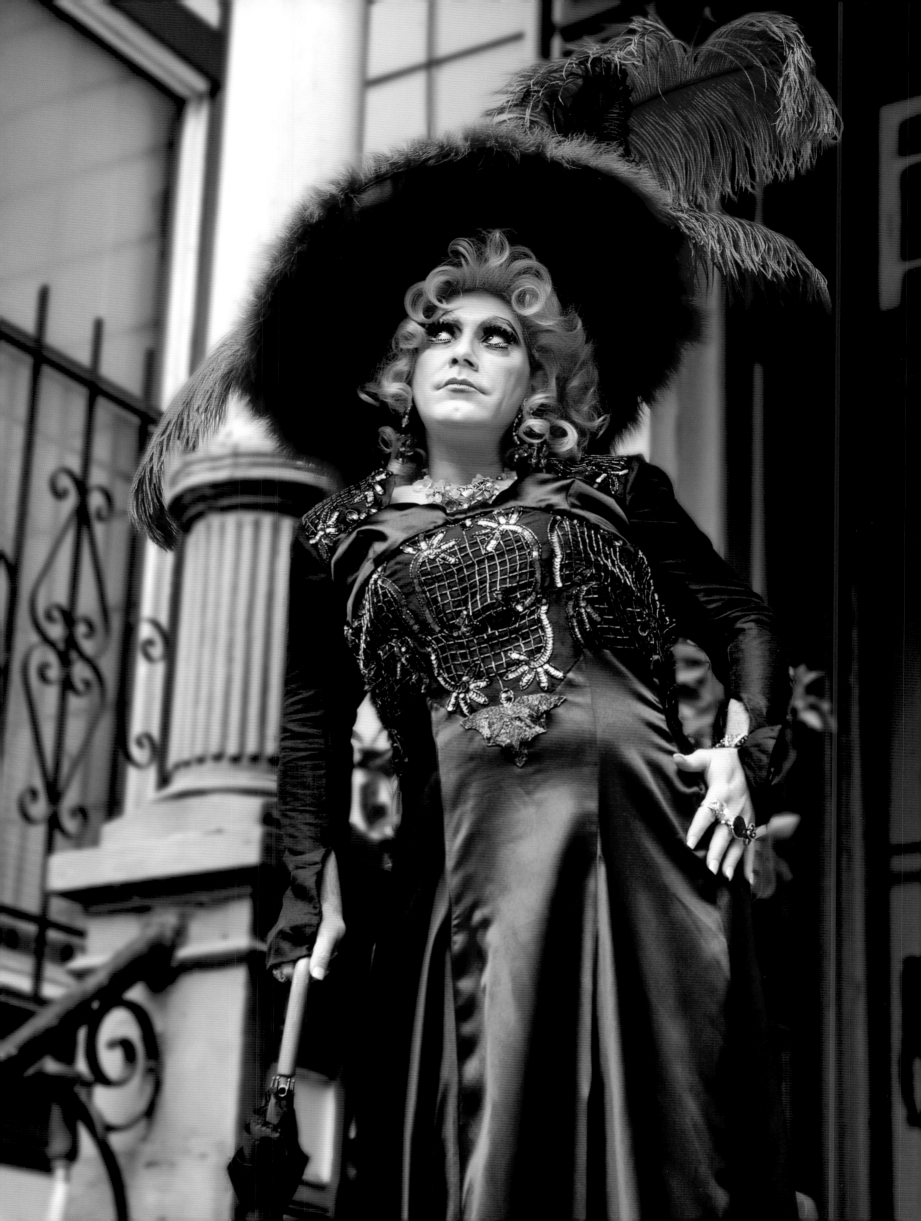

Tweaka Turner inspired by
Mae West

Tweaka Turner
Tweaka Turner, who calls Mae West her drag mother, lives in San Francisco. There, she works as a video artist and also produces music. With *Space Tranny*, she had a top ten hit on the U.S. indie charts in 2011.

Tweaka Turner, die Mae West als ihre Drag Mutter bezeichnet, lebt in San Francisco. Dort arbeitet sie als Video-künstlerin und produziert außerdem Musik. Mit *Space Tranny* hatte sie 2011 einen Top-Ten-Hit in den US-Indie-Charts.

Before this femme fatale became one of the highest paid film stars of the 30s, she passionately broke sexual taboos and proclaimed the freedom of love. Right off the bat, with her first major play *Sex* in 1926 she landed in the hot spot: She was sentenced to prison for "obscenity on the stage". In her second production, *Drag*, in which she strongly advocated for homosexual rights, she had 40 transsexuals dance on stage. The play was banned from Broadway.

She was 39 when she finally had her silver screen debut in Hollywood. And she was one of the first women to ever write the screenplays for her own films. For mainstream America, however, Mae was still seen as a threat to morality. She had a big mouth, and wasn't afraid to use it. Her collection of quotes is a priceless treasure trove for anyone looking for a new Gayromeo headline: "When I'm good I'm very good, but when I'm bad I'm better." Or: "Ten men waiting for me at the door? Send one of them home, I'm tired." And of course, her most famous quote: "Is that a gun in your pocket, or are you just happy to see me?"

Bevor die Femme Fatale in den 30er Jahren zu einem der bestbezahlten Filmstars wurde, brach sie leidenschaftlich gern sexuelle Tabus und proklamierte die Freiheit der Liebe. Gleich mit ihrem ersten großen Theaterstück *Sex* handelte sie sich 1926 Ärger ein: Wegen „Obszönität auf der Bühne" muss sie ins Gefängnis. In ihrer zweiten Produktion *Drag*, in der sie sich für die Rechte von Homosexuellen stark machte, ließ sie 40 Transen auf der Bühne tanzen. Das Stück wurde vom Broadway verbannt.

Erst mit 39 hatte sie ihr Leinwanddebüt in Hollywood. Als eine der ersten Frauen schrieb sie die Drehbücher ihrer Filme selber. Doch im prüden Amerika galt Mae weiter als eine Gefahr für die Moral. Schließlich hatte sie ein loses Mundwerk. Ihre lange Zitate-Sammlung ist eine unschätzbare Fundgrube für alle, die dringend eine neue Gayromeo-Headline suchen: „Wenn ich lieb bin, bin ich richtig gut. Bin ich böse, bin ich noch besser." Oder: „Vor der Tür stehen zehn Männer, die auf mich warten? Schick einen nach Hause, ich bin müde." Und natürlich ihr bekanntestes Zitat: „Ist das eine Pistole in deiner Hose oder freust du dich bloß, mich zu sehen?"

She was the original drag mother who ushered me out of the closet and into a corset.

— **Tweaka Turner**

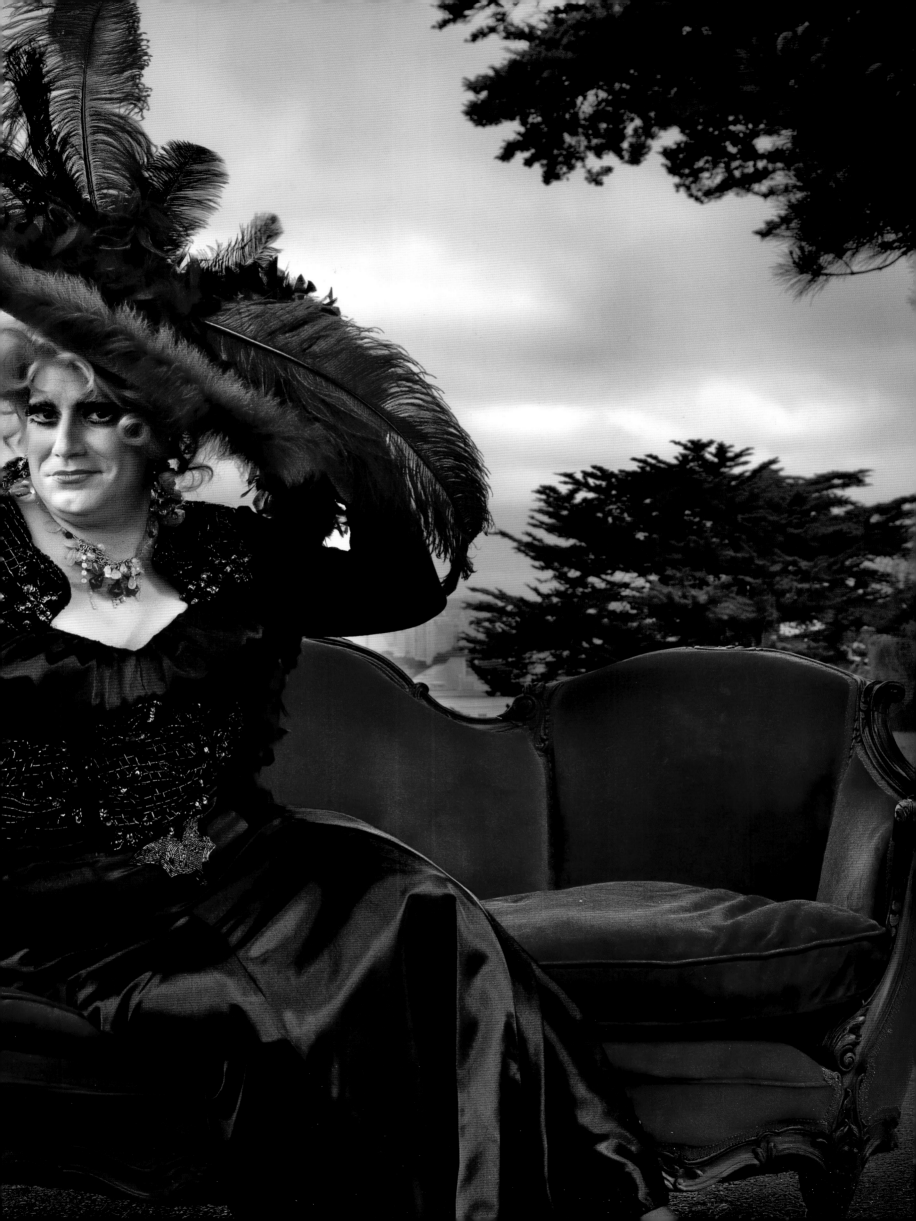

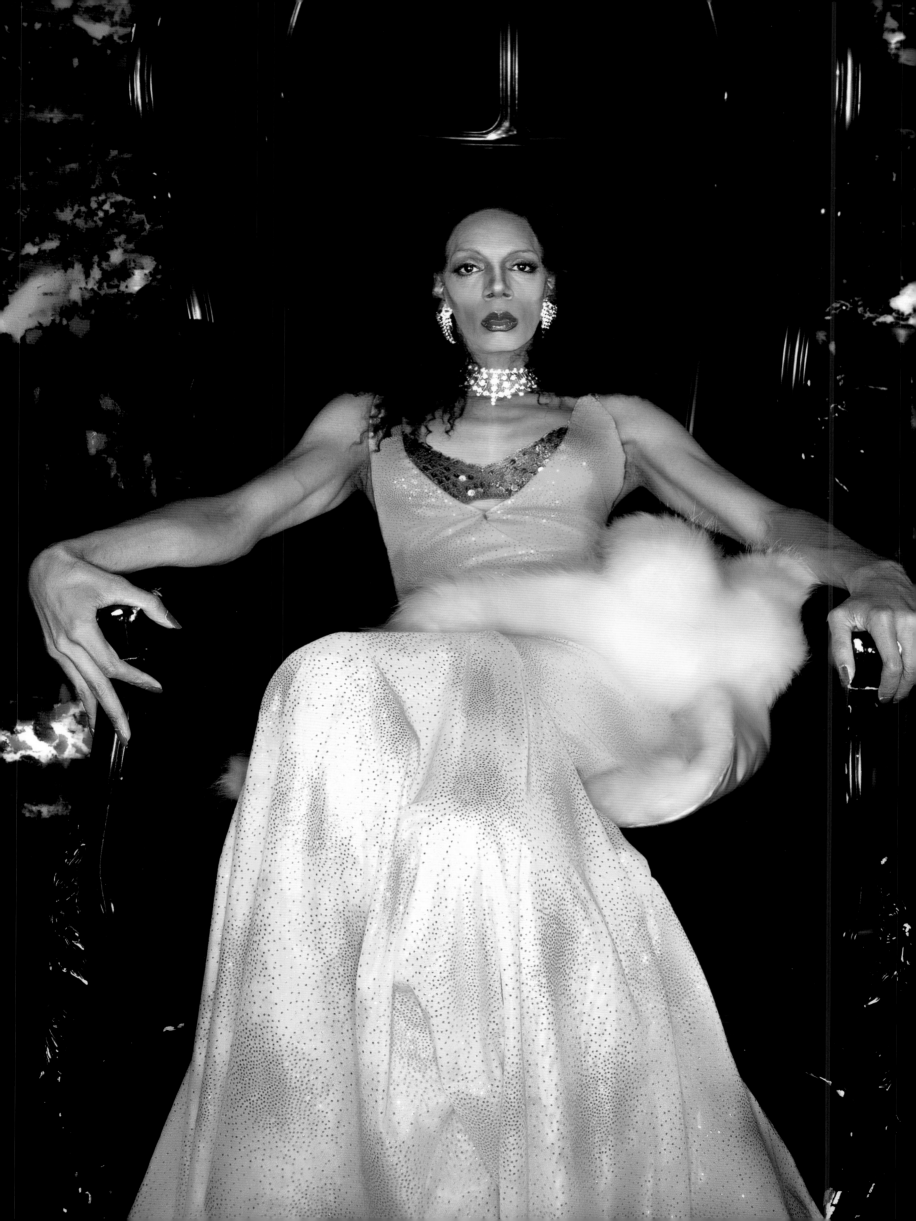

BeBe Sweetbriar inspired by

Diana Ross

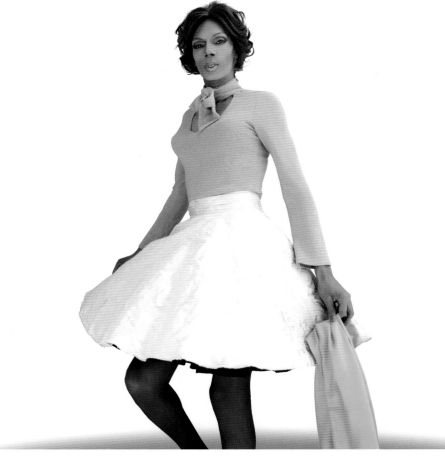

BeBe Sweetbriar
"Miss Gay San Francisco 2008" and "Miss Desperate Diva 2008" works as a writer, actress and singer. As one of the few drag queens to perform live, BeBe Sweetbriar has also appeared as the opening act for Kelly Rowland.

Die „Miss Gay San Francisco 2008" und „Miss Desperate Diva 2008" arbeitet als Autorin, Schauspielerin und Sängerin. Als eine der wenigen Drags performt BeBe Sweetbriar live und ist schon im Vorprogramm von Kelly Rowland aufgetreten.

We can thank her for the virtual soundtrack for the moments in which we realize that we love differently than the rest of society. The urge to dance and tell the world that we're gay, lesbian, transgender or who knows what. The song *I'm Coming Out* was written by Nile Rodgers after he went to the bathroom in a New York tranny bar and ran into three drag queens who all looked like Diana Ross.

According to the Guinness Book of World Records, the "Entertainer of the 20th Century" is the most successful female singer of all time. In the US she recorded 18 number one hits. Going all the way back to her time with the Supremes, Diana has had a reputation as something of a bitch. To stand out from the others, she started to put herself two steps in front of them on the stage. Of course, every diva can sympathize: Once you've managed to make it up onto the damn stage, why share the attention with the other girls?

Ihr verdanken wir den Soundtrack für diese Momente, in denen wir feststellen, dass wir anders lieben als der Rest der Gesellschaft. Das Gefühl, tanzen und der ganzen Welt mitteilen zu wollen, dass wir schwul sind, lesbisch, transgender oder werweißwas. Geschrieben wurde der Song *I'm coming out* von Nile Rodgers, nachdem er in einer New Yorker Transenbar aufs Klo ging und am Pinkelbecken drei Drag Queens entdeckte, die alle aussahen wie Diana Ross.

Sie, die „Entertainerin des 20. Jahrhunderts", wie sie genannt wurde, ist die laut Guinness Buch erfolgreichste Sängerin aller Zeiten. In den USA hatte sie immerhin 18 Nummer-Eins-Hits. Seit ihrer Zeit mit den Supremes hat Diana den Ruf als Zicke. Um sich von den anderen abzuheben, begann sie irgendwann damit, sich auf der Bühne zwei Schritte vor die anderen Sängerinnen zu stellen. Das versteht doch jede Diva von Herzen: Wenn man es schon mal auf die Bühne geschafft hat, warum sollte man dann noch die Aufmerksamkeit mit den anderen Hupfdohlen teilen?

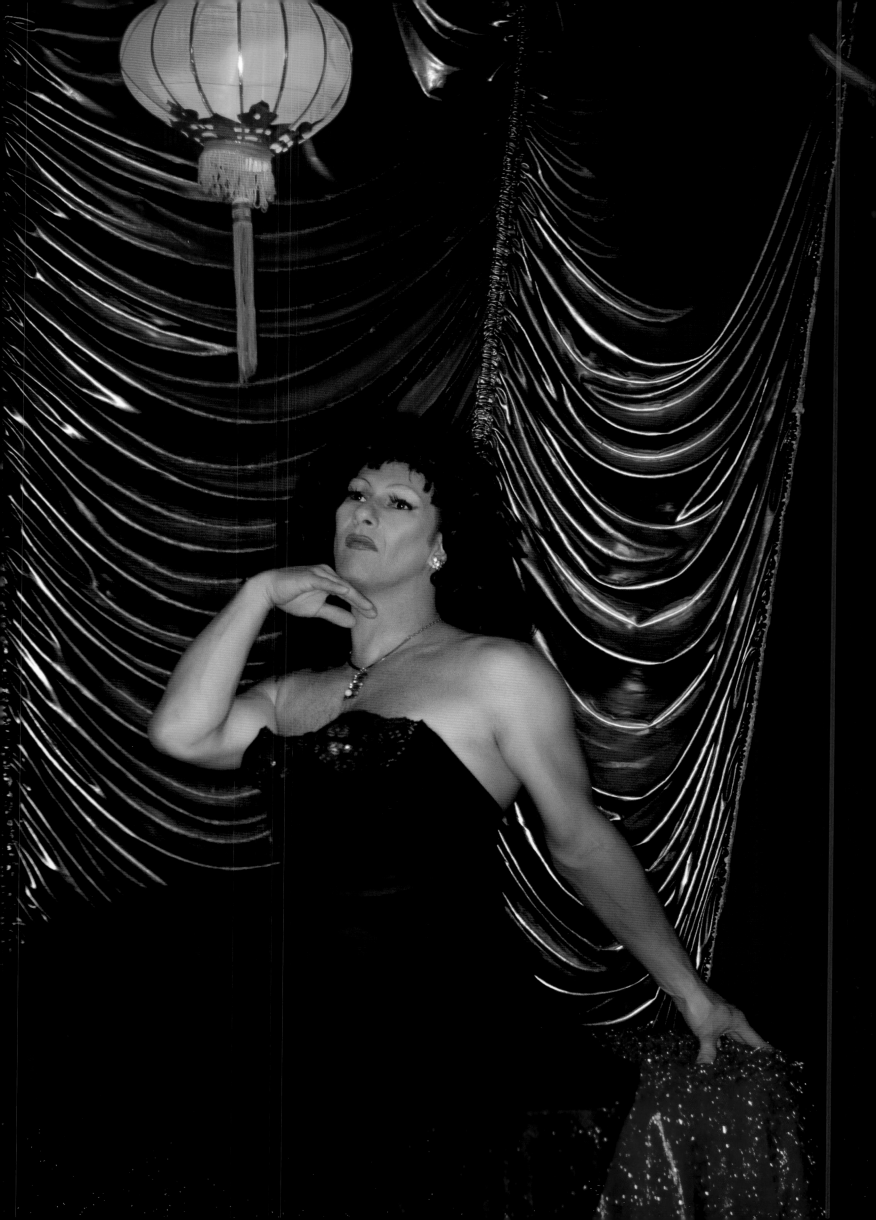

Olgadina Meyer inspired by
Sophia Loren

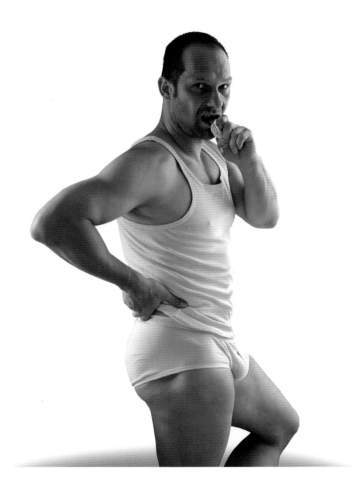

Olgadina Meyer
Olgadina Oslovska Petruschka Meyer is always in action, whether as a model, GoGo dancer, director or actor. At Adel Zabel's side, she played in the comedy *Ediths heiße Spalte* (Edith's Hot Crack).

Olgadina Oslovska Petruschka Meyer ist ausgesprochen umtriebig: ob als Model, Gogo-Tänzer, Regisseur oder Schauspieler. An der Seite von Adel Zabel wirkte sie in der Aufklärungscomedy *Ediths heiße Spalte* mit.

As a girl, people called Sophia "toothpick". As a grown woman, she was called the Italian Marilyn Monroe. She brought fear into the hearts of her male counterparts; at almost 5'9" she was taller than most of them once she put on high heels. She was married for 50 years, and to just one man. Her husband Carlo is said to have given her a rose every day (over 18,000 in all). Who among us doesn't yearn for that kind of romance as we cuddle into our Jake Gyllenhall bedding at night?

Sophia hated hair salons, so she always did her own hair and nails. At the start of the 80s, she was the first actress to bring out her own perfume. Recently she took it off for the Pirelli calendar, at over 70! Only one thing remains unforgiveable: She turned down a role in *Dynasty*. She definitely would have taken Alexis down in mud wrestling.

Das Mädchen Sophia war so dürr, dass man ihr „Zahnstocher" nachrief. Als erwachsene Frau wurde sie die italienische Marilyn Monroe genannt. Vielen männlichen Schauspiel-Kollegen hat sie das Fürchten gelernt, denn mit ihren 1,74 Meter hat sie alle übertrumpft, sobald sie High Heels trug. 50 Jahre lang war sie verheiratet – und das auch noch mit demselben Mann. Gatte Carlo soll ihr jeden Tag eine Rose geschenkt haben (macht 18.250 Stück). Sehnen wir uns nicht alle nach so viel Romantik, wenn wir uns nachts in unsere Jake-Gyllenhall-Bettwäsche kuscheln?

Weil Sophia Friseursalons hasst, macht sie ihre Haare und Nägel immer selber. Anfang der 80er Jahr brachte sie als erste Schauspielerin ihr eigenes Parfum auf den Markt. Vor kurzem hat sie sich noch für den Pirelli-Kalender ausgezogen – mit über 70! Nur eines kann man ihr schwer verzeihen: Dass sie es abgelehnt hat, im *Denver-Clan* mitzuspielen. Beim Schlammcatchen mit Alexis hätte sie bestimmt gewonnen.

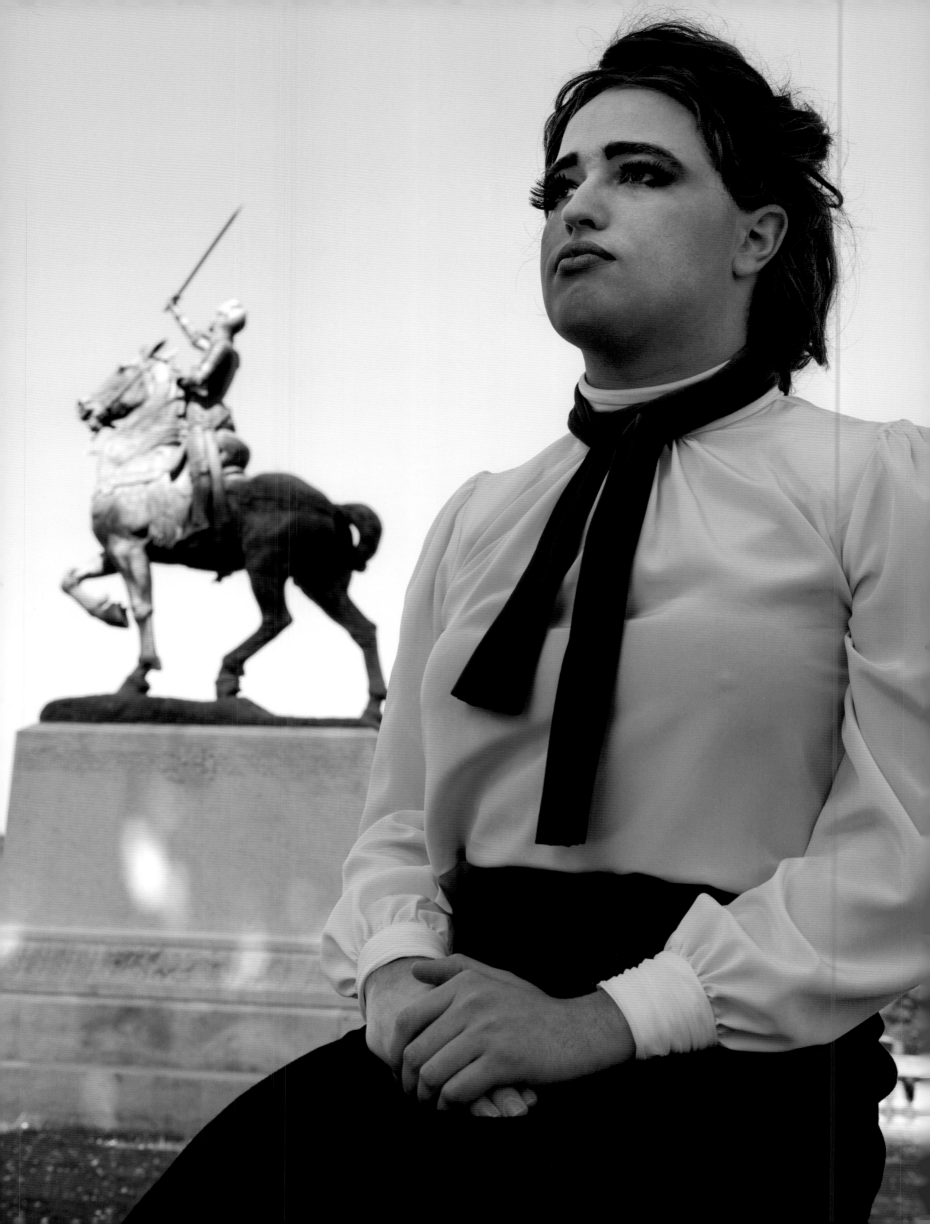

Lil Miss Hot Mess inspired by
Emma Goldman

To publicly promote the use of condoms in New York in 1916 was pretty brave. This was prohibited at the time and Emma was arrested. Today her position has long since become the societal consensus: unwanted pregnancies lead to unhappy children and reinforce the economic dependency of women. Emma never gave up. She fought tirelessly, whether she was organizing anti-war meetings or questioning democratic forms of government: "If voting changed anything, they'd make it illegal."

Future FBI Director J. Edgar Hoover called her "the most dangerous anarchist" in America. She saw force as being necessary in bringing about political and social change. This even included the killing of those responsible. Emma also promoted an idea that was uncommon at the beginning of the 20th century, even among anarchists: the liberation of homosexual men and women. She described the fact that the world had so little understanding for different forms of love as a "tragedy".

Lil Miss Hot Mess
Lil Miss Hot Mess captivates her audience with a mixture of drag show, dance, and her radical views. She is also politically active and outspoken, just like her idol Emma Goldman.

Lil Miss Hot Mess verzaubert ihr Publikum mit einer Mischung aus Drag Show, Tanz und ihren radikalen Ansichten. Außerdem engagiert und äußert sie sich politisch, ganz wie ihr Vorbild Emma Goldman.

1916 in New York öffentlich für den Gebrauch von Kondomen zu werben, war ziemlich mutig. Denn solche Vorträge waren verboten, Emma wurde festgenommen. Heute ist ihre Position längst Konsens: Ungewollte Schwangerschaften schaffen unglückliche Kinder und verstärken die wirtschaftliche Abhängigkeit der Frau. Emma gab nicht auf. Egal, ob sie Versammlungen gegen den Krieg organisierte oder die demokratische Staatsform in Frage stellte: „Wenn Wahlen etwas ändern würden, so wären sie verboten!"

Der spätere FBI-Chef Hoover nannte sie die „gefährlichste Anarchistin" in den USA. Denn sie betrachtete Gewalt als notwendig, um politischen und sozialen Wandel herbeizuführen. Dazu gehörte auch das Töten verantwortlicher Persönlichkeiten. Was Anfang des 20. Jahrhunderts nicht mal unter Anarchisten üblich war: Emma sprach sich für die Befreiung homosexueller Männer und Frauen aus. Dass die Welt so wenig Verständnis hätte für die verschiedenen Spielarten der Liebe, nannte sie eine „Tragödie".

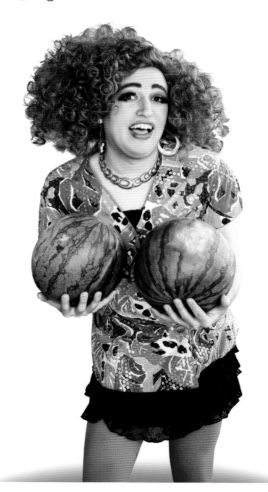

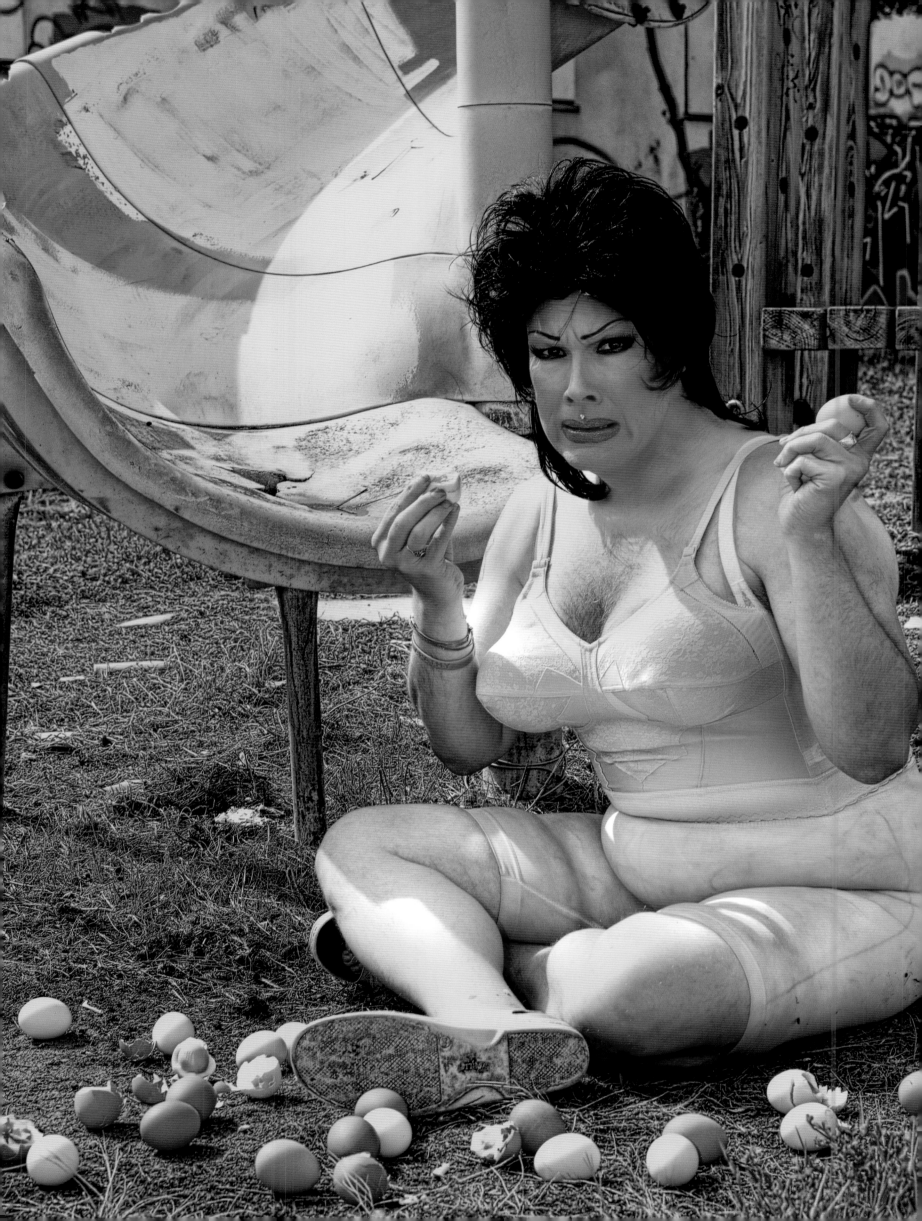

Phatima inspired by
Edith Massey

Before the start of her film career, she worked in a hotel in Baltimore, where she was discovered by *Hairspray* director John Waters. He cast her – a woman who certainly did not represent the mainstream image of a movie star – in five of his culturally controversial films. In the first of these, *Multiple Maniacs* (1970), she played a double role: Herself and the Virgin Mary. In *Female Trouble*, where she wore a black dominatrix outfit, she tries to convince a hairdresser to become gay. He prefers to marry a young criminal, played by Divine.

The plump little woman with crooked teeth was a master of self-irony, turning her "unfortunate" looks into a great asset. Like the time Edith posed for greeting cards. Later she toured as a singer for the punk band Edie and the Eggs. Their song *Big Girls Don't Cry* made it onto the compilation *The World's Worst Records (Vol. 1)*. After her death, her ashes were buried in the Westwood Village Memorial Park Cemetery in Los Angeles, a neighbor of Marilyn Monroe and Dean Martin: Just like a real film star.

Phatima
Since the late 1980s, Phatima has performed on stage in San Francisco as a drag queen and she has certainly earned the title "Grandmother of the Underground". A number of her multiple personalities have become the stuff of legend.

Seit den späten 80ern steht Phatima in San Francisco als Drag auf der Bühne und hat sich den Titel „Grandmother of the Underground" redlich verdient. Einige ihrer multiplen Persönlichkeiten haben heute Legendenstatus.

Vor ihrer Filmkarriere arbeitete sie in einem Hotel in Baltimore, wo sie von *Hairspray*-Regisseur John Waters entdeckt wurde. Der besetzte die Frau, die so gar keinem Filmstar-Ideal entsprach, auch gleich in fünf seiner geschmacklich sehr umstrittenen Filme. Im ersten, *Multiple Maniacs* (1970), spielt sie direkt eine Doppelrolle: sich selbst und die Jungfrau Maria. In *Female Trouble*, wo sie ein enges schwarzes Domina-Outfit trägt, versucht sie, einen Friseur zu überreden, schwul zu werden. Der heiratet aber lieber eine jugendliche Straftäterin – dargestellt von Divine.

Der kleinen dicken Frau mit den schiefen Zähnen ist es mit bewundernswerter Selbstironie gelungen, Vorteil aus ihrem nicht so vorteilhaften Äußerem geschlagen. Etwa indem sich Edith für Grußkarten ablichten ließ. Später tourte sie als Sängerin der Punkband Edie and the Eggs. Deren Song *Big Girls Don't Cry* hat es auf den Sampler *The World's Worst Records (Vol. 1)* geschafft. Nach dem Tod wurde ihre Asche im Westwood Village Memorial Park Cemetery in Los Angeles bestattet – in der Nähe von Marilyn Monroe und Dean Martin: ganz wie ein echter Filmstar.

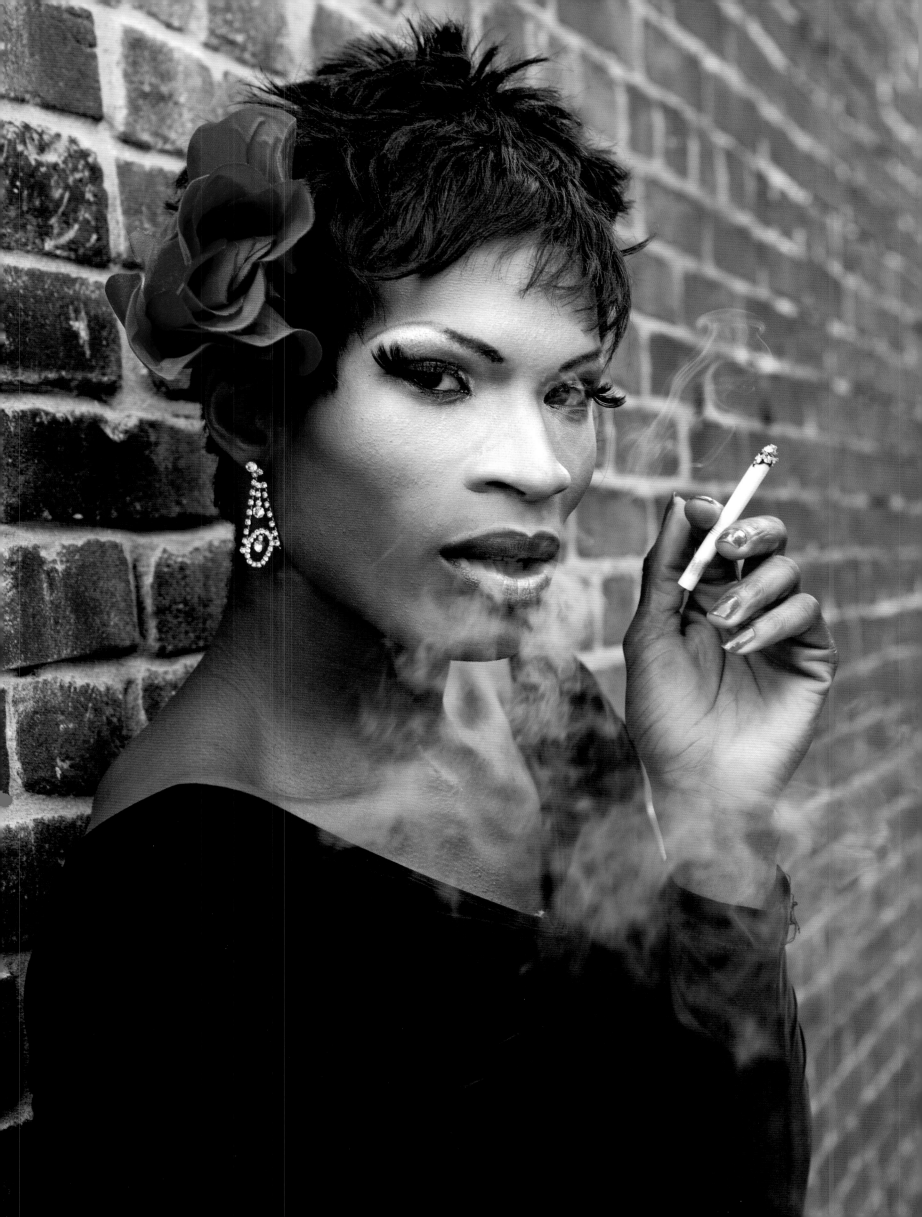

Miss Rahni inspired by
Dorothy Dandridge

At the start of her career she only got the stereotyped roles available to African-American women: a queen or princess of the jungle. If she was lucky, she got to play a murderer. By the end of the 40s, she stopped acting altogether and instead performed as a nightclub singer. Things started to look up in the 50s. For the role of Carmen Jones alongside Harry Belafonte she was the first black woman in history to be nominated for an Oscar in the category of Best Actress. After that, she was the first African-American woman allowed to appear on the cover of *LIFE* magazine. If you ask artists like Halle Berry or Janet Jackson who their role model was, they'll tell you: Dorothy Dandridge.

At the age of 43 she died from an overdose of antidepressants. She was lonely in her last years. Her second husband had taken her for all she was worth, and she died with a mere $ 2.41 in her bank account.

Miss Rahni
Born in South Carolina, where she started early with music and dance, Miss Rahni left for San Francisco in 2009. There she has been awarded important drag titles, such as "Miss Tranny-shack" and "Miss Gay Northern California".

Geboren in South Carolina, wo sie sich früh mit Musik und Tanz beschäftigte, ging Miss Rahni 2009 nach San Francisco. Dort hat sie seitdem wichtige Drag-Titel wie „Miss Tranny-shack" und „Miss Gay Northern California" abgeräumt.

Zu Beginn ihrer Filmkarriere bekam sie meist die Klischee-Rollen, die für afroamerikanische Frauen in den USA vorgesehen waren: Prinzessinnen oder Königinnen aus dem Dschungel. Wenn sie Glück hatte, durfte sie eine Mörderin spielen. Ende der 40er Jahre drehte sie gar nicht mehr, trat dafür ab und zu in Nachtclubs als Sängerin auf. In den 50ern ging es dann bergauf. Für die Rolle der Carmen Jones an der Seite von Harry Belafonte wurde sie als erste Schwarze in der Oscar-Geschichte in der Kategorie Beste Hauptdarstellerin nominiert. Danach war sie die erste Afro-Amerikanerin, die das Magazin *LIFE* auf ihrem Cover duldete. Fragt man Künstlerinnen wie Halle Berry oder Janet Jackson nach ihrem Vorbild, lautet die Antwort: Dorothy Dandrigde.

Mit 43 starb sie an einer Überdosis Antidepressiva. Sie war einsam. Ihr zweiter Mann hatte sie ausgenommen wie eine Weihnachtsgans. Bei ihrem Tod hatte Dorothy ein Guthaben von 2,14 Dollar auf dem Konto.

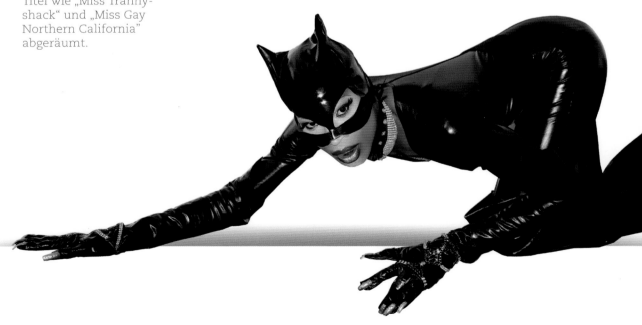

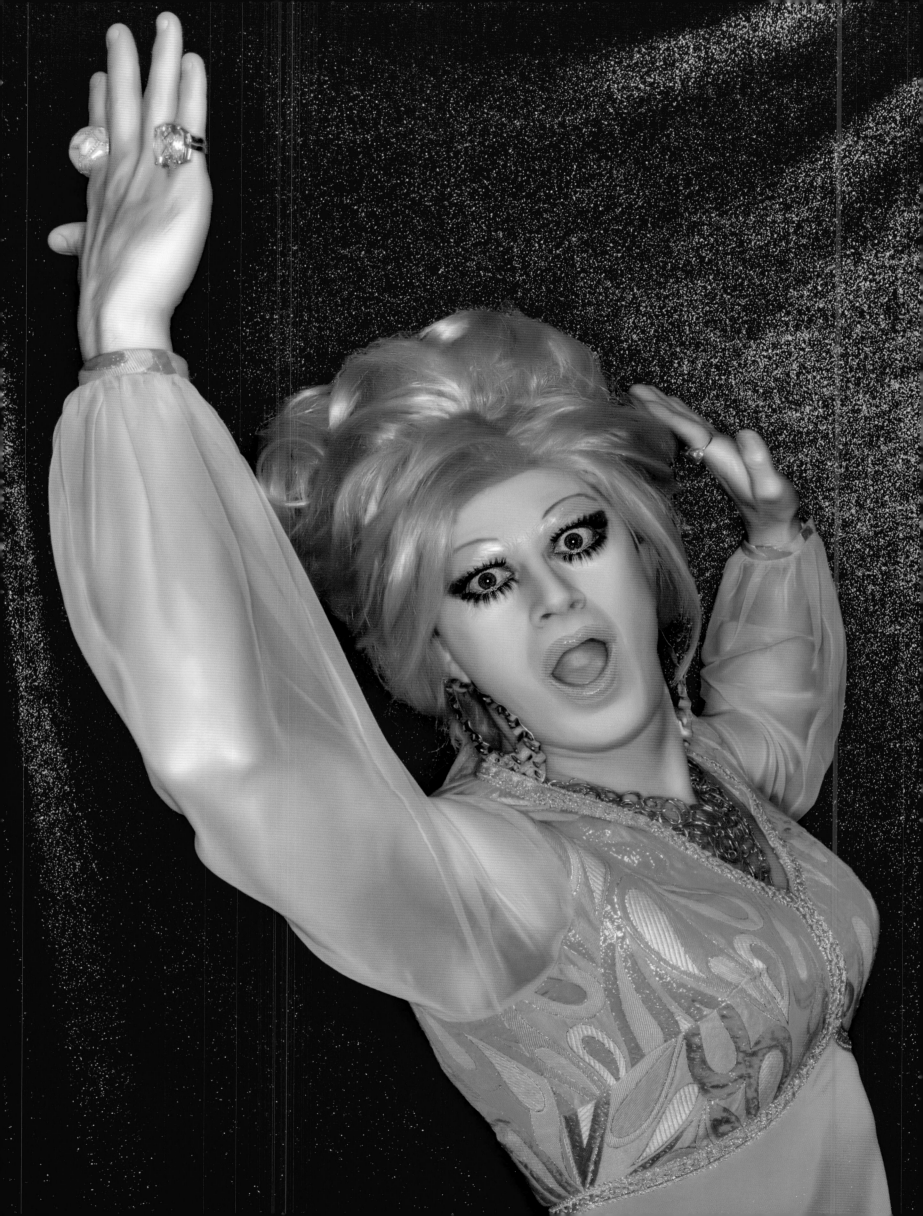

Frieda Laye inspired by

Dusty Springfield

One of the more harmless gay-male erotic fantasies is to seduce the son of a pastor. And for anyone who didn't figure this out before 1968, Dusty Springfield helped them out a bit with her song *Son of a Preacher Man*. The "Queen of Soul" secured a place in the hearts of her gay fans in 1972 when she declared that she was equally into men and women. Unfortunately, her relationship with a folk singer in the 60s failed. It's no wonder that the Pet Shop Boys were eager to work with her. In 1990 they released the album *Reputation* together. The woman with the towering beehive hairdo, last seen on Amy Winehouse, referred to herself as a drag queen. She certainly was a diva. She couldn't keep her hands off of drugs; wasted on stage once, she went off on the drummer.

Frieda Laye

Frieda Laye has been on the stage for over 20 years. She keeps in shape by riding her bicycle to every performance, naturally in a dress, make-up and high heels.

Seit mittlerweile 20 Jahren steht Frieda Laye auf der Bühne. Sie hält sich fit, indem sie zu jedem Auftritt mit dem Fahrrad kommt – mit Fummel, Make-up und High Heels.

Es gehört zu den harmloseren erotischen Phantasien eines schwulen Mannes, den Sohn des Pfarrers zu verführen. Und wer sich dessen vor 1968 nicht bewusst war, dem hat Dusty Springfield mit ihrem Song *Son of a preacher man* ein bisschen auf die Sprünge geholfen. Endgültig einen Stein im Brett hatte die weiße „Queen des Soul" bei ihren schwulen Fans, als sie 1972 erklärte, dass sie auf Männer und Frauen gleichermaßen stehe. Ihre Beziehung mit einer Folksängerin war in den 60ern leider gescheitert. Klar, dass die Pet Shop Boys darauf brannten, mit ihr zu arbeiten. 1990 kam ihr gemeinsames Album *Reputation* heraus. Die Frau mit der turmhohen Beehive-Frisur, wie man sie zuletzt bei Amy Winehouse sah, hat sich selber als Drag Queen bezeichnet. Eine Diva war sie sowieso. Von Drogen konnte sie die Finger nicht lassen und sie hat sogar mal hackenstramm auf der Bühne einen Schlagzeuger vermöbelt

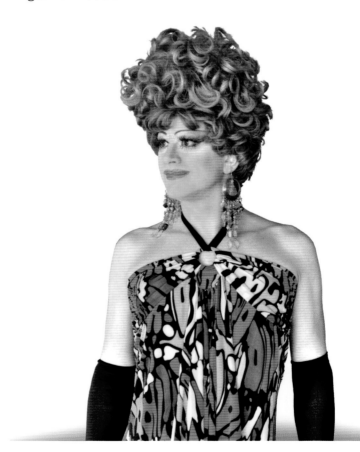

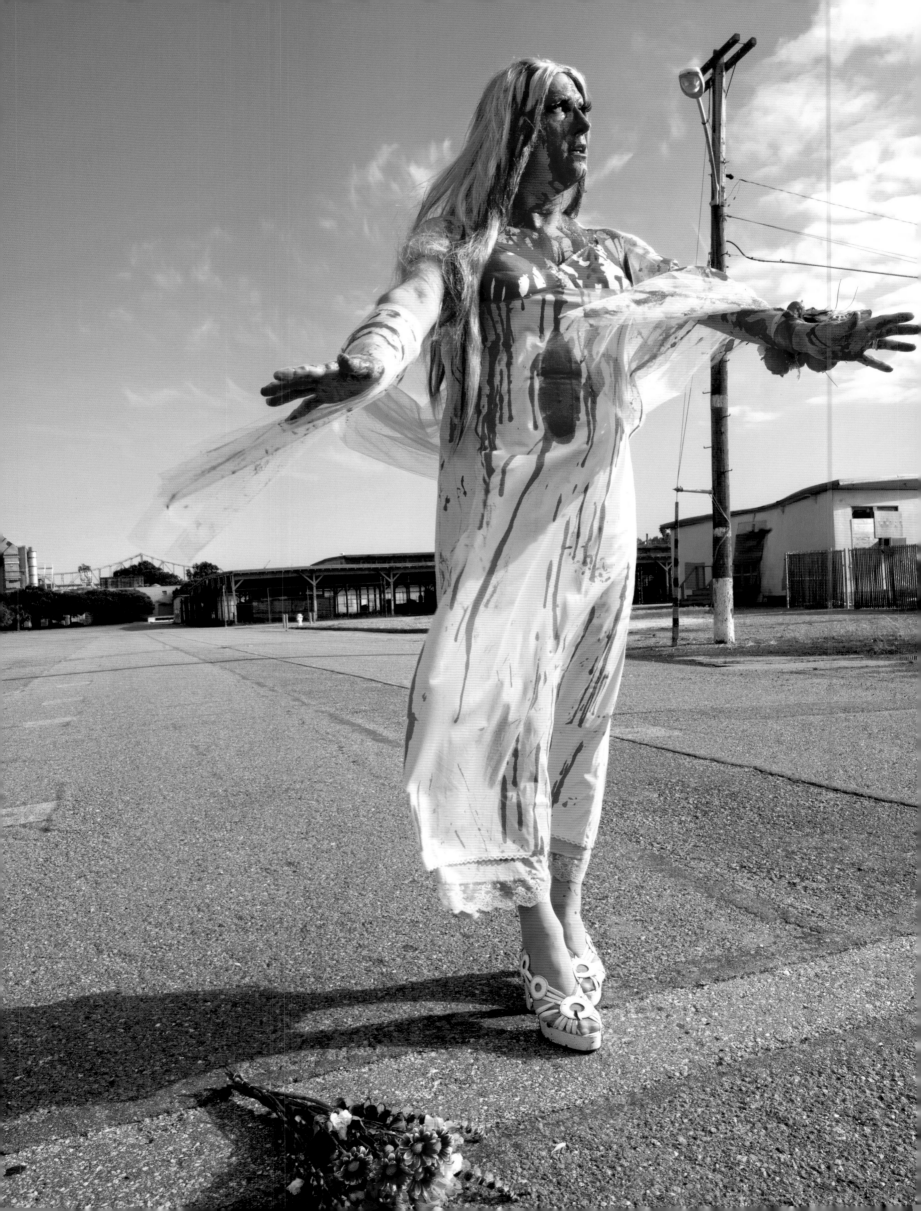

Cookie Dough inspired by
Sissy Spacek
in **Carrie**

Even though she is one of Hollywood's most accomplished actresses, astoundingly little is known about her personal life. Aside from the fact that she demonstrated against the Vietnam War with the daughter of former President Reagan. One of her most famous movies was *Carrie*. In 1976 Sissy, who seemed so heartbreakingly fragile, played the title figure: a young girl who was an outcast and was bullied by her classmates. At the prom, the most important night of her life, Carrie kisses a boy for the first time. And what a boy, the heartthrob of all the other girls. The jealous girls extract their revenge and pour pig's blood on her. Up till now, a story that could just as well happen to victims of homophobic bullying. Like Cookie Dough says, she could feel Carrie's pain in the film, brought about by her nasty classmates and overbearing mother. In the film Carrie defends herself, and naturally for a Stephen King story, everyone dies horribly. Even though the Oscar jury usually has no love for horror movies, Sissy was nominated for best actress. However, Sissy herself was not happy with her performance, which is why she never wanted to make a sequel.

Cookie Dough
Cookie Dough has appeared as a drag queen in her hometown of San Francisco since 1999. Her *Monster Show* ran longer than any other in the Castro. Recently she was elected Grand Duchess of San Francisco.

Cookie Dough tritt seit 1999 in ihrer Geburtsstadt San Francisco als Drag Queen auf. Ihre *Monster Show* lief so lange wie keine sonst im Castro. Vor kurzem wurde sie dort zur Grand Duchess gewählt.

Obwohl sie zu Hollywoods besten Schauspielerinnen gehört, weiß man über ihr Privatleben nicht sonderlich viel. Mal abgesehen davon, dass sie zusammen mit der Tochter des früheren US-Präsidenten Reagan gegen den Vietnamkrieg demonstriert hat. Zu ihren bekanntesten Filmen gehört *Carrie – Des Satans jüngste Tochter*. 1976 spielt Sissy, die so herzerweichend zerbrechlich wirkt, die Titelfigur: ein junges Mädchen, das von seinen Mitschülerinnen gemobbt wird. Beim Abschlussball, der eigentlich Carries großer Abend werden soll, küsst sie das erste Mal einen Jungen – noch dazu den Schwarm aller Mädchen. Doch die rächen sich an ihr und übergießen sie mit Schweineblut. Soweit eine Geschichte, wie sie auch Opfern homophoben Mobbings passieren könnten. Wie Cookie Dough sagt, konnte sie im Kino Carries Schmerz nachfühlen – ausgelöst durch die fiesen Mitschülerinnen und die herrische Mutter. Im Film wehrt sich Carrie – und da die Geschichte aus der Feder von Stephen King stammt, müssen alle grauenvoll sterben. Obwohl die Oscar-Jury für Horrorfilme sonst nicht viel übrig hat, wurde Sissy als beste Hauptdarstellerin nominiert. Sie selbst fand sich furchtbar, weshalb sie nie eine Fortsetzung drehen wollte.

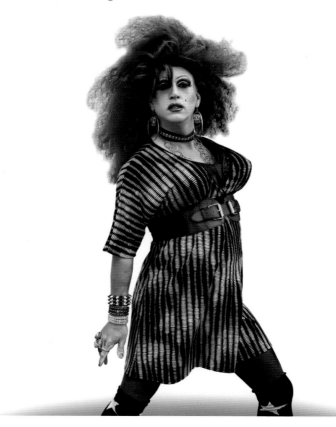

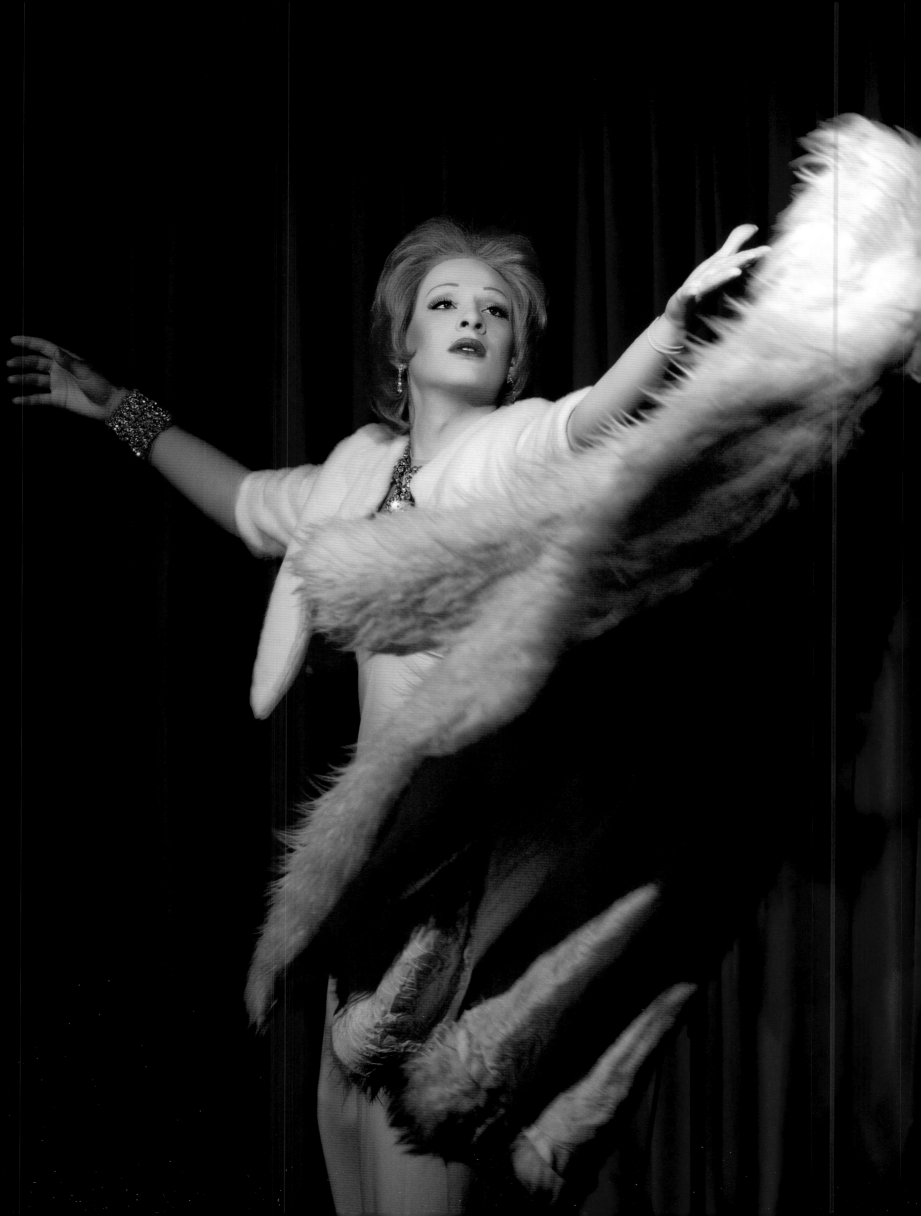

Thary Plast Ic inspired by
Marlene Dietrich

Right off the bat, in her Hollywood debut *Morocco* in 1930, she made history. She was the first German woman to be nominated for an Oscar. And she wore a pants suit, first causing a scandal then starting a new fashion trend. She had no time for petty gender limitations. "I am at my heart a gentleman," she liked to say in her deep, sensual voice. Or: "Sex is much better with a woman, but then one can't live with a woman!"

Dietrich, known even back in her schooldays for her bedroom eyes, liked to boast of sleeping with three Kennedy men, including JFK. Her onscreen kisses were so intense, her lipstick had to be redone afterward. The Nazis made enticing film offers to bring her back from America. Marlene refused them all and was hated in Germany for a long time as a traitor. Of course, they should have kissed her feet instead – the part of her body she liked the least.

Thary Plast Ic
From makeup artist to model to Marlene, whom he performed as at the infamous Berghain, there's practically nothing that Thary Plast Ic has not tried. He is also the face of the successful Berlin party Horse Meat Disco.

Von Make-up-Artist über Model bis Marlene, als die er im berüchtigten Berghain auftrat: Es gibt fast nichts, was Thary Plast Ic noch nicht probiert hätte. Nebenbei ist er das Gesicht der Berliner Erfolgsparty Horse Meat Disco.

Marokko war ihr Debüt in Hollywood, 1930, und gleich schrieb sie Geschichte. Als erste Deutsche wurde sie für den Oscar nominiert. Und: Sie trug einen Hosenanzug, was erst einen Eklat auslöste und danach einen neuen Modetrend. Kleinkarierte Geschlechtergrenzen waren ihre Sache nicht. „Tief in meinem Herzen bin ich ein Gentleman", sagte sie gerne mit ihrer tiefen sinnlichen Stimme. Und: „Sex macht mit Frauen viel mehr Spaß. Dummerweise hält man es mit ihnen nicht lange aus."

Dietrich, die schon in der Schule für ihren Schlafzimmerblick bekannt war, gab später damit an, mit drei Männern aus dem Kennedy-Clan geschlafen zu haben – darunter JFK. Bei Filmküssen legte sie sich so ins Zeug, dass hinterher der Lippenstift nachgezogen werden musste. Die Nazis machten ihr verlockende Filmangebote, um sie aus Amerika zurückzuholen. Marlene schlug alle aus und wurde in Deutschland noch lange als Landesverräterin gehasst. Dabei hätte man ihr die Füße küssen müssen – den Teil ihres Körpers, den sie selbst am wenigsten mochte.

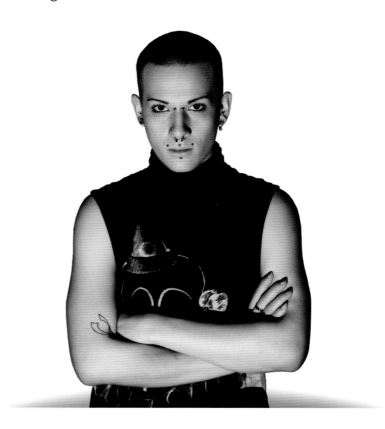

*Darling, the legs
aren't so beautiful,
I just know what
to do with them.*

— **Marlene Dietrich**

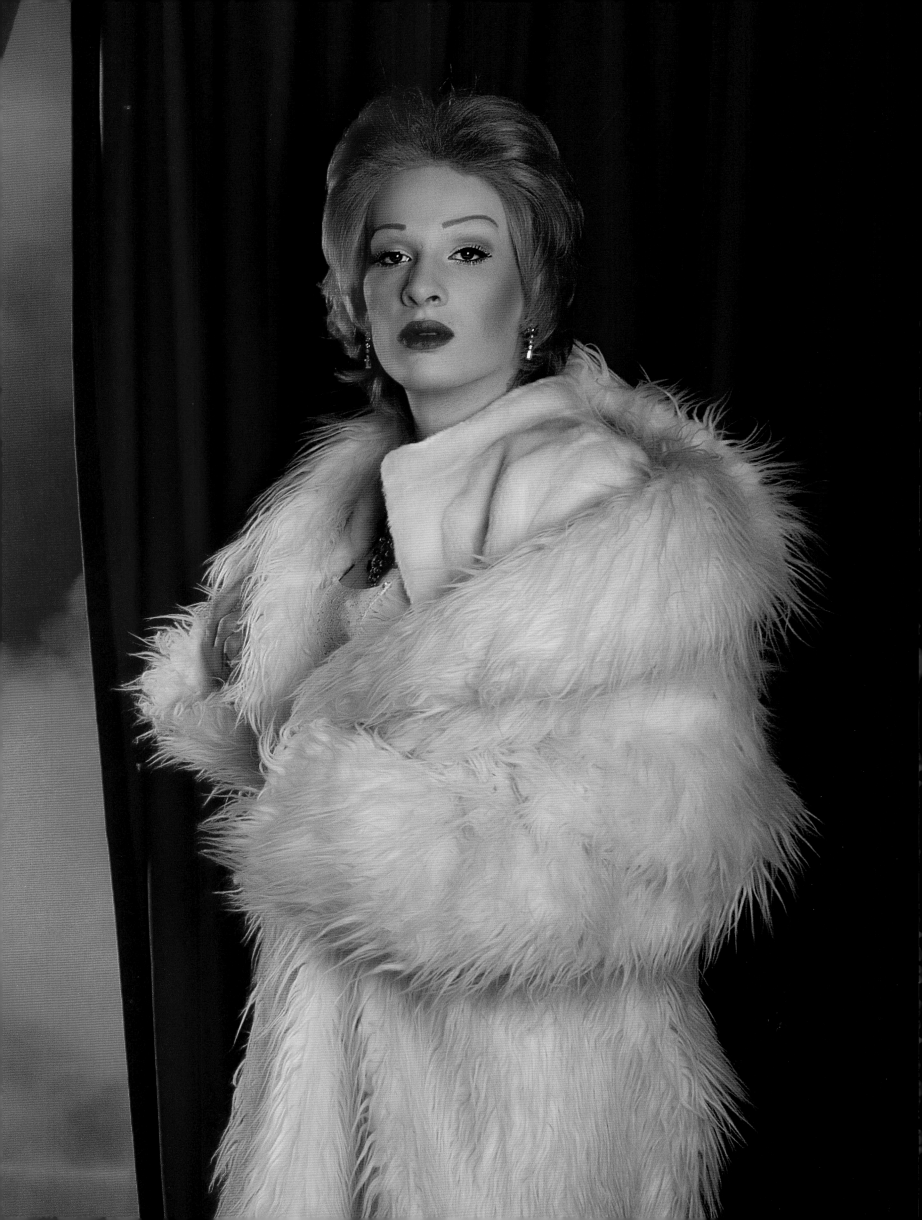

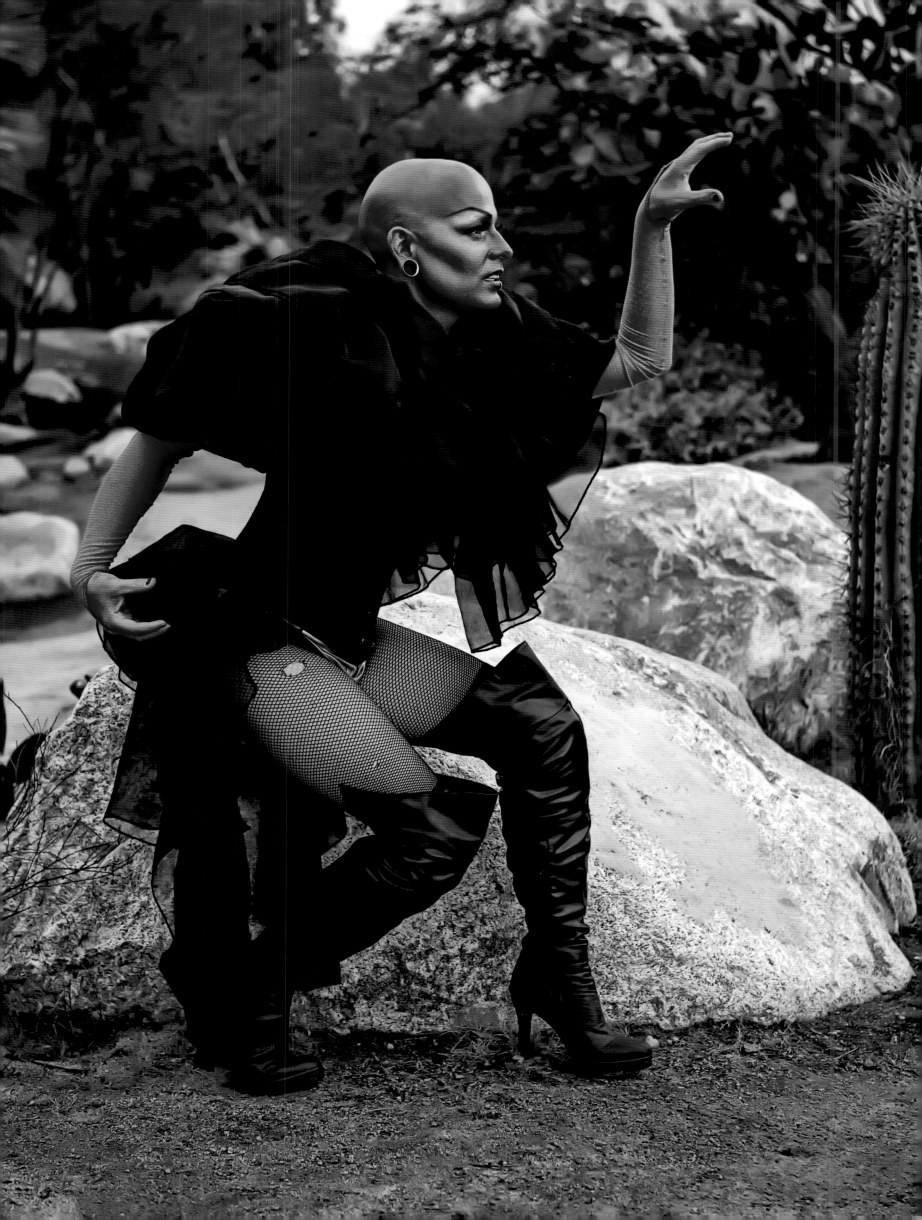

Disco Dollie inspired by
Grace Jones

At the end of the 70s, the eccentric Studio 54 opened in New York, where excessive drug use and uninhibited sex were just another part of the scene. Grace liked to come bare naked. This daughter of a clergyman presented an image of a woman that was wicked and self-confident at the same time. Her role as the Amazon May Day in the 007 film *A View to A Kill*, where she first fights against James Bond and then with him, is legendary. In a bedroom scene with Roger Moore, she played the Top and showed him, who's the boss in bed. During filming she reportedly strapped on a rubber dildo as revenge for his complaints about her loud music in her hotel room. Even Schwarzenegger, with whom she made *Conan the Destroyer*, learned what a real man Grace Jones could be. In an interview later Arnold complained that Grace had been a bit too rough with him.

Ende der 70er Jahre öffnete in New York das exzentrische Studio 54, wo Drogenexzesse und hemmungsloser Sex an der Tagesordnung waren. Grace kam gerne direkt splitternackt. Überhaupt prägte die Tochter eines Pfarrers ein Frauenbild, das verrucht und selbstbewusst zugleich war. Legendär ihr Auftritt im *007-Film Im Angesicht des Todes*, wo sie als Amazone May Day erst gegen James Bond kämpft, später mit ihm. In einer Bettszene mit Roger Moore geriert sie sich als Top und zeigt ihm, wer der Chef im Bett ist. Bei den Dreharbeiten soll sie sich aus Rache einen Gummischwanz umgeschnallt haben, weil Moore sich zuvor über die laute Musik in ihrem Hotelzimmer beschwert hatte. Auch Schwarzenegger, mit dem sie *Conan der Zerstörer* gedreht hat, bekam zu spüren, dass in Grace Jones ein richtiger Kerl steckt. In einem Interview hat sich Arnie später beschwert, Grace habe ihn ziemlich hart rangenommen.

Disco Dollie

Raised in Seattle, Disco Dollie now lives in San Diego and works as a freelance make-up artist for fashion shows and other events. Her first time in drag was 1997.

Aufgewachsen in Seattle, lebt Disco Dollie in San Diego und arbeitet als freiberuflicher Make-up-Artist, u.a. für Fashion Shows. In den Fummel geschlüpft ist sie zum ersten Mal 1997.

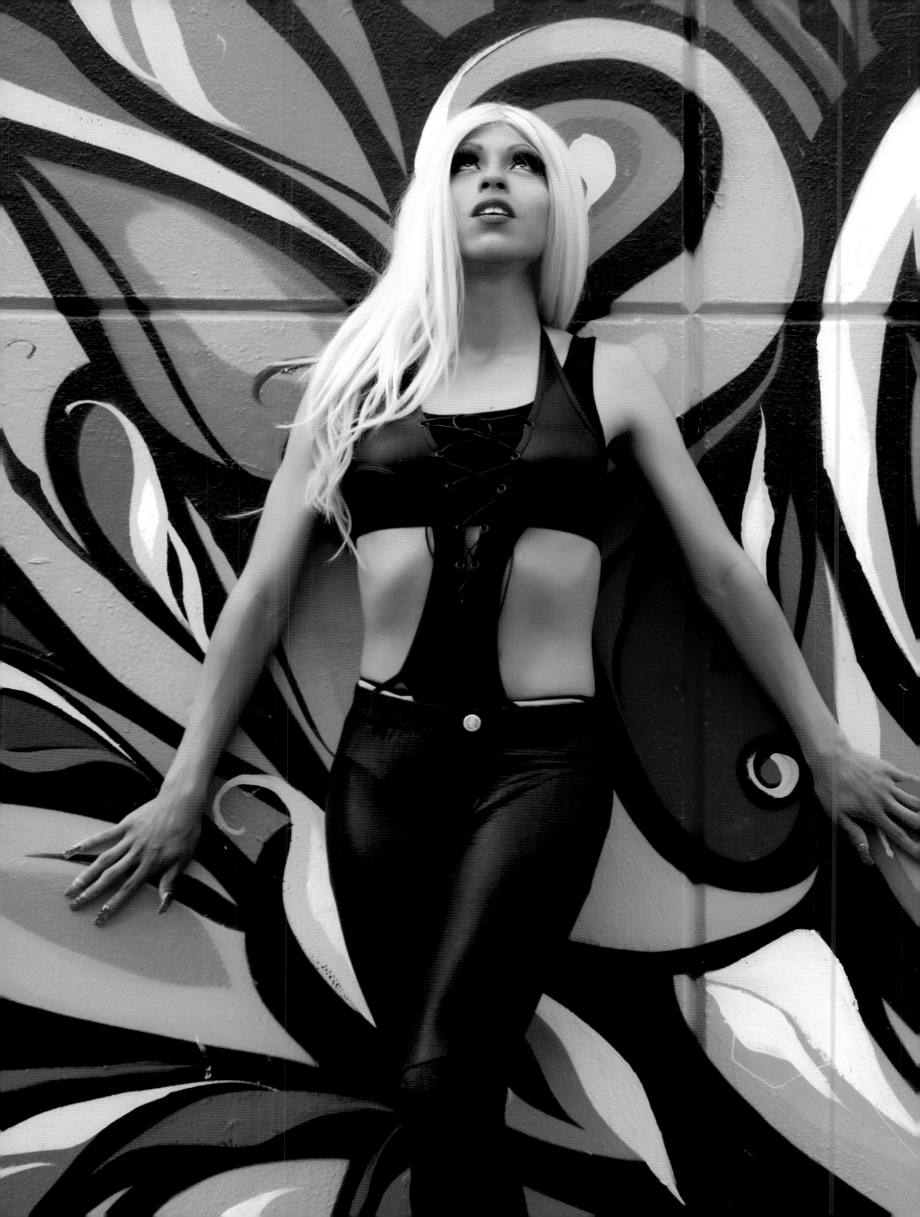

Reyna inspired by
Ivy Queen

Reggaeton is not for the faint of heart. This is true both of the music and the lyrics. In particular with respect to its depiction of women. Sometimes they are described as cats – preferably in heat –, as bandits who loot men or as the devil who abuses them. Put simply: just like you and me.

And this is no longer just the view of men. The few women in this tough business portray themselves this way. Above all, Ivy Queen. What makes her different from the rest is she leaves out the inflammatory homophobic rhetoric that her macho counterparts are so found of expressing. Instead, she advocates for the rights of gays and lesbians. The US gay rights organization GLAAD has honored the Puerto Rican singer for her efforts. She has no time, however, for gossip that she is interested in women or is even transgender. "I think like a man, rap as one, but I am no lesbian."

Der Reggaeton ist nichts für zartbesaitete Gemüter. Das gilt für Musik und Text gleichermaßen. Besonders, wenn es um das Bild der Frau geht. Mal wird sie als Katze bezeichnet – vorzugsweise läufig –, als Banditin, die Männer erbeutet, oder als Teufelin, die sie missbraucht. Kurz: eine wie du und ich.

Das ist jedoch längst nicht nur die Sicht der Männer. Die wenigen Frauen in dem harten Geschäft stellen sich gern selber so dar. Allen voran Ivy Queen. Was sie jedoch vom Rest der Gang unterscheidet, ist der Verzicht auf jegliches homophobes Geseier, das ihre Macho-Kollegen so gerne von sich geben. Stattdessen setzt sie sich für die Rechte von Schwulen und Lesben ein. Die US-Schwulenrechtsorganisation GLAAD hat die Sängerin aus Puerto Rico dafür bereits ausgezeichnet. Von Gerüchten, sie stehe auf Frauen oder sei sogar transgender, will sie allerdings nichts hören. „Ich denke wie ein Mann und rappe wie ein Mann. Aber ich bin keine Lesbe."

Reyna
Reyna, which means "Queen" in Spanish, is from San Francisco. Although she prefers slipping into the role of Latin artists, she doesn't shy away from American pop icons.

Reyna, was auf Spanisch „Königin" bedeutet, stammt aus San Francisco. Am liebsten schlüpft sie in die Rollen von Latin-Künstlern, macht aber auch vor amerikanischen Popgrößen nicht Halt

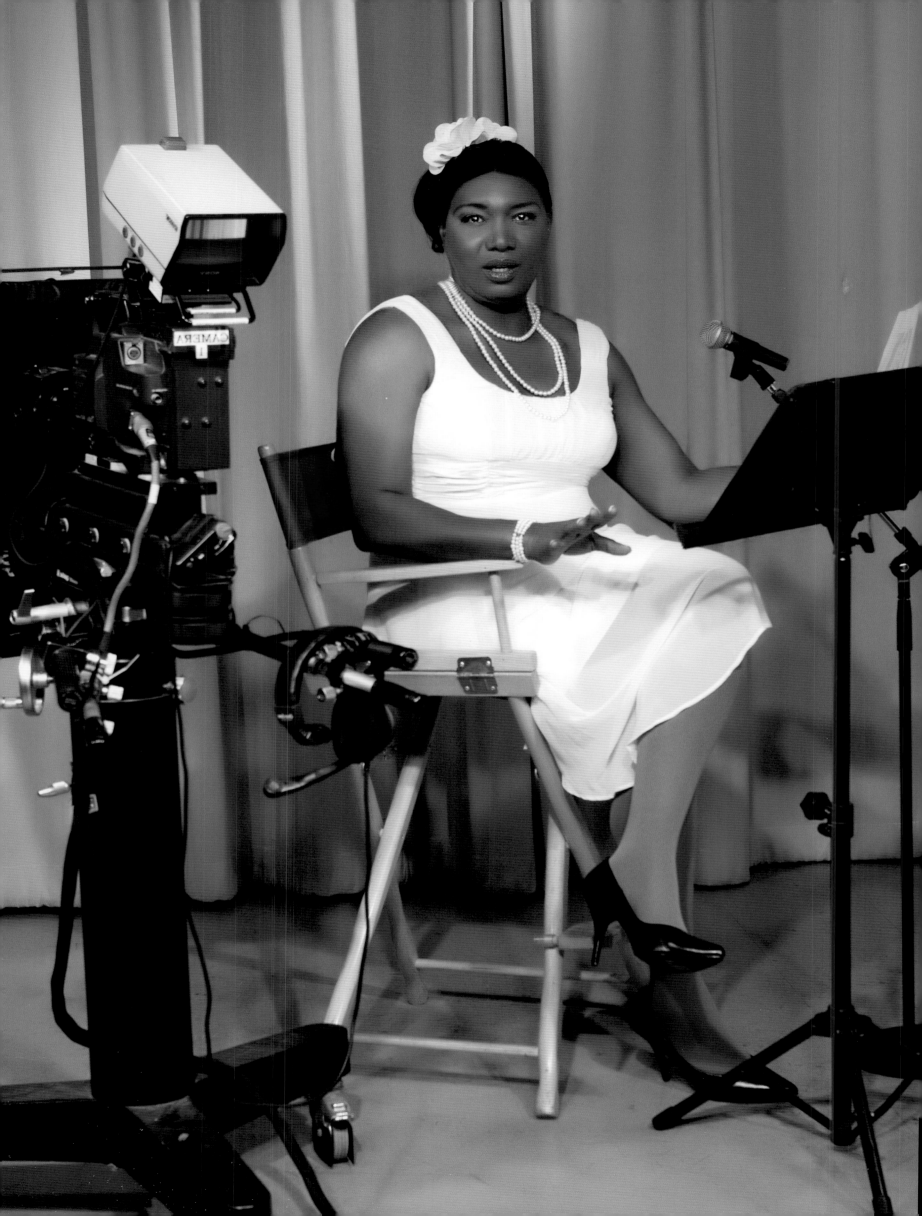

Lexi Gerard inspired by
Billie Holiday

In today's world, we can hardly imagine such a degree of racism. The woman who was Frank Sinatra's musical idol had to enter through the backdoor when she appeared with white musicians. In movies, she was cast as a maid. "Maid or hooker, has a black woman ever played another role in Hollywood?" she would later ask.

Yes, but not until after her time. She only lived to the age of 44, and her life was full of hardship and sorrow. She was raped as a child, then put into a Catholic reform school. Later she worked in a brothel, first as a cleaning lady, then as a prostitute. There was a gramophone there, which is how she discovered the music of Louis Armstrong. That was how the jazz icon found her way to music. No one sang the way she did. She found it boring to interpret a song the same way twice; every performance was unique. Her voice had something profoundly melancholic about it. *Gloomy Sunday* became a phenomenon as the ultimate soundtrack for suicides around the world, causing the BBC to ban the song from its playlists.

Man kann sich diesen Rassismus heute kaum vorstellen. Die Frau, die Frank Sinatras musikalisches Idol war, musste zum Hintereingang rein, wenn sie mit weißen Musikern auftrat. Beim Film wurde sie als Dienstmädchen besetzt. „Magd oder Nutte, hat eine Schwarze in Hollywood schon mal eine andere Rolle gespielt?", fragte sie später.

Ja, aber das war nach ihrer Zeit. Sie wurde nur 44 Jahre alt, ein Leben voller Kummer. Als Kind vergewaltigt, danach in einer Erziehungsheim gesteckt. Später arbeitete sie im Puff, erst als Putzhilfe, später als Prostituierte. Dort stand ein Grammofon, über das sie die Songs von Louis Armstrong entdeckte. So kam die Jazz-Ikone zur Musik. Keine sang wie sie. Weil es sie langweilte, einen Song zweimal auf die gleiche Weise zu interpretieren, klang jeder Auftritt anders. Und dann diese Melancholie in ihrer Stimme. Ihr *Gloomy Sunday* war für Selbstmörder auf der ganzen Welt der allerletzte Soundtrack, sodass die BBC den Song lange aus ihrer Playlist verbannte.

Lexi Girard
Lexi Girard is known in San Francisco as a reporter always on the go to glamorous events and drag shows. In addition to her own stage shows, she developed a diet, named Lexi-cize.

Lexi Girard ist in San Francisco als rasende Reporterin bekannt, immer unterwegs bei glamourösen Veranstaltungen und Drag Shows. Neben eigenen Bühnen-Shows hat sie eine Diät namens Lexi-cize entwickelt.

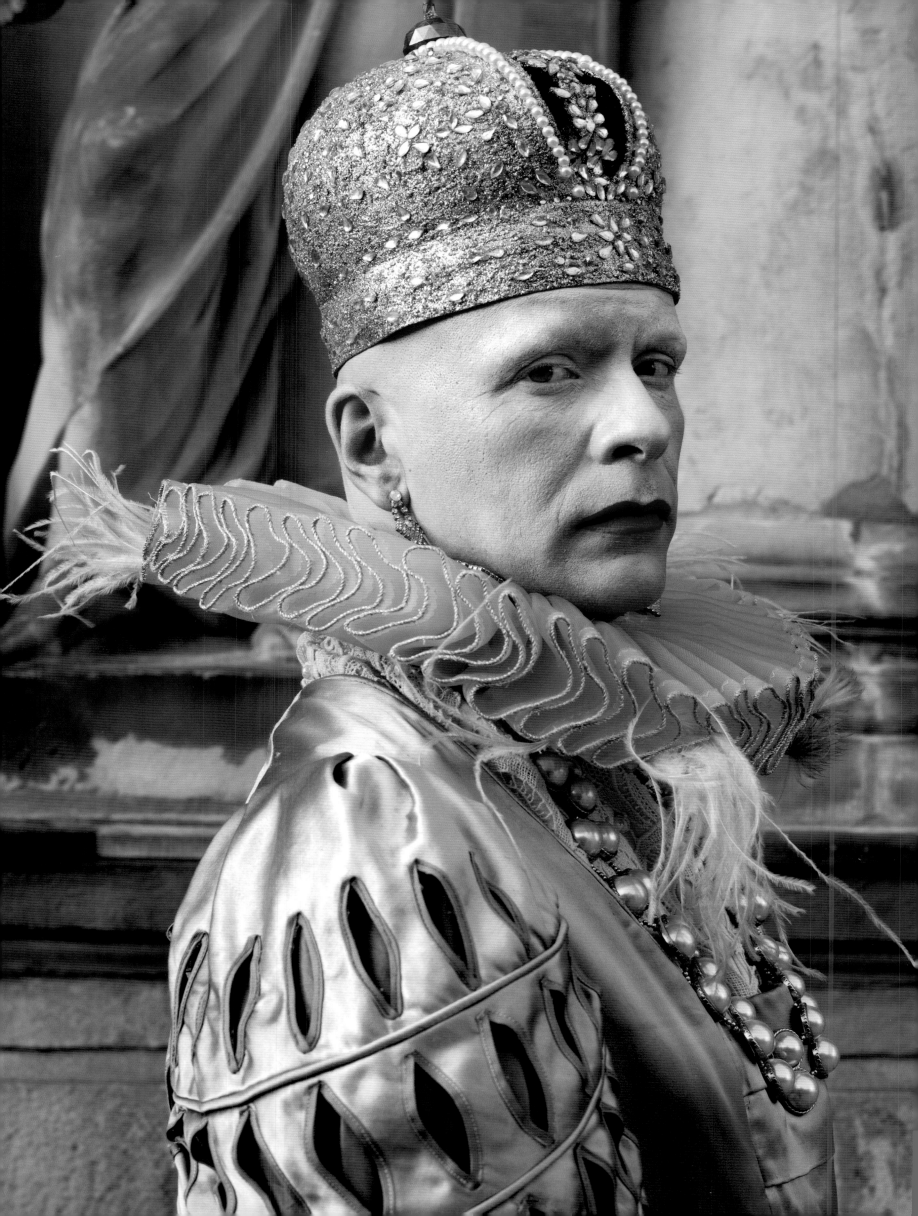

Chicago Rose inspired by

Queen Elizabeth I

She was the child of the sex-obsessed Henry VIII. While his womanizing ways were notorious, his daughter Elisabeth went down in history as "the Virgin Queen". Her favorite colors were black and white, all the better to rub in her unstained purity. She never married and died childless. She may, however, have slept with her childhood friend Robert Dudley. How his wife died falling down the stairs is puzzling to say the least.

She could be proud of her accomplishments as a ruler: She reduced the national debt, stimulated trade and had the head of her adversary Mary Stuart chopped off. Her reign is considered a golden age. During that time, the theater began to flourish and William Shakespeare revolutionized drama. Elisabeth ruled for 45 years, an energy-sapping job: "I know I have the body of a weak and feeble woman, but I have the heart and stomach of a king, and of a King of England, too."

Chicago Rose
Chicago Rose has been in show business for 25 years—and she's managed this feat without a facelift, Botox, or bribery. She is also politically active, for instance in human rights work.

Chicago Rose arbeitet seit einem Vierteljahrhundert im Showgeschäft – und das ohne Facelift, Botox oder irgendeine Art von Bestechung, wie sie betont. Nebenbei engagiert sie sich politisch, etwa für Menschenrechte.

Sie war das Kind des sexbesessenen Heinrich VIII. Während sein Frauenverschleiß berüchtigt war, ging Tochter Elisabeth als die „jungfräuliche Königin" in die Geschichte ein. Ihre Lieblingsfarben waren schwarz und weiß, damit rieb sie ihre Unbeflecktheit allen unter die Nase. Sie hat nie geheiratet und starb kinderlos. Möglicherweise schlief sie aber mit ihrem Jugendfreund Robert Dudley. Warum dessen Frau bei einem Treppensturz ums Leben kam, ist zumindest rätselhaft.

Die Bilanz ihrer Herrschaft kann sich sehen lassen: Sie reduzierte die Staatsverschuldung, kurbelte den Handel an und ließ ihrer katholischen Widersacherin Maria Stuart den Kopf abschlagen. Ihre Regierungszeit gilt als Goldenes Zeitalter. Damals blühte das Theater auf, William Shakespeare revolutionierte das Drama. 45 Jahre lang hat Elisabeth regiert, ein kräftezehrender Job: „Mein Körper ist der einer schwachen, kraftlosen Frau, aber ich habe das Herz und den Magen eines Königs, eines Königs von England."

I shall desire ... that I ... may make a good account to the Almighty God and leave some comfort to our posterity on earth.

— **Elizabeth I**

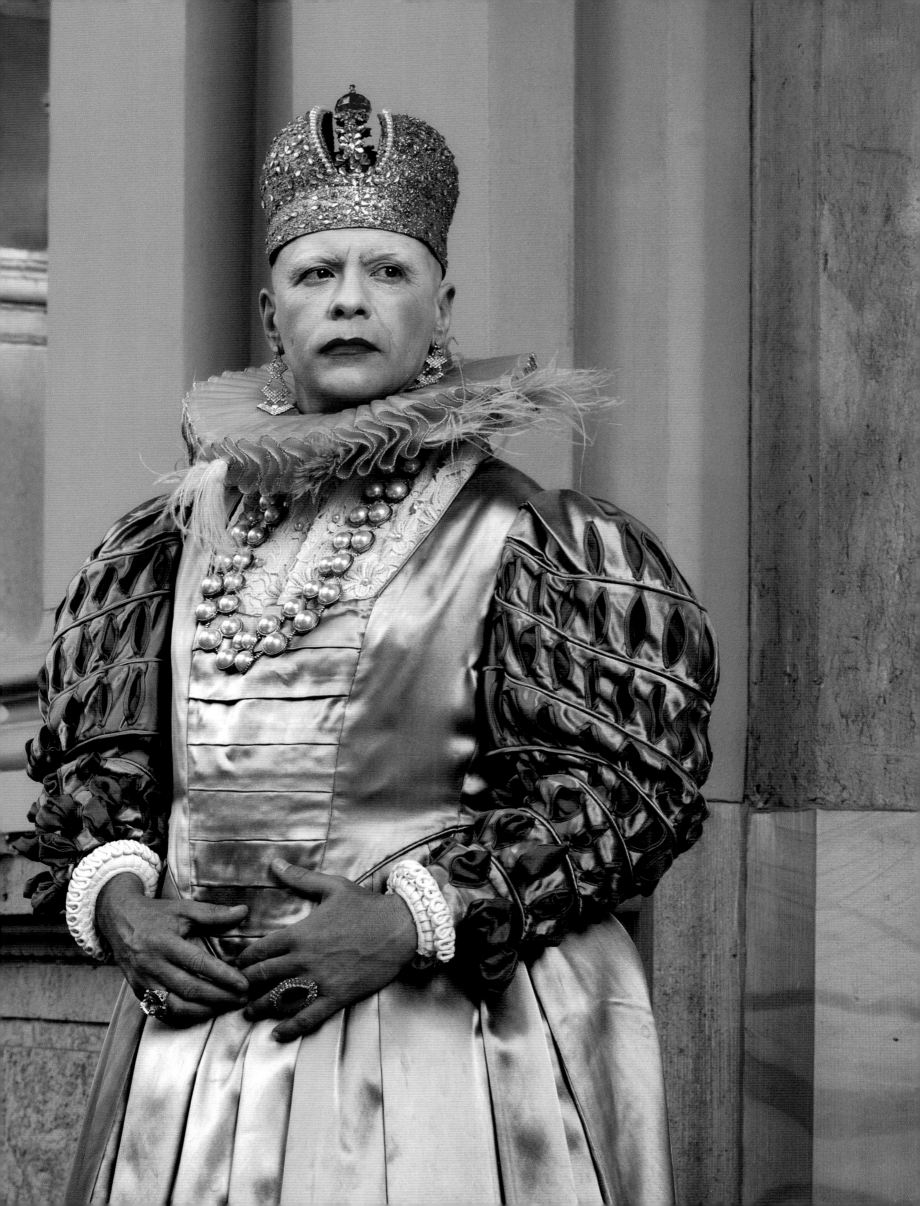

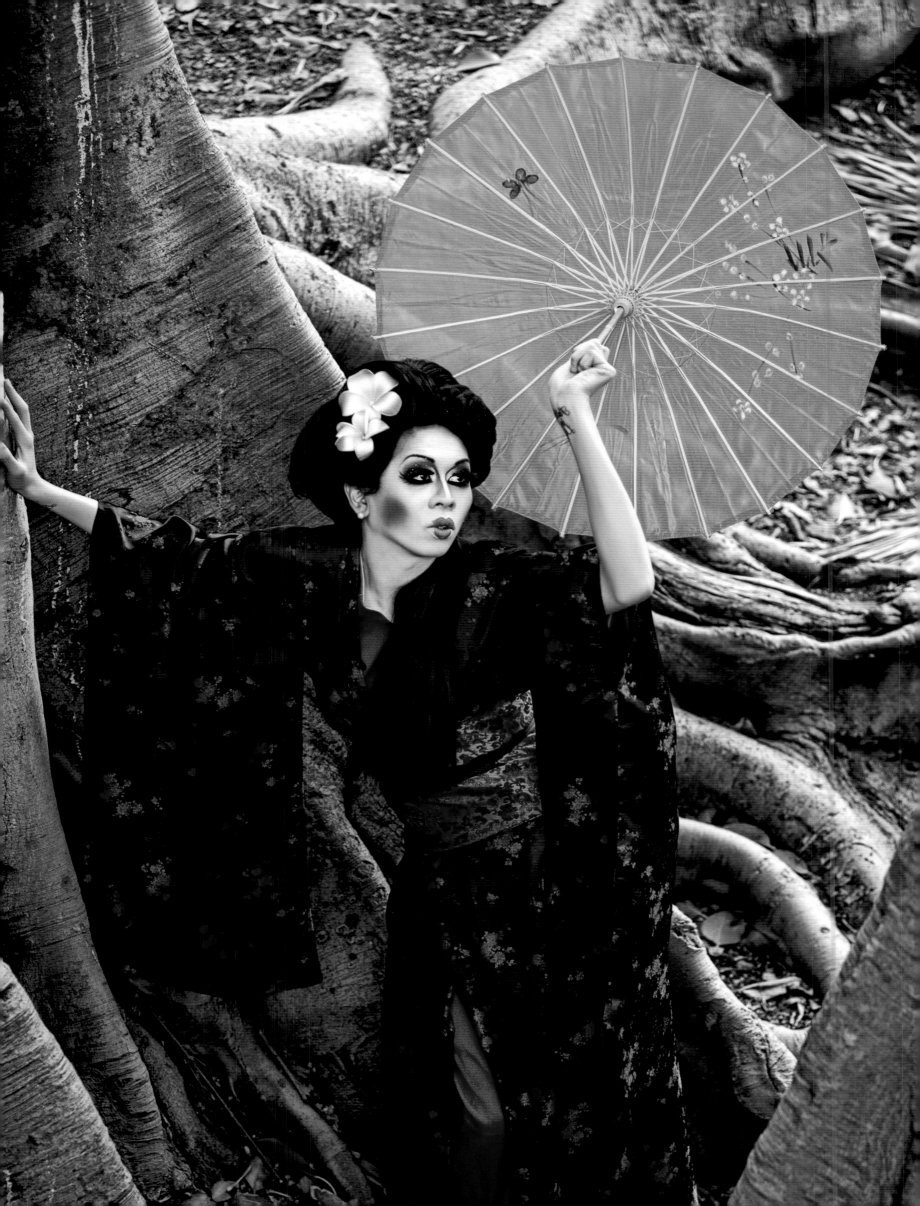

Paris Sukomi Max inspired by
Mineko Iwasaki

Even though many still haven't figured it out: A geisha is not a prostitute. Not that this means that some of them wouldn't spread their legs for a customer or two. Strictly speaking though, a geisha is an artist, trained in dance and song. Originally they were meant to entertain customers with small talk or clever tricks in the teahouses of the red-light districts. Only later did the geisha become respectable.

After arduous training, Mineko debuted at 15 and quickly blossomed into the star geisha of Japan. The top earner was often booked for years in advance. Her customers included the designer Gucci and the British Queen. She apparently had little interest in chatting with Mineko. With Prince Philip, however, she was more animated. Elizabeth II was not amused. The royal couple spent the following night in separate beds.

At the age of 29, Mineko retired from the business, but she is still admired by many in Japan.

Auch wenn viele es immer noch glauben: Eine Geisha ist keine Hure. Was nicht heißt, dass nicht die eine oder andere für ihre Kunden vielleicht doch mal die Beine breit macht. Genau genommen ist die Geisha eine Künstlerin – ausgebildet in Tanz und Gesang. Ursprünglich sollten sie in den Teehäusern der Rotlichtbezirke die Kunden mit Smalltalk oder Kunststückchen unterhalten. Erst später wurde die Geisha salonfähig.

Nach einer langen Ausbildung debütierte Mineko mit 15 und mauserte sich schnell zur Star-Geisha Japans. Manchmal war die Spitzenverdienerin über Jahre hinweg ausgebucht. Zu ihren Kunden gehörten Designer Gucci und die britische Queen. Die hatte aber offenbar wenig Interesse, mit Mineko zu plaudern. Umso angeregter unterhielt die sich mit Prinz Philip. Elisabeth II. war darüber not amused. Das Königspaar verbrachte die folgende Nacht in getrennten Gemächern.

Im Alter von 29 hat sich Mineko aus dem Geschäft zurückgezogen, aber noch immer wird sie von vielen Japanern bewundert.

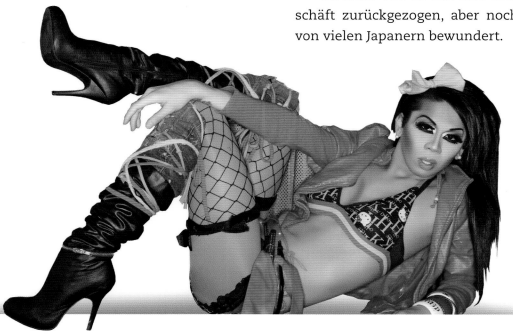

Born in Bavaria, **Peter Werner** moved to Berlin at the end of the 1980s, where he received his theatrical education. Later, Peter moved to Los Angeles and discovered where his true passion lay: not in the spotlight itself, but behind the camera. In 2002 he started studying photography in Orange County. He then established himself as a photographer for artist portraits. In 2009 he started the *Me and My Idol* series in San Francisco, which caused waves on both sides of the Atlantic. Peter Werner lives and works in Berlin and California.

Kriss Rudolph is author, moderator and DJ. After studying literature, he sat behind the mic at major German stations including SWR3 and WDR2. In 2002 he moved to Los Angeles, where he worked as a celebrity reporter. There he wrote his first novel, *L.A. Affair*, which is now available in both German and English. In addition, he writes regularly for the German magazine *Männer*. In 2002, his Offenbach rendition *Berliner Leben* (Berlin Life) premiered at the Neukölln Opera. Kriss Rudolph lives in Berlin.

Lady Bear
Elizabeth Taylor
www.LadyBear.com
Make-up: www.meaganmilano.com

Anna Conda
Greta Garbo
www.facebook.com/AnnaCondaSF

Pristine Condition
Grace Jones
www.facebook.com/PristineCondition

Adriana Mia Diamante
Lady Gaga
www.facebook.com/AdrianaDiamante
www.twitter.com/AdrianaMia
www.youtube.com/AdrianaMiaSF

Syphillis Diller
Jean Harlow
www.facebook.com/Syphillis.Diller

Disco Dollie
Grace Jones
www.facebook.com/DiscoDollie
Coat: Nenee Couture

Athena Van Doren
Jayne Mansfield
www.facebook.com/MissAthenaVanDoren

Cookie Dough
Sissy Spacek in Carrie
www.CookieVision.com

Fergie Fiction
Dolly Parton
www.facebook.com/FergieFiction
Make-up: Thary Plast Ic

Lexi Girard
Billie Holiday
www.sxelv.blogspot.com
www.facebook.com/Lexi.Girard1
Make-up: www.Sadaishashimmers.com

Daft-Nee Gesuntheit!
Lucille Ball
www.daft-nee.com
Hair: Lance Knight
Location: Home of Kevin Reher

Artist Index

Glitz Glam
Nina Hagen
www.facebook.com/GlitzGlam69
www.GlitzGlam.com

Heklina
Lynette "Squeaky" Fromme
www.Trannyshack.com
Make-up: Phatima

Lil Miss Hot Mess
Emma Goldman
www.LilMissHotMess.com

Stefan Kuschner
Jessye Norman
www.facebook.com/Stefan.Kuschner
Make-up: Thary Plast Ic
Man at the piano: Tom Petrick

Frieda Laye
Dusty Springfield

Paris Sukomi Max
Mineko Iwasaki
www.facebook.com/SukomiMax

LeMay
Hedy Lamarr
www.ChezLeMay.com
www.retrofityourworld.com
Make-up: www.meaganmilano.com

Honey Mahogany
Helen of Troy
www.ItsHoney.com
Costume: Allan Herrera
www.homoatelier.com
Models: Jonathan Edward Althaus,
Ryan Fuimaono
Costume in small image: Mr.David

Lucy Manhattan
Bette Davis

Pollo del Mar
Anna Nicole Smith
www.Facebook.com/PolloDelMarFans

Mataina
Annie Lennox
www.Mataina.com
Costume: Shazy

Olgadina Oslovska Petruschka Meyer
Sophia Loren

Mona Lot Moore
Celine Dion

Gibson OGF
Erykah Badu
Extra: Johnathan Lay

Sandra O.Noshi-Di'n't
Empress Myeongseong
Costume: Max Christian Larson
www.facebook.com/Sandra.O.Noshidint

Phatima
Edith Massey

Thary Plast Ic
Marlene Dietrich
www.facebook.com/Thary.Plastic
Costumes and Extra: Lars Schwuchow
www.meindekorateur.de

Miss Rahni
Dorothy Dandridge
www.facebook.com/MissRahni

Reyna
Ivy Queen

Kenneth Rex
Eva Peron
www.facebook.com/KennethRex

Chicago Rose
Queen Elizabeth I
www.ChicagoRose.de
Make-up: www.lewi-makeup.com

Bob Schneider
Joan Collins
www.BobSchneider.de
Make-up: Thary Plast Ic

Miz Sequoia (Pam Grier) in
Foxy Brown
www.facebook.com/MSequoia
Costume: Donna Terrell
Styling: Melisa Miller-Handley

Sandy Shorts
Katharine Hepburn

Katya Smirnoff-Skyy
Joan Crawford
www.RussianOperaDiva.com
Costume: Mr. David

Suppositori Spelling
Demi Moore
www.facebook.com/SpazSpelling

BeBe Sweetbriar
Diana Ross
www.facebook.com/BeBeSweetbriar

Gillette Thebestamancanget
Janette Jackson
www.facebook.com/GilletteTheBestAMan-
CanGet

Tweaka Turner
Mae West
www.facebook.com/Tweaka.Turner
costume: John Maxwell
Hat design: www.paulwoodfordservices.
com

Erika Von Volkyrie
Lotte Lenya
www.myspace.com/ErikaVonVolkyrie
Make-up: www.meaganmilano.com

Jason Wimberly
Marilyn Monroe
www.wimberlyworldwide.com
www.twitter.com/JasonWimberly
www.facebook.com/WimberlyWorldwide
Make-up: Alexandra Dickinson

Flynn Witmeyer
Siouxsie Sioux
www.FlynnWitmeyer.com
Make-up: www.meaganmilano.com

Ades Zabel
Madonna
www.AdesZabel.de
Make-up: Thary Plast Ic
Extras: Thary Plast Ic, Patrick Pfeil,
Paul, Stefan Kuschner
Set design: Lars Schwuchow,
www.meindekorateur.de

© 2012 Bruno Gmünder Verlag GmbH
Kleiststraße 23-26, D-10787 Berlin
Phone: +49 30 61 50 03-0
Fax: +49 30 61 50 03-20
info@brunogmuender.com

Editor-in-Chief: Stephan Niederwieser
Art Director: Steffen Kawelke
Editorial Coordination: Simeon Morales
Pre Press & Print Management: Zwei G Consult

Concept and photography © 2012 Peter Werner
www.wernerimages.com
Texts: Kriss Rudolph
www.kriss-rudolph.com
Translation: Tokeem Talbot

Printed in South Korea

ISBN: 978-3-86787-234-8

Check out all of our books:
www.brunogmuender.com